Fifty Early Medieval Things

Fifty Early Medieval Things

Materials of Culture in Late Antiquity and the Early Middle Ages

Deborah Deliyannis, Hendrik Dey, and Paolo Squatriti

Cornell University Press
Ithaca and London

First published 2019 by Cornell University Press

Printed in Canada

Library of Congress Cataloging-in-Publication Data

Names: Deliyannis, Deborah Mauskopf, 1966– author. | Dey, Hendrik W., 1976– author. | Squatriti, Paolo, 1963– author.
Title: Fifty early medieval things : materials of culture in late antiquity and the early Middle Ages / Deborah Deliyannis, Hendrik Dey, and Paolo Squatriti.
Other titles: 50 early medieval things
Description: Ithaca [New York] : Cornell University Press, 2019. | Includes bibliographical references and index.
Identifiers: LCCN 2018019485 (print) | LCCN 2018020085 (ebook) | ISBN 9781501730283 (pdf) | ISBN 9781501730290 (epub, mobi) | ISBN 9781501725890 | ISBN 9781501725890 (cloth; alk. paper) | ISBN 9781501725906 (pbk.; alk. paper)
Subjects: LCSH: Civilization, Medieval. | Material culture—Mediterranean Region—History—To 1500. | Mediterranean Region—Civilization. | Mediterranean Region—History—To 476. | Mediterranean Region—History—476–1517.
Classification: LCC CB351 (ebook) | LCC CB351 .D43 2019 (print) | DDC 937—dc23
LC record available at https://lccn.loc.gov/2018019485

Contents

Acknowledgments

Writing this book has been a genuinely collective project. For each of us, it has meant an unaccustomed foray into the most contemporary style of academic work, collaborative scholarship. We can say with confidence that three authors are behind every entry in *Fifty Early Medieval Things*. Though each artifact in our assemblage was researched and written up by one of us, we took full advantage of the possibilities opened by current electronic forms of communication: the others read, weighed in on, commented, and edited every Thing. Our cooperation began fortuitously, as a coffee-hour discussion at a medieval studies conference in 2011, and developed through hundreds of e-mails, online PDF exchanges, and further meetings in person. Thus we must acknowledge first each other's contribution to what we wrote individually, and to the formation of the book.

But if we think *Fifty Early Medieval Things* is not the product of traditional, isolated scholarly research into the past, that is also due to the kindness and interest of numerous other people who have read parts of the book, provided valuable sounding boards, given encouragement, supplied materials, offered advice, and made important corrections in our text, beginning with the three anonymous reviewers for Cornell University Press. Among those people, we somewhat arbitrarily single out the following for their generous engagement with our work: Haley Behr, Leila Bisharat, Vincenzo Binetti, Gianfranco Brogiolo, Heidi Busch Binetti, Lanfredo Castelletti, Alice Choyke, Erdem Cipa, Florin Curta, Rosanna Di Pinto, Bonnie Effros, Laura Garver, Stefan Heidemann, Lynn Jones, Kenneth Jonsson, Filip Kobylecki, Genevra Kornbluth, Anita Korom, Stephanie Leitzel, Will MacFarlane, Daniele Manacorda, Bob Miller, Giovanni Minonne, Ian

Mladjov, Eric Morgel, Tina Pannella, Helmut Puff, Giacomo Squatriti, Marina Uboldi, Umberto Utro, Fred van Doorninck, Carola Zimmermann. To all of them, our grateful thanks.

Further thanks are due to the University of Michigan Office of the Vice President for Research, Indiana University's Institute for Advanced Study, and the Presidential Fund for Faculty Advancement at Hunter College, CUNY, for contributing funds toward the book's production.

Paolo Squatriti's share in the present volume is dedicated to Anna, Giulia, and Luisa, whose commitment to materiality is different than this book's, but who always look over his historical pursuits with indulgence. Hendrik Dey dedicates his share to his students at Hunter College, who always remind him in various ways of how and why things matter so much. Deborah Deliyannis dedicates her share to Plato, Harry, and Simon, whose answer to every question is "Sutton Who?"

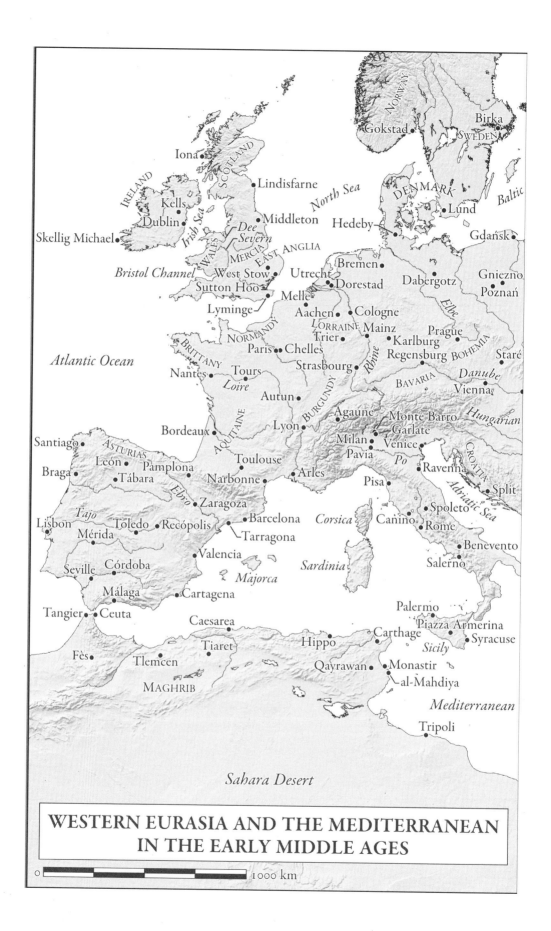

WESTERN EURASIA AND THE MEDITERRANEAN
IN THE EARLY MIDDLE AGES

0 _____ 1000 km

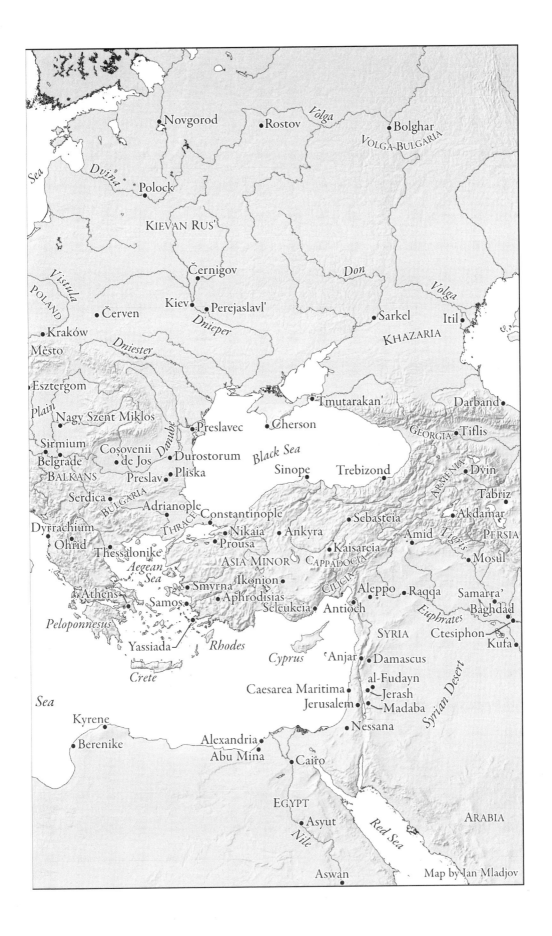

Map by Ian Mladjov

Fifty Early Medieval Things

INTRODUCTION

Things, Matter, and Meaning in Late Antiquity and the Early Middle Ages

At the very end of the early Middle Ages, in the year 1000, a gathering of colonists from Scandinavia who had settled in Iceland took the unprecedented step of voting to abandon the ancestral gods and embrace Christianity. Disregarding the King of Hearts' excellent advice in *Alice in Wonderland* to "begin at the beginning," in this case it makes sense to begin at the end because the meeting of Icelanders was called a "thing."[1] Like the closely related Old English word *þing* that spawned modern English "thing,"[2] the Icelandic assembly suggests that the postclassical era (ca. AD 300–1000, and divided by historians into the overlapping periods of Late Antiquity and the Early Middle Ages) has much to offer to the contemporary study of material culture. Indeed, we shall see in what follows that some of the most acute theorizers on material culture, like Martin Heidegger, have borrowed from this early medieval etymology of "thing" to analyze modern engagement with objects.

Fifty Early Medieval Things has its roots in our conviction that the material culture of the postclassical world is not only inherently interesting but also opens vistas onto the period that are fresh, surprising, and instructive.[3] In this volume, we deal with tangible things—artifacts, buildings, and archaeological features— while remaining alert to their intangible, even invisible dimensions so as to fit the things we discuss into appropriate historical contexts. Our things are usually interpreted alongside written sources that help in understanding their historical context; however, sometimes the material culture seems to contradict what the writings say, or even fills spaces left void by written sources. One purpose of this book is to show how material culture from the period AD 300–1000 informs us

both about the past *and* how interpreting such material culture can be fraught, difficult, and ambiguous.

Our presentation of late antique and early medieval things is informed by (and hopefully informs) ideas about the relationship of material culture to the study of the past that have established themselves in recent scholarship. Until lately, the study of the medieval past tended to take place in compartments, divided between those who studied its manufactured objects, buildings, traces of agricultural practice, and human remains—primarily archaeologists and art historians—and those who studied *historia* in the form in which the written sources delivered it to the present. Historians have only in the past two decades begun to interact fruitfully with archaeologists', anthropologists', and art historians' findings, and with their theories of material culture. The 1990s development of a "thing theory" as part of the broader "material turn" in academia has offered a new way to understand material culture and bring it into literary and historical discourse. Since people made and used things during the period 300–1000, investing them with meanings that could go well beyond the practical, we concur that the study of postclassical things can benefit from these recently developed ideas about material culture. We also think that the late antique and early medieval periods have much to contribute to material culture studies, which have tended to focus on the nineteenth and twentieth centuries.

In the following sections, we introduce the reader to the historical background and theoretical underpinnings for the study of early medieval material culture. The first section presents an outline of late antique and early medieval history in Europe and the Mediterranean. The second part traces the main contours of the academic study of things. And in the third part, we explore the materiality of late antiquity and the early Middle Ages, providing an overview of what the things included in this book can tell us about early medieval people and the material world they inhabited.

Outlines of a Postclassical History

The late antique and early medieval periods were characterized above all by sharp fluctuations in the power of rulers and their governments, and by the conversion of most people in western Eurasia and northern Africa to Christianity or Islam. The two processes were of course closely connected, but here we treat them sequentially, beginning with the history of state authority, and then turning to the history of the most successful monotheisms of that time.

The term *Late Antiquity* refers to the period of time in which the regions of the Roman Empire and the Mediterranean saw many changes, while at the same time retaining political and economic structures from the classical past. In the

third century, the Roman Empire faced civil war, invasion, epidemic disease, and economic depression. The empire reacted to these events by reforms; the gradual, mostly controlled reduction in the range and proficiency of Rome's imperial administration affected Rome's western provinces the most. In the eastern half of the empire, there were more numerous and populous urban centers, more robust and variegated agriculture and industry, better-developed infrastructure for the circulation of people and goods, and more committed rulers, ensconced in an impregnable new Rome on the Bosporus: Constantinople. Such resources meant that life in the East flowed by with fewer ripples and waves, at least until the seventh century. Even in the 600s the eastern Roman Empire was solid enough that it became one model of efficient governance for the most effective postclassical state of all, the Islamic Caliphate (another of whose models was the Sasanian Empire, centered in Persia). But demographic decline (related to recurrent epidemics after 541), military reverses, and general impoverishment related to both of these, deprived eastern Roman government of capability.

This state of affairs was ruptured in the early seventh century. First the Sasanians occupied vast swathes of Roman territory. Before the eastern Roman Empire had completed its reconquest, in the 630s Arabs, politically and religiously unified by Muhammad, began to conquer large parts of Persia and the Roman Mediterranean, and after 711 had reached Spain and the Hindu Kush, setting up their own imperial state. The Islamic Caliphate's central government judiciously marshaled its assets, including the financial backing (there was a special poll tax on non-Muslims) and the know-how of its Jewish, Zoroastrian, and Christian subjects. Whether in Damascus (under the Umayyads, AD 661–750) or in the new, circular capital of Baghdad, "crossroads of the universe," under the Abbasid dynasty (750–1258), early medieval caliphs formed and managed efficient, meritocratic, literate state apparatuses based on taxation of their subjects' property. This upbeat account of early medieval state formation is tempered somewhat by the tenth-century revival of provincial authorities in Iran, Egypt, North Africa, and Spain, where governors who were increasingly independent of Baghdad ruled and represented local interests, and some of whom eventually adopted the title of caliph themselves.

The Roman Empire in Constantinople continued as a political entity in its reduced territories, still emphasizing its connections with the Roman past; modern historians often call it the Byzantine Empire. From 650 to 850, Byzantine emperors ruled a rump state, tenuously clinging to Anatolia, pockets of the southern Balkans, south Italy, and the Aegean islands. Constantinople's rulers never stopped taxing land or paying troops in cash, while around their Great Palace literate administrators scurried with documents a Roman bureaucrat might have recognized. In the tenth century, buoyed by the Caliphate's decentralization and Baghdad's weaker grip over the provinces, as well as by the creation of

vigorous Orthodox Christian churches in the Balkans and, by 1000, in Russia, the Byzantine Empire could again imagine itself as an ecumenical power in the truest sense.

The early medieval Islamic and Byzantine states were far more centralized than their contemporaries in Latin Christian Europe. There, during the fifth century, outsiders identified by the Romans as "barbarians"—Visigoths, Ostrogoths, Franks, Angles, Saxons, Lombards, and others—replaced western Roman governance with competing, regional polities. Their leaders relied on personal ties to elite subjects and on ethnic loyalties to create solidarity and maintain power. Though most early medieval rulers surrounded themselves with capable clergymen as well as muscular retainers, few had elaborate administrations or the ability to systematically tax their subjects. These weaknesses kept barbarian hegemony regional in scale until the eighth-century rise of the Frankish Carolingian family. And though the Carolingians experimented skillfully for about a century (ca. 750–850) with pan-European statehood and power, their precarious construction fell apart in the later ninth century. Certainly the collapse of the Carolingian Empire was aided by incursions of Vikings, Arabs, and Magyars to which the Franks found no adequate military response. But the personal nature of royal authority, the limited range of state bureaucracy, and the scanty taxation of which early medieval kingdoms were capable meant that tenth-century Europe settled back quickly into its congenital divided condition. Attempts to revive the Roman Empire of Charlemagne (d. 814) by the dukes of Saxony (now called the Ottonians) were ephemeral and enjoyed limited support in Europe. Otto II (d. 983) confronted continuous uprisings in Italy, Bavaria, and along the Elbe River; his successor Otto III (d. 1002) faced stiff resistance even in Rome, nominal capital of his empire.

In the cultural sphere, the affirmation of relatively new, exclusive monotheistic religious systems was certainly late antiquity's biggest innovation. Rome's tolerant, inclusive paganism had allowed Christianity to survive, and then from the third century to thrive. The conversion to Christianity by Rome's emperor Constantine and, over a few generations, by the governing class of the empire, led to more rigid conceptions of religious community. By the fifth century, openly polytheistic believers were few in Roman-ruled territories, and pagan religious practices were banned. Christianity became the official state religion, and though Judaism was allowed to exist, it did so under severe restrictions. Islam's swift expansion into west Asia and the Mediterranean in the mid-seventh century further extended the influence of One-God religions. Originating in Arabia, on the southernmost fringe of the ancient world, its success can appear surprising. (Indeed, surprise is often invoked to explain why the Sasanian and Roman empires so ineffectively resisted the armies of the Rightly Guided Caliphs in AD 630–670.) But Islamic monotheism participated in a broader trend.

In the Roman Empire, Christian clergymen labored diligently to adapt their religion to the new circumstances in which it found itself after Constantine's conversion. They hammered out a consensus on what Christians should believe, which texts they should consider divinely inspired, and which Christians should hold authority in society. Supported by the Roman government and funded by Roman elites, these ideas took hold in cities throughout the empire. Particularly in places where Roman authority became weaker, bishops became urban leaders in a practical as well as a spiritual sense.

Even where cities (and hence bishops) were fewer, for example in Western Europe, Christianity remained an urban religion well past the middle of the first millennium. The conversion to Christianity (and indeed, to Islam) of rural populations is not well understood, but clearly monotheism penetrated more slowly in rural areas. Monasteries, many of which were built as isolated rural retreats, played an important role in spreading Christianity there. Monasticism had arisen in the Egyptian wastelands around 300 partly as a critique of Christianity's compromises with power. Christian nuns' and monks' evident holiness, as embodied in their self-discipline and apparent disregard of social obligation, as well as their living out Jesus' injunctions to his followers, elevated them above ordinary folk. They won respect and social prestige. This was just as true in Constantinople, the foothills of the Caucasus, and the hamlets of the Nile Valley as it was on the windswept crags of Ireland. Especially in Europe, Irish and English monks had an impact disproportionate to their numbers on the export of Christianity to the countryside. Monks were also effective missionaries to Germanic- and Slavic-speaking areas (eastern Germany, southern Scandinavia, Poland, the Danube Valley, even the Balkans, via Byzantine missions) from the seventh century onward.

In the last centuries of the early Middle Ages, monastic institutions turned their high spiritual and social standing into economic and political power through the patronage of wealthy families and powerful secular rulers. This transformation is not entirely surprising. From its inception, monasticism was also an integral part of the Christian societies that supported it, reflecting not just the aspirations of pious people but also the realities of their lives. Europe's aristocratic abbesses and monks, and opulent monasteries, reflected the hierarchical arrangement of tenth-century communities.

The aristocratic tenor of European monasticism circa AD 1000 mirrors the renewed ascendancy of elites in other Christian societies, like Byzantium. It also mirrors the growing authority of the *ulama*, the class of legal specialists who, after about 800, articulated a code of conduct for Muslims out of the Qur'anic scriptures and the records of Muhammad and his immediate followers' activities (*hadith*). The Islamic communities of western Asia, North Africa, and Iberia were far more socially and economically complex than the Christian one of Europe

(or Byzantium outside Constantinople); yet late in the first millennium new social hierarchies emerged within them, too, reflecting a new cultural balance. Thus, the universal acceptance of monotheistic belief systems, initially sponsored by all-powerful imperial rulers, had the unexpected consequence of fostering new self-confident elites more independent of central authority. By the tenth century, Islamic belief and practice provided sufficient legitimation to these elites.

The seven postclassical centuries, therefore, encompass both state failure (the western Roman Empire) and state building (the Caliphate, the Carolingian Empire, several smaller polities with more provincial horizons, like Fatimid Egypt, Bulgaria, or Wessex in England). They also witnessed massive cultural shifts, particularly in religious sensibilities that would shape the medieval, early modern, and modern Eurasian world. The later repercussions of political and religious choices made by postclassical people impart special interest to their material culture.

Material Turns

As noted above, it has been only in surprisingly recent times that historians have joined the fashion for material culture studies. Scholars of things associate the "material turn" that Anglophone academia took sometime late in the 1990s—which foregrounded discussions and analyses of material culture, of objects, artifacts, and things—with the reception of a now-celebrated collection of essays, including one by Igor Kopytoff entitled "The Cultural Biography of Things: Commodification as Process," that questioned the distinction between human and thing and proposed that objects had voices.[4] The intellectual movement labeled "material turn" was partly a reaction to an earlier "discursive turn" and to perhaps exaggerated interest in how words alone constitute perceived reality. But one of the key insights it generated is that objects are best understood when closely scrutinized within their real-life contexts. Some of the leading practitioners of the trend have taken up this important concept and set their own movement into *its* cultural context, speculating that at least four contemporary conditions undergirded the "material turn."[5]

First, in the last twenty years, the gradual and growing digitization of culture may have inspired the fascination with objects and their use. Since many of the academics who fashioned or followed the "material turn" grew up when (for example) listening to music was done not by download but by putting a round piece of black plastic onto a record player (or, later, a silvered, slightly smaller one into a disc-player), they are particularly sensitive to the dematerialization that digital culture brings. Lovers of books, too, might rue the digital flows of text and image by which contemporary information moves between people, and these

examples could easily be multiplied. Thus, a kind of compensatory anxiety typical of recent settlers in the e-world might motivate the current heightened interest in objects and how they function among people.

Closely related to this is a second bit of cultural background. The increasing competence of things, their ability to perform all manner of tasks formerly the exclusive domain of people, their ability to replace people, has blurred the lines between thing and person, but also fostered worries and curiosities about things' nature. When robots regularly beat Grand Masters at chess, drive far more safely than commuters do, and leave floors much cleaner than human hands can, a rational human reaction might be to begin to wonder about things and to want to observe them more closely.[6] This remains true even though the underlying cause of the triumph of things over people is intangible artificial intelligence.

A third important component of the cultural context within which First World people took the "material turn" is globalization and advanced capitalism.[7] One of the peculiarities of that economic and cultural formation is the ever speedier production, circulation, and consumption of goods, namely of things. But in order to consume more things more quickly, people have to make room for them by abbreviating the utilization of the things they already have. The very fast life cycle of things necessary to sustain the contemporary consumption economy is based on a rapid devaluation of things, enabling them to be thrown away and replaced. This novel situation has produced some curious side effects. For instance, since human memory depends on things to avoid oblivion, some critics propose that contemporary indifference to the past derives from the enforced indifference to things that rapid consumption cycles imply.[8] In addition, some historians note that the history of hoarding, the opposite of the throw-away-to-consume-more culture, is quite shallow, barely extending back past 1950. Though early medieval people did create hoards that have been uncovered centuries later, they generally did so in exceptional moments of stress, as when natural disasters or invading armies undermined the foundations of their lives and they feared losing the things they deemed most valuable (see Things 1, 23, 34). And in the North Sea region, ritual deposits also created hoards, from the fourth through the seventh centuries. But houses full to the rafters of collected knick-knacks, plastic bottle caps, old newspapers, long-unworn baseball caps, or whatever else the inhabitant fancied, are a phenomenon of very recent times, one that has been plausibly connected to the huge surge and rapid turnover in the possession of things that advanced capitalism generates.[9]

The modern hoarder, then, may be expressing anxiety about the impermanence of things and their apparent loss of value by clinging to them, even though the neighbors consider them useless and the hoarder crazy. Hoarders might seem to resemble the nostalgic collectors of Barbie dolls, or muscle cars, in attempting to resist the impermanence of the contemporary material culture as it has

been shaped by the prevailing economic system. Yet the collectors do more than reflect twenty-first century attitudes toward things; ironically, this nostalgia for objects, particularly objects associated with the nostalgic person's youth, itself feeds a booming business and supports the heightened consumption patterns of the twenty-first century.[10]

A fourth contextual explanation for the "material turn" is ecological. The earth, to some of the proponents of the turn, is the most precious thing of all, and it is being devastated on a scale and at a speed with few precedents, none in the past few millennia. The realization that the irrevocable ruin of the planet on which we live may be imminent, and that the productive systems that sustain us increase the likelihood of its destruction, seems to some of those engaged in the study of material culture an important motivation for their studies. They point out that it is the very things that make our lives easier and more pleasant that are causing the damage, both because producing them has several unintended consequences, and because after they are discarded we lose control over things and they go about their business, decomposing at variable rates (or not), in ways that are detrimental to our interests. Environmental pollution, in other words, is an inevitable component of human involvement with things, giving the "new materialists" (a collective term for those who study material culture after the "turn") even more reason to uncover the history of humanity's relationship to the things it creates.

One could object that these various rationales for current interest in things are all predicated on an exceptionalist idea of contemporary times, as if only twenty-first century capitalism has produced the conditions for deep engagement with artifacts. Yet it was the great early twentieth-century economist John Kenneth Galbraith who proposed (way back in 1958) that Western societies had attained an unprecedented level of affluence, making it possible for people to surround themselves with unprecedented numbers of things, and to enjoy thereby unprecedented ease.[11] Taking a broader perspective, we find that for at least two hundred years capitalist modernity has coincided with the production, distribution, and consumption of lots of things, so one may doubt that what has transpired over the past twenty years is radically different from what happened earlier, well before anyone had swerved into any "material turn." This leaves the causes of First World intellectuals' "material turn" somewhat indeterminate. But, as we shall see in the next section, indeterminacy characterizes things, at least in their abstract, written form.

Object, Artifact, Thing: Secret Agents?

Our discussions of things have tended so far toward a rather unscientific vagueness about what a thing is. We want to uphold this indeterminacy: the terms *thing*,

artifact, and *object* are used pretty much interchangeably in this book, though here we follow fashion and tend to use "thing" the most.[12] While we recognize that significant semantic distinctions are possible, and respect the intellectual labor behind the construction of these distinctions, in our book, which is about specific things more than theories of things, it seems sufficient to explain what differences practitioners of material culture studies have seen in the words used to describe things, and some ramifications deriving from the chosen vocabulary.[13] This section explores in a little more depth the recent scholarly theories about things and sketches in some of their genealogies.

Artifact is perhaps the easiest to deal with, as it involves artifice and human ingenuity and is thus a special category of thing: one made by humans. But even that apparently simple distinction, under scrutiny, becomes hard to support. For it is possible to argue that virtually nothing in the material world is utterly unaffected by humans. Even seemingly pristine wilderness depends on human choices and strategies of resource use, its animal populations are shaped by faraway humans' hunting, gathering, and farming activities, and its plants are affected by people's use of fire, whose aerially transmitted waste can settle hundreds of kilometers from where the people are. Similarly the natural, organic chestnut (Thing 12), like all domesticated plants, is a product of centuries of human selection, propagation, grafting, and is not so purely natural after all.

"Object" is the least popular term these days, as it implies a subject who controls it, and many who took the "material turn" are unconvinced by the subject/object divide, as they are by other traditional dualities like person/thing and mind/matter. Since the object is (according to the word's Latin etymology) that which is thrown up against, or that which opposes the subject, the use of the word *object* reduces the thing's capacity to shape outcomes except in this oppositional way. Hence most new materialists follow the lead of Bill Brown and especially of Ian Hodder and embrace the word *thing*. To them, things are what artifacts and objects aspire to be; that is, they are the realization of artifactual and objective potential. Things are vastly more capable and potent than objects and artifacts, more in control of their fates, and ours.

A central tenet to most current theories of things is the recognition of things' irreducible *thingness*, their uncontrollable nature. Things have an ability to cooperate with people in producing outcomes without ever being completely dominated by them. Thus, new materialists tend to deny humans any supremacy in the material world. They suggest that things can do things. They propose that reality is a composite of humans and things, knitted together in an infinitely convoluted mesh. Within this mesh both humans and things "co-constitute" each other because it is the relations between them that create the physical world; both depend on dealings with the other for their own existence and identity. The perplexities of the new materialism confirm the wisdom of Winnie the Pooh, who

said, "When you are a Bear of Very Little Brain, and you Think of Things, you find sometimes that a Thing which seemed very Thingish inside you is quite different when it gets out into the open and has other people looking at it."[14] Things had seemed so simple and determinate; they turn out not to be at all.

The new materialism is, of course, in dialogue with older materialisms in the long history of Western philosophy. Some recognize in ancient Greek atomist philosophy the precursor of the current "material turn." Building on it, the Latin Epicurean Lucretius's poem *The Nature of Things* described the perceptible world as the outcome of the random circulation of miniscule particles. The contemporary materialists, who define a thing as a stage in the process of matter's never-ending transformation are no doubt cheered by the encounter with such venerable antecedents to their own sense of the world. The idea that everything, including people, is made of the very same particles has also resonated among those who find the distinction between human and nonhuman things troubling.[15]

More directly relevant to most new materialists, however, are the materialisms of the nineteenth century devised by thinkers who observed how the new industrial modes of production that emerged after 1800 multiplied the number of things.[16] In particular, Karl Marx's insights into relations between people and things as a result of industrial capitalism, which he termed "fetishism," have deeply informed the recent scholarship on things.[17] For Marx, industrialization was an epochal shift in the history of things, because the "use value" of things lost ground to their commercial value when the things' makers no longer had full control over, and thus full understanding of, what they had made; for now all decisions regarding production were made by the capitalists. Regardless of the skepticism that surrounds it as a philosophical system, Marxist materialism contributed to the "material turn" an insistence on the importance of matter and commodities, especially their production, in any analysis of culture. It also contributed a worldview in which capitalist, industrial modernity radically departed from a premodernity that encompasses Late Antiquity and the Early Middle Ages.

While Marxist materialism focuses on production, theories on the consumption of things have diverse genealogies.[18] In the 1970s, anthropology became interested in the "consumer society" and the cultural ramifications of being inundated with things.[19] Historians of consumption soon followed suit, inspired by the innovative French historian Fernand Braudel (d. 1985), again identifying in heightened modern consumption patterns a turning point in history.[20] But interest in the "crystallized" form of things, the version of them the consumer encounters, means that contemporary scholarship on things sometimes forgets Marx's point about the materials that went into making the thing, and the processes of production. For instance, the ongoing transformation of things, their impermanence, their erosion or decay, depends on the materials that make them up, which Ingold believes need to be taken more seriously in the study of material culture.[21]

Another formidable figure in the intellectual lineage of the new materialism is the German philosopher, Martin Heidegger (d. 1976). In his 1950 lecture on "The Thing" (which was published in English in 1971),[22] Heidegger discussed a pottery jug, proposing that the void within it, though not produced by the potter, is central to its being. Like the jug, other things gather together materials, forms, human work and care, but their thingness remains autonomous, beyond their manufactured properties. Heidegger was deeply impressed by the early medieval usage of the word *thing* to mean a gathering, like the Icelandic assembly with which this introduction opened. Heidegger's belief in things' autonomous reality and their ability to gather human intentions and wants has inspired materialists who ascribe a vigorous agency to things. To some of them, things are "vibrant matter" endowed with a kind of vitality that constrains and directs human activity.[23] They advocate for more conscious, respectful treatment of things, recognizing that people and things are not so very different. They resist the notion that equating things and people, as for instance did early medieval slave traders and some landowners, so lowers human status as to invite inhuman treatment of people.[24] Instead they think more democratic relations between things and people will produce humbler people acting in more ecologically responsible ways.

Related to this critique of twentieth- and twenty-first-century engagement with the material world is actor network theory (ANT), associated especially with the French sociologist of science Bruno Latour. ANT, too, assigns a kind of agency to things. Latour called things "actants" because they participate in creating the outcome of any action. Hence, in a lab, the white apron and the test tube are actants, like the technician using them. All three are symmetrical in a relationship that produces the experiment.[25] In a certain sense, ANT aligns with the late thinking of Charles Darwin (d. 1882), whose study of earthworms resulted in his belief that they exercised a "small agency," with impact on history because of the worms' positive contribution to plant and human life.[26] Likewise, ANT advocates argue for less anthropocentric conceptions of how events happen. Unsurprisingly, Latour has been an important presence in discussions of the hybrid object, the robot or the bionic man that melts some of the formerly rigid boundaries between thing and person.[27]

Over the past few years, Ian Hodder, the archaeologist most active in excavating and publicizing the large Neolithic and Chalcolithic town at Çatalhöyük in southern Anatolia, has also animated debates about things.[28] At University College, London, Hodder has organized a center of material culture studies that also publishes the *Journal of Material Culture*.[29] His notion of "entanglement" attempts to convey how things, whose life cycles do not synchronize with those of humans, drive people into ever deeper, more laborious relationships through maintenance. For example, the mud brick walls of Çatalhöyük's houses forced the inhabitants to rebuild, reinforce, buttress, and fix them with still more walls

practically every year, because of the wall's material nature (gooey when wet, which made thickening them prudent prior to the rainy winter months). Hodder eventually came to see such entanglement as a more sinister "entrapment."[30] Each thing calls for other things in order to work properly, and human servicing of the mesh of interrelated things becomes increasingly burdensome over time. Yet a "path dependency" obliges people to keep up the cycle of fixes, endlessly adding more things to the mesh to keep it running.[31] Thus, Hodder recognizes that a thing, even if it is not a conscious, intentional "primary" agency, has the power to create outcomes.[32] In fact, he thinks that it is precisely when things blend into the background, when people hardly notice them any more so essential are they to the everyday rhythms of life, that things are most powerful: they have become naturalized.

Not everyone is persuaded that the thing has agency (with academics, unanimity is unattainable). Both archaeologists, long acquainted with artifacts, and historians, congenitally predisposed to skepticism, have expressed doubt over this particular perspective afforded by the "material turn."[33] Indeed, the anthropologist Tim Ingold has called the agent thing "magical mind-dust" and advocated paying more attention to what things are made out of, how, and why.[34] Ingold concedes things may have an animating principle but suggests that to conceive of such a principle as external to the things, added to it somehow, and not inherent in their matter, is wrongheaded. Even Brown, who was instrumental in convincing literary scholars that the material lurking in the words they read was an important intellectual concern, allowed that it might be disappointing for those who turned toward things in search of the solid, the authentic, the straightforward, to find that instead the object world was active, unstable, tricky, and very complicated.[35]

For our part, as historians, art historians, and archaeologists trained before the swerve toward materiality dematerialized things into sophisticated sets of ideas, we tend to side with the skeptics about the utility of imagining "agential objects" and "vibrant matter." But as we think *Fifty Early Medieval Things* proves throughout, we are very much in sympathy with the attempt to understand the past less anthropocentrically, to see more symmetries in the relations between people and their stuff, to recognize the limits in human capacities to control events and things, and overall to observe the things that surround people as a crucial, even "co-constitutive" part of their reality, past as well as present.

Early Medieval Things I: Enchantment

Recent treatments of things, as described above, are largely indifferent to the premodern period, and particularly to the Middle Ages. It is the supposedly

unprecedented acceleration in the circulation of things around 1450, the increased consumption levels that accompanied it, and the incipient scientific approach to the physical world that render things worthy of study.[36] According to this idea, modernity corresponds to a "disenchantment" with the material world, to a rational ability to see things empirically, indeed objectively, and to a persuasion that stuff is just stuff and need not mean anything beyond itself.[37] Cultures in which this was not the case are hard for these theories to digest. Thus scholars of early modern times fit their objects of study into the discourses of the new materialists by differentiating post-1450 attitudes from the medieval millennium. The unspoken assumption has been that a time like the later first millennium, associated with otherworldliness and primitive living conditions, cannot offer much to the comprehension of things and material culture.[38]

We would instead argue that these conditions provide an even more interesting case study about the relation of things to people. Many writers of the late antique and early medieval period did consider the created, material world to be less significant than the immaterial, invisible one, but the very fact that they could make this argument implies not indifference to, but a notable awareness of, materiality. And most who study the period today would agree that the archaeological and literary evidence for considerable reductions in the size and refinement of economic activity is very strong, especially for the period 550–800 in Western Europe, the Balkans, and Anatolia. The "decline and fall of the Roman empire" and the attendant economic shrinkage provide a thought-provoking case study in *dis*-entanglement with things and call into question some teleological assumptions of the followers of the "material turn." Thus, postclassical culture offers some important insights for the conceptualization of things today.

In the early seventh century, Isidore of Seville, a bishop and early medieval polymath, noted the atomist theories of ancient materialist philosophers. As he was attempting to capture all necessary knowledge, and to explain the observable world through the meaning of words, he was highly motivated to include materialist teachings in his encyclopedia called *Etymologies*. It is intriguing that he did not actually condemn them.[39] Isidore of Seville had other, theocentric ideas about the nature of matter and the process whereby the material world was created, yet he presented the atomist universe dispassionately as a feasible hypothesis. He also discussed the nature of matter, as usual for him etymologically, and pointed out that the word *materia* (he was writing in Latin) was identical to the word for wood, and that both were related to the word for mother (*mater*). Consequently, the great Iberian data-cruncher conceived of matter as a generative substance, able to give birth to things, alive as trees are alive, and thus potentially an agent. However subordinate to the will of God the creator, Isidore's material world was certainly not inert or passive.[40]

This curious alignment of a Dark Age thinker with postmodern materialist thought is replicated also when we consider the enormous respect early medieval people, especially, but not only, Latin and Eastern Orthodox Christians, had for certain things. By the fifth century, relics—the corporeal remains of holy people or objects those people had touched—were just about the most potent things in the Mediterranean region. Relics were often parts of a human body, and sometimes were housed in special containers (see Things 16 and 19). Even fragmentary relics, veiled from view by elaborate reliquaries, nevertheless were able to evoke the full presence of God's most devoted servants, the dead saints, and channel into the everyday world all the power of God that saints could evoke. Late antique and early medieval Christians had a decidedly postmodern awareness of the power in apparently inert stuff. They understood how the material fused with the immaterial aspects of life.

Likewise, portraits of holy people, properly approached, could function in a similar way.[41] Such icons, whether portable or in buildings, were the target of state-sponsored destruction in the iconoclastic movement that gripped the Byzantine Empire, off and on, in the eighth and ninth centuries. Iconoclasm was also based on a recognition of these special objects' enormous power, which became the subject of reams of theological arguments on both sides.[42] That a Frankish ruler, far removed from Byzantine influence, should worry about the issue, and become personally involved in composing a theological treatise about the correct treatment of icons in the 790s, underlines the point, as do eighth- and ninth-century Muslims' doubts about the appropriate religious use of pictures:[43] early medieval people took their material culture very seriously, and many ascribed potency to things, whether natural or man-made.[44]

This observation is confirmed by early medieval laws of Celtic, Germanic, and Roman inspiration. These routinely ascribed to things the ability to do harm to people, and punished plants and animals (considered animated things), as well as obviously inanimate things like swords, for the harm they did. The culpability of things was related to the religious sensibility behind Latin liturgical invocations addressed at objects. These elaborate prayers abjured objects to behave well or stop behaving badly, in ways that were damaging to people. Like the secular laws, such prayers could only be effective in a thought world where things had agency, and in which they could understand human language and reasoning.[45]

Of course, the reason why postclassical people thought things had talent was not the same as the reason why postmodern critics perceive thingly agency around them and argue for an indissoluble union of matter and culture. In a series of lectures about late medieval European attempts to grapple with the problem of how the holy, which is eternal, could become embroiled in matter, which is ephemeral, Caroline Walker Bynum pinpointed a basic tension in

Christian theology.[46] Bynum emphasized the differences between early and late medieval Christian sensibilities, illuminating late medieval Europe's greater propensity to recognize the vitality in matter, and the later period's dedication to a very human (and therefore material) Christ as opposed to the severe, distant, rather abstract judge early medieval people apparently preferred. Yet early medieval Christians, too, dealt with the material world under the assumption that God created it, so it could manifest Him. They too knew that matter could be in touch with God and make God accessible on earth. Indeed, the manufacture of so-called contact relics, sometimes quite humdrum things like scraps of cloth that had been in contact with holy things like relics, or liquids that had been near them (see Things 19 and 24), was well under way in the sixth century, and remained an early medieval passion thereafter. The existence of holy things like relics and contact relics, but also of mosques and the Torah, qualifies early medieval engagement with the material world. If the incarnation of God as Jesus did not enjoy the primacy in early medieval theology that it came to enjoy later, still early medieval Christians accepted that matter could and sometimes did present ordinary mortals with a chance to grasp the immaterial, however scary the experience might be. Muslims and Jews, more persuaded by divine transcendence, nevertheless accepted that an omnipotent creator might manifest Himself miraculously in the physical world.

In the early Middle Ages, not everyone rejoiced over the potential of things. Most matter was not incorruptible, like saints' bodies, but prone to decay, a reminder of human transience. To some it was primarily a distraction from the more urgent concerns of life. Zoroastrians in the Persian Empire were committed to advancing spirituality and restraining materiality both in everyday transactions and in the cosmic encounter between good and evil of which believers were earthly witnesses. Christian and Islamic asceticism derived from a more fundamental, scripturally sanctioned, suspicion of the material world and of enjoyment of its plenty. The ability to control one's bodily wants, to reduce one's dependence on others, and throughout to limit one's use of things was highly regarded from Ireland (Thing 30) to Armenia, from Monastir (Thing 33) to Novgorod. Monasticism in its various forms was a response to Jesus' injunctions and to a widespread longing to be free of things, or anyhow less involved with them so as to focus on spiritual pursuits monks and nuns imagined to be immaterial. Some of the most successful holy people of the first millennium managed to find viable compromises with things, like the wealthy Cappadocian aristocrat Macrina, who turned her mansion into a monastery around AD 350, or the charitable widow Mathilda, who fed and clothed the indigent in tenth-century Germany.[47] That many early medieval hermits and monasteries ended up quite entangled in the material world, despite herculean efforts to the contrary, does not reduce the impact of their ideal. It is an ideal that animates, still today, many

apparently secular ideologies, and arguably one that undergirds the aspiration of many scholars of the "material turn" to disentangle from capitalist patterns of hyperconsumption.

Early Medieval Things II: Disentanglement

Both in their acceptance of matter as animate and in their suspicion of matter as spiritually corrupting, postclassical people seem to speak to contemporary concerns about relations between people and things.[48] Though the separation of matter and spirit seems to many new materialists an unnecessary one, there is another way in which this remote time seems able to participate in the current debates about matter, things, and modern consumption: during the late antique period, in many of the regions where our fifty things were made and used, there occurred a visible reduction in the availability and use of things.

This widespread, sometimes dramatic (and sometimes attenuated) slump in the production, circulation, and consumption of things is related to the end of Roman power in the Mediterranean, and the economic restructuring that event made necessary. Some scholars describe it much as the luminous British historian Edward Gibbon did in the eighteenth century: it was "the decline and fall of the Roman empire," at least in the western Mediterranean.[49] They single out the administrative discontinuities, the shriveled cities, the abandoned villas, the smaller size of ships (see Things 21, 39, and 42), the absence of imported wares, and many other signs of what they consider a civilizational collapse that began in the fourth century and was accomplished by the seventh.[50] Even those with a more optimistic sense of what happened, who abbreviate the "transformation of the Roman world" (beginning in the 400s, with a big acceleration in the 500s), and restrict its impact to Western Europe and the Balkans, remark on a vast shrinkage in economic activity.[51] Though this narrative is easy to nuance, pointing out how some regions flourished (Sicily, northern Syria, Constantinople and its hinterland, probably Persia) at the same time as others floundered, taken as a whole the archaeological record is unequivocal. By the sixth and seventh centuries, in most regions in the early medieval world by any measure the economy was smaller than it had been two centuries before and much smaller than it had been in the second century AD.

Whether a slow, gradual, and partial deflation of an economic balloon overinflated by Roman state appropriations took place, or a catastrophe created by a perfect storm of barbarian invasion, volcanic eruption, climatic deterioration, and epidemic disease, the postclassical period offers students of material culture an opportunity to observe how societies deal with a reduction in the production, circulation, and consumption of things. This is pertinent to those new materialists

who suppose that people have grown increasingly entangled by things over time.[52] They point out that for the first 70,000 years of human existence, people used very few things.[53] Then, quite suddenly, 10,000 years ago people began to farm, live sedentary lives, and to do both with increasing numbers of things. Those ten millennia have brought growing entanglement because each thing leads humans to "path dependency," obliging the humans to take care of it, often by means of acquiring more things. Things are liable to unavoidable "biological, chemical, and physical processes of transformation" that humans try to control with the use of still more things because humans and things deteriorate at different speeds (things have different "temporalities" that make them "unstable" in human terms). As things are usually already themselves entangled with other things, the result is an ever-expanding "heterogeneous entanglement juggernaut" held together by a mesh of mutual dependencies.[54]

A frequently cited example of how one thing leads to another, in entanglement narratives, is the wheel. Its invention about 4000 BC is supposed to have put people on a narrow path of dependency that led (through animal domestication, war chariots, and metallurgy), to the internal combustion engine, suburban living, and "global warming."[55] It is the inevitable, ineluctable part of the story that deserves scrutiny, for during the early medieval period large swaths of the Islamic world disentangled themselves from use of the wheel, the laborious maintenance of roads, and the irrational long routes wheeled traffic imposed, and developed a highly integrated, commercial economy based on camels, donkeys, and other quadrupeds excellently adapted to getting around the Caliphate with packs strapped to their backs, and wholly without wheels.[56]

The shift to unwheeled traffic shows how contingent on cultural choices can be the history of entanglement. The late antique and early medieval economic downturn in turn shows that a large, complex, affluent, materially entangled society (ancient Rome and its neighbors) can *dis*-entangle itself from the strangling constraints of material engagement. It also suggests how such interruptions in the forward march of entanglement might work out in practice. Recently Hodder recognized that entanglement and any disentanglement from things will affect people in different socioeconomic groups in different ways, or that these processes will have a class dimension (he is less clear about whether it also has a gender or age dimension).[57] Since social preeminence tends to be mediated through access to things, the more entangled in society, namely the elites, should find disentangling harder to carry out. On the contrary, Hodder has found, it is the poorer, less powerful members of societies whose entrapment is more total and whose dependency on things more inescapable.

Postclassical material conditions in Europe, the Balkans, and the western Mediterranean area were more measly than they had been when Rome's hegemony was strong. Tiny hamlets prevailed, built of light, ephemeral materials,

especially wood, thatch, and mud (Thing 15). Tools too were simple (e.g., Thing 26), and the landscape showed fewer signs of human interference than it had for centuries before: there were ample woodlands and teeming swamps. While full autarchy (economic self-sufficiency, where people consume only what they themselves produce) never prevailed, a lot of people grew and made most of what they consumed and used. It is hard for archaeologists to distinguish between the houses and settlements of ordinary farmers and those of the people who exercised military and political power for the period of about two hundred years between AD 550 and 750. It therefore seems that in several parts of Europe, though not in northwestern France between the Rhine and Loire rivers, peasant and elite living standards were very similar. Everyone was disentangled from things, with only small distinctions visible in house size, burial ornaments, and so on.

The best accounts of what happened suggest that when the state stopped taxing and recruiting in order to sustain its military machine, and the aristocracy in consequence suffered limitations on its ability to take rents from lesser folk working the land, social groups that had been lowly under Roman governance felt very considerable relief. This was true in places as different as the Danube basin, Tuscany, or the Basque lands. It was also true in Anatolia, though somewhat later, and with somewhat different effects (because the Byzantine state was not dead yet). Perhaps the most striking example of this simplification of economic arrangements comes from the Lower Danube basin, rapidly "de-Romanized" in late antiquity, and filled with tiny villages whose occupants relocated often, whenever soil fertility waned: a fine case of disentanglement, of deliberate, premeditated separation from the things people took care of.[58] It is possible to poke fun at descriptions of this liberated peasantry, newly able to orient its productive strategies as it saw fit, with less concern about producing surplus for taxes and rents. It has been called the "hippie economy," because it imagines farmers who produced household subsistence and rested when they had attained that minimal goal.[59] More soberly, one leading scholar of the early medieval economy has called this (echoing a famous conversation between an English medievalist and an Italian archaeologist that seems to have taken place in the mid-1960s[60]) "the golden age of the peasantry."[61] And lately a giant survey of global inequality, from the Stone Age to the Internet Age, has singled out this period as one of a tiny handful of cases when the economic and social gap between "haves" and "have nots" actually shrank a bit.[62]

Like all golden ages, this one turned to bronze soon enough. It had never been universal anyway, and being a peasant in the Frankish heartland or in the vast Caliphate was not so different from being a peasant in Sasanian or Roman times. But also in Europe by about 800 again prevailed more competent states,

more acquisitive aristocracies, and more farmers with more obligations toward both states and aristocracies. The castles of the aristocracy we still call feudal (see Thing 44), and the beautiful manuscripts of the Carolingian renaissance (Thing 40), are indications that human entanglement with things had resumed its progress. Still the major "correction" at the end of late antiquity and the beginning of the early Middle Ages stands as a reminder that growing entanglement, indeed entrapment, is not destiny. The codependency between people and things through which both co-constitute each other has many tones and, whatever its causes, a lower one is possible.[63] It is an encouraging thought for dispirited new materialists considering their twenty-first century. Likewise encouraging is the thought that when societies disentangle, the majority on the low end of the pyramid can come out on top, or anyway enjoy conditions as good as anyone else, and arguably a lot better than those of their more entangled ancestors. "Golden age" peasants worked less, and less monotonously, than Roman farmers did, which seems like a decent compensation for having less access to high-quality pottery like ARS (Thing 3).

Another way to consider the lessened materialism that the removal of the Roman state from the ancient economy permitted is in the trash heap. Critics of contemporary consumer culture have been interested in the creation of vast dumps, or vast "storage" industries, for the unwanted stuff people find stifling. Coping with garbage is an important entanglement that things impose on people: in societies with high consumption levels and rapid turnover of things much labor and energy gets invested in disposing of unwanted things, according to local cultural parameters. Abbasid Baghdad, Roman Carthage, tenth-century Constantinople were large agglomerations of people and things, and their "urban metabolisms" depended on dumping a lot of things in nearby rivers, roadways, and fields.[64] They did this in an organized way, disposing of items in places other than where they were used. By keeping their dwellings scrupulously distinct from their garbage dumps they assigned an order to things.

The most famous early medieval garbage dump was discovered in downtown Rome in the 1980s, and by 2000 had occasioned the creation of a new museum (see Thing 39). The Crypta Balbi contained a dazzling array of things, many of them imported to seventh-, eighth-, and ninth-century Rome from far away: since camels are not native to central Italy, an eighth-century camel bone, with butchery marks on it, tells a surprising story of involvement with (probably) North Africa, and there are pots and amphoras (see Thing 21) from across the eastern Mediterranean.[65]

Their garbage is always a more truthful revelation of what people are actually doing than what they say they are doing. In the Crypta Balbi case, several dwellings, and a couple of refined workshops manufacturing beautiful things of wood,

bone, and metal, as well as a kiln where ancient marble was baked into lime (an essential ingredient for mortar) were doing different things at different moments in the long history of occupation of the site. But here what matters is the collective indifference to waste materials, to jettisoned things, that transpires pretty much uninterrupted from the fifth century onward. The people who dumped stuff at Crypta Balbi deposited what archaeologists call "primary refuse" (intentionally discarded, usually worn out items, in their location of use) in the long run creating a thick matrix of deposits that goes a long way to explaining why the current ground level is six meters higher than the early medieval one (see Thing 39). This casual approach to garbage, tipped where people lived and worked, is quite unlike what took place in the same area during classical antiquity and reveals a new, maybe more indifferent attitude toward things, or at least toward their previous ordering. At Crypta Balbi old and useless, as well as quite new and functional artifacts got mixed in with semifinished objects, food waste, and the bits of horn and bone or metal that were carved off during manufacture, compounded with sludge deposited by the occasional flood of the Tiber that no doubt contributed to the mixing. Since the floors were hard at Crypta Balbi, one must have carefully picked one's way around, wearing robust shoes.[66]

The promiscuous mixture of things at Crypta Balbi is exceptional in several ways, not least because the site lies in the center of early medieval Western Europe's most populous city. But if other garbage dumps are simpler, and less extensive, it seems fair to say that the garbage most postclassical communities generated was hardly perceived as garbage at all. Instead it was a conglomerate of things few felt a need to keep at a distance. Such unwillingness to invest work and energy on waste disposal might be interpreted as another form of early medieval disentanglement.

So might the postclassical obsession with recycling and reusing older things. The most famous example is the use of *spolia*, or architectural elements from previous, often pagan, buildings in early medieval structures, often churches or mosques, as well as many luxury artifacts (see Things 10, 16, 23, 32, 46).[67] But a similar enthusiasm for ancient things and repurposing them has been tracked in the British Isles, where shortages of metal and other useful materials led to the stripping and destruction of older structures by teams of avid scavengers.[68] Yet if the widespread practice of recycling things, for pragmatic or for ideological reasons, typified early medieval attitudes to material culture and limited waste, similar frugal habits also signal early medieval attachment to things. Surely it was her emotional investment with the brooch that led those who buried her to include a worn and broken fibula in the tomb of an Anglo-Saxon woman of the eighth century (see Thing 18 for a fibula).[69] This was an heirloom, a thing she had loved and kept after it broke and lost its functionality, and the people who buried her respected her investment in it. In the early Middle Ages, detachment

from things could coexist with passionate attachment to them, to deep emotional entanglements.

Certainly that is what some written sources suggest. In spite of the declared hostility to the material world, Christian and Islamic institutions found it clung to them tenaciously. To an extent, this was because in both religious cultures the act of giving things away was important, for both individuals and religious structures. Numerous benefactors caused churches, monasteries, and mosques to amass landed property as well as movable things. Charitable redistribution of goods by religious foundations was expected, and celebrated. In practice, religious institutions became managers and stewards of lots of things, intermediaries between the donors and the religious figures or ideals to whom the gift was offered. Since these things had a special status, and participated in an immaterial economy of salvation, as well as in a terrestrial economy of production and consumption, they tended to be meticulously recorded in writing.

An example is the collection of papal biographies known as the *Liber Pontificalis*, wherein stupefyingly long lists of gifts to churches, including lamps, altar cloths, candlesticks, clerical clothing, equipment for the celebration of Christian rituals, and so on fill up at least half of the book's pages. When responding to iconoclastic antimaterialism seemed necessary, as it did in Rome around 800, it may not have been love for these things that motivated the listings; yet donors and recipients certainly paid intense attention to the objects in circulation.[70] And though the records that survive give pride of place to descriptions of things that came into the possession of religious foundations, private wills also reveal an intense engagement with the paraphernalia of domestic life, furniture and bedding in particular when the testator was a woman, war gear for upper-class men.[71] Likewise, the diplomatic dealings of Byzantine emperors and Abbasid caliphs involved much exchange of thoughtfully selected gifts (like Thing 47), scrupulously described and listed, especially but not only by the givers, in such a way as to betray sensual involvement in their materiality.[72]

The material early Middle Ages, all told, are far more interesting than the modernist narratives of the new materialism imagine. This period gave life to a vigorous antimaterialism and to a real case of large-scale societal disentanglement that tests the belief in things' relentless and always expanding pull on people and communities. Europeans experimented with a new way of being on the land, imposing a far lighter footprint on it, and therefore accumulating around themselves far fewer things derived from it. With somewhat different rhythms the Byzantines in Asia Minor did the same, but on the southern rim of the Mediterranean, in Egypt and into Persia, most opulent entanglements arose, the stuff of *A Thousand and One Nights*, in a rich and commercially oriented society. The variegated early medieval world shows how complex, culturally contingent, and sometimes downright passionate could be people's dealings

with things. Though we may be modern and disenchanted with our environments, we can still see that.

The Order of Things

As Dr. Seuss knew, Thing One should precede Thing Two.[73] We arranged our book chronologically, so the artifacts and monuments that were created earlier appear before those that were created later in the postclassical period. Thus our collection opens with the imperial standards discovered recently near the Roman Forum and concludes with the fresco cycle representing a horse race in Kiev. This arrangement has its limits, naturally. For things have "biographies" and their durability often implies that they were used, not necessarily in the way their makers intended, long after they were made. But our entries account for the afterlife of things and show how early medieval people, and in some cases later people too, repurposed the things before they ended up inside glass cases, or on tourist itineraries, having finally become heritage. The "Vienna Dioscurides" (Thing 8) is a case in point, a book whose multiple users for over a millennium left traces of their engagement with its words, and images, on pages that sixth-century scribes first created.

We have attempted to choose things we consider particularly interesting, worth knowing about, and representative of something else, especially of trends we see as significant to the history of the early medieval world; to us, all the things in these pages fuse matter and meaning usefully for any who want to understand the period 300–1000. Our choices are of course idiosyncratic, a mirror of our formations and outlooks, and many other ones could have been made. Though our assemblage of things contains several that are famous, and many that were associated with the topmost segments of postclassical societies, we purposefully included many humdrum things. We are aware that the material record is as tendentious, in some ways, as the written one, and reflects social hierarchies as much as texts do. But since neither early medieval people, nor modern archaeologists, completely controlled the things they deposited or unearthed, the material record can give a better random sampling of the texture of life, which as we know involved mostly ordinary people doing ordinary things, like combing their hair (Thing 22), or plowing their field (Thing 26), or attempting to bring home in a bottle some of the transcendence of the very special places they visited (Thing 19).

As the first and last things in this collection already suggest, our thing-ly pursuits took us far afield, from the fringes of Ireland to the middle of Ukraine. We are pleased by this ecumenicism because we think that the early medieval period was less sundered than it was knitted together by its cultural, economic,

and social patterns. Certainly the division of the Roman Empire in this period, the ethnogenesis of competing barbarian peoples in Europe, and the development of an expansive Caliphate that swallowed the Sasanian polity whole, along with the juiciest slices of former Roman territory, introduced new boundaries, and divisions. Yet the prevalence of various types of monotheism, the reception and interpretation of classical Greek and Roman motifs and ideas, the continued circulation of goods like wine and marble, the predominance of courts and their culture, the political importance of military men, the ubiquitous agricultural practices, the persistent belief in the value of writing and texts, and many other characteristics besides, seem to us to create a vast, if vaguely bounded and unstable, culture zone in western Eurasia and the Mediterranean. For this reason, we gathered together "materials of history" from across the ample "world" that succeeded the ancient Mediterranean one.

This is a didactic book. Though we hope more advanced readers will benefit from their encounter with some of our artifacts, the primary intended audience for our Things is beginners in the study of the early Middle Ages, and indeed of material culture. We think that the conjugation of the two areas of study usefully expands both and offers readers new ways to approach a period when texts mattered, but were relatively few, and when the human experience was wrapped up in the material world in challenging yet compelling ways.

Notes

1. On Icelandic institutions, see J. Byock, *Viking Age Iceland* (London, 2001), 170–84, and 297–301 on Iceland's conversion.
2. I. Hodder, *Entangled: An Archaeology of the Relationships between People and Things* (Chichester, 2012), 42, 48, remarks on the early medieval Germanic languages' propensity for the *thing* word. *The Oxford English Dictionary* lists a dozen different early medieval usages of the word, although the earliest "thing" (in a legal text of 685–86) is a deliberative meeting.
3. L. Thatcher Ulrich et al., *Tangible Things: Making History Through Objects* (Oxford, 2015), 1–10, nicely argues for the educational benefits of "focusing on a single object." Another example of history-through-things is the former director of the British Museum, N. MacGregor's *A History of the World in 100 Objects* (London, 2010), whose BBC radio version thrilled millions of listeners.
4. A. Appadurai, ed., *The Social Life of Things: Commodities in Cultural Perspective* (Cambridge, 1986). Kopytoff's essay occupies 64–93.
5. This account, and the following discussion, is based on Hodder, *Entangled*, 211; B. Brown, *Other Things* (Chicago, 2015), 12–13; D. Miller, *Stuff* (Cambridge, 2010), 1–5; B. Mayer and D. Houtman, "Material Religion," in *Things*, edited by D. Houtman (New York, 2012), 1–23.

6. Brown, *Other Things*, 13, argues that "newly agential objects" trouble people and pique their interest.

7. But Miller, *Stuff*, points out that noncapitalist societies of nonconsumers are just as materialistic as contemporary hypercapitalistic ones.

8. C. Knappett, *An Archaeology of Interaction: Network Perspectives on Material Culture and Society* (Oxford, 2011), 211–12.

9. D. Smail, "Neurohistory in Action: Hoarding and the Human Past," *Isis* 105 (2014): 110–22.

10. G. Cross, *Consumed Nostalgia: Memory in the Age of Fast Capitalism* (New York, 2015), 36–43 on dolls, and 65–72 on fast cars. For Cross only contemporary forms of nostalgia focus on things, as opposed to institutions or types of community.

11. J.K. Galbraith, *The Affluent Society* (Boston, 1958).

12. *The Oxford English Dictionary*, which supplies nine dense columns, spread out over three pages, of definitions for "thing," also offers the following rather noncommittal one: "a material object, a body or entity consisting of matter or occupying space. (Often, a vague designation for an object which it is difficult to denominate more exactly.)"

13. Authoritative guides in Hodder, *Entangled*, 5–13; and *Studies*, 13–18; C. Hesse, "The New Empiricism," *Cultural and Social History* 1 (2004): 201–7; H. Hahn, "Words and Things," in *Materiality and Social Practice*, edited by J. Maran and P. Stockhammer (Oxford, 2012), 8–10.

14. A. Milne, *The House at Pooh Corner* (New York, 1928), 101.

15. J. Bennett, *Vibrant Matter* (Durham, 2010), 18–20.

16. Miller, *Stuff*, 12–60; and Hahn, "Words and Things," 4–10 give nice accounts of Western materialisms.

17. Hahn, "Words and Things," 5–6.

18. Hodder, *Entangled*, 31–32.

19. M. Douglas and B. Isherwood, *The World of Goods* (New York, 1979), is a lucid defense of "merchandizing" and "ownership" of things as morally neutral: everything depends on what people do with the things they consume.

20. Hahn, "Words and Things," 5. Braudel's materialist masterpiece was the three-volume *Civilization and Capitalism: 15th–18th Century* (New York, 1981–84).

21. Ingold, "Materials," 13–14.

22. "The Thing," in his *Poetry Language Thought* (New York, 1971), 163–80. The German was published in 1954.

23. Bennett, *Vibrant Matter*.

24. On early medieval slave-trading, M. McCormick, *Origins of the European Economy: Communications and Commerce, 300–900* (Cambridge, 2001), 244–54, 733–77; C. Hammer, *A Large-Scale Slave Society of the Early Middle*

Ages: Slaves and Their Families in Early Medieval Bavaria (Aldershot, 2002), argues for widespread Bavarian slavery.

25. B. Latour, *Reassembling the Social: An Introduction to Actor Network Theory* (Oxford, 2005), 63–86.

26. Bennett, *Vibrant Matter*, 94–95.

27. Brown, *Other Things*, 6.

28. Hodder, *Entanglement*, is the classic formulation of his ideas.

29. There is also a blog: www.materialworldblog.com.

30. In his 2015 *Studies*, Hodder explained entanglement more grimly than earlier.

31. D. Smail et al., "Goods," in *Deep History*, edited by A. Shryock and D. Smail (Berkeley, 2011), adopt the "history of more and more stuff" model, but nuance it.

32. Degrees of agency are discussed by C. Knappett, *An Archaeology of Interaction* (Oxford, 2011), 171–73.

33. Ingold, "Materials"; Smail, "Neurohistory," 117, who is more elastic about distributing agency in A. Shryock and D. Smail, "Introduction," in *Deep History*, edited by Shryock and Smail (Berkeley, 2011), 8, 15–16.

34. Ingold, "Materials," 11.

35. Brown, "Thing Theory," 1–2.

36. P. Findlen, "Objects in Motion, 1500–1800," in *Early Modern Things*, edited by P. Findlen (London, 2013), 3–27; R. Ago, "Denaturalizing Things," in *Early Modern Things*, 363–67. See also H. Hahn, "Words and Things," in *Materiality and Social Practice*, edited by J. Maran and P. Stockhammer (Oxford, 2012), 4, on modern plenty as a new departure.

37. The German sociologist Max Weber (d. 1920) most famously theorized a medieval/modern divide between enchanted and disenchanted worlds, with modern, scientific, secular outlooks the result of (Protestant, northwest European) Progress. F. Oakley, *Kingship: The Politics of Enchantment* (Malden, 2007), is a leading medievalist's muscular challenge to the idea as it applies to European politics.

38. This provokes militant rebuttals: K. Robertson, "Medieval Materialism: A Manifesto," *Exemplaria* 22 (2010): 99–118.

39. *The Etymologies of Isidore of Seville*, trans. S. Barney et al. (Cambridge, 2006), 13.2.1–4, p. 271. See also Robertson, "Medieval Materialism."

40. *The Etymologies*, 9.5.6, p. 206; 19.19.3, p. 382; 13.3.1–3, p. 271 develops the assonance between "matter" and "wood" extending it to "silva" (forest), so that in effect all visible things are made of a primeval forest-stuff. Aristotle and high medieval philosophers instead distinguished between matter as potency and form as act, so while a mother provided the raw material of life, only the father was the agent in it.

41. The great spokesman for this way of seeing early medieval art is H. Belting, *Likeness and Presence: A History of the Image before the Era of Art* (Chicago, 1994), esp. chaps. 1–12.

42. L. Brubaker and J. Haldon, *Byzantium in the Iconoclast Era, c. 680–850: A History* (Cambridge, 2011), try to diminish Byzantine iconoclasm's footprint.

43. T. Noble, *Images, Iconoclasm, and the Carolingians* (Philadelphia, 2009).

44. E. Gertsman and A. Mittman, "Rocks of Jerusalem," in *Natural Materials of the Holy Land and the Visual Translation of Place, 500–1500*, edited by R. Bartal et al. (London, 2017), 157–71, discuss a sixth-century reliquary containing some stones, bits of wood, and dirt intended to remind onlookers of the Holy Land.

45. G. MacCormack, "On Thing-liability (*Sachhaftung*) in Early Law," *The Irish Jurist* 19 (1984): 322–49; E. Bartsch, *Die Sachbeschwörungen der römischen Liturgie* (Münster, 1967). The liturgists' prayers hoped to move God to act through the objects, but for early medieval jurists agency was less obviously located outside the thing.

46. C. Bynum, *Christian Materiality: An Essay on Religion in Late Medieval Europe* (New York, 2011).

47. Gregory of Nyssa, *The Life of St. Macrina*, translated by L. Clarke (London, 1916); *Queenship and Sanctity: The Lives of Mathilda and the Epitaph of Adelheid*, translated by S. Gilsdorf (Washington, 2004).

48. Findlen, "Objects in Motion," 7, suggests fluctuations between euphoric consumerism and antimaterialistic militancy are universal. Brown, "Thing Theory," 12, adopts Latour's motto "We have never been modern" to justify contemporary ideas of animate and inanimate integration. Maybe we've always been early medieval?

49. B. Ward-Perkins, "Continuitists, Catastrophists, and the Towns of Post-Roman Northern Italy," *Papers of the British School at Rome* 65 (1997): 157–76, nicely frames the period's main schools of interpretation.

50. B. Ward-Perkins, *The Fall of Rome and the End of Civilization* (Oxford, 2005), is an eloquent example of the extreme catastrophist reading of events.

51. McCormick, *Origins*; C. Loveluck, *Northwest Europe in the Early Middle Ages, c. AD 600–1150: A Comparative Archaeology* (Cambridge, 2013). The "transformation" terminology got a big boost in the 1990s when a major EU-funded research initiative employed it.

52. Hodder, *Studies*, 20–24, 41–42. In chap. 9 of that book, Hodder's German critics, most philosophically inclined, pointed out the teleological assumptions in Hodder's model.

53. C. Renfrew, "Toward a Theory of Material Engagement," in *Rethinking Materiality*, edited by E. De Marais et al. (Cambridge, 2004), 23–31, describes "the sapient paradox."

54. Hodder, *Studies*, 4, 7.

55. Hodder, *Entangled*, 45–47, 71–72; *Studies*, 68–69, 100–101, 148.

56. R. Bulliet, *The Camel and the Wheel* (Cambridge, MA, 1975).

57. Hodder, *Studies*, 64–68; R. Ago, *Gusto for Things* (Chicago, 2013), discusses how gender affects people-thing relations.

58. F. Curta, *Southeastern Europe in the Middle Ages, 500–1250* (Cambridge, 2006), 56–57.

59. T. Maier, "A Farewell to the Market!" in *Processing, Storage, Distribution of Food*, edited by T. Klápstë and P. Sommer (Turnhout, 2011), 280–300.

60. The phrase is used in a footnote by Philip Jones (Wickham's teacher) and credited to the pioneer of early medieval archaeology in Italy, Gianpiero Bognetti: P. Jones, "L'Italia agraria nell'alto medioevo," in *Settimane di studio del CISAM* 13 (Spoleto, 1966): 86.

61. C. Wickham, *Framing the Early Middle Ages: Europe and the Mediterranean, 400–800* (Oxford, 2005), 383–517, offers a masterful survey of peasant history that sweeps across the early medieval world. Counterarguments can be found in R. Hodges, *Dark Age Economics: A New Audit* (London, 2012), 11–15, 41–66.

62. W. Scheidel, *The Great Leveler* (Princeton, 2017), 264–69.

63. These causes remain *the* main issue in the history of the postclassical period.

64. R. Hoffmann, "Footprint Metaphor and Metabolic Realities: Environmental Impacts of Medieval European Cities," in *Natures Past*, edited by P. Squatriti (Ann Arbor, 2007), 288–326, develops the idea of premodern urban metabolism.

65. English publications on this site are woefully lacking, but the museum guidebook was translated: D. Manacorda, *Museo Nazionale Romano Crypta Balbi* (Milan, 2000).

66. Hodder, *Entangled*, 74, suggests that increased entanglement correlates with more meticulous waste removal, because the waste underfoot is more complex and hazardous.

67. M. Greenhalgh, *Marble Past, Monumental Present: Building with Antiquities in the Medieval Mediterranean* (Leiden, 2009); and for a Peloponnesus case study J. Frey, *Spolia in Fortifications and the Common Builder in Late Antiquity* (Leiden, 2016).

68. R. Fleming, "Recycling in Britain after the Fall of Rome's Metal Economy," *Past and Present* 217 (2012): 3–45.

69. T. Martin, "The Lives and Deaths of People and Things: Biographical Approaches to Dress in Early Anglo-Saxon England," in *Writing the Lives of People and Things, AD 500–1700*, edited by R. Smith and G. Watson (Farnham, 2016), 67–87.

70. *The Lives of the Ninth-Century Popes* (*Liber Pontificalis*), translated by R. Davis (Liverpool, 1995), is part of a three-volume translation of all the biographies up to 891.

71. L. Tollerton, *Wills and Will-Making in Anglo-Saxon England* (York, 2011), 180–227. Like all texts, wills could stage a persona as much as any things: see C. La Rocca and L. Provero, "The Dead and Their Gifts," in *Rituals of Power from Late Antiquity to the Early Middle Ages*, edited by F. Theuws and J. Nelson (Leiden, 2000), 225–80.
72. A. Cutler, "Gifts and Gift Exchange as Aspects of Byzantine, Arab, and Related Economies," *Dumbarton Oaks Papers* 55 (2001): 247–78.
73. Dr. Seuss, *The Cat in the Hat* (New York, 1957), 33.

Further Reading

Histories of Late Antiquity and the Early Middle Ages

P. R. L. Brown, *The Rise of Western Christendom: Triumph and Diversity, A.D. 200–1000*, 2nd ed. (Malden, MA, 2003).

A. M. Cameron, *The Mediterranean World in Late Antiquity A.D. 395–600* (London, 1993).

R. Collins, *Early Medieval Europe 300–1000*, 3rd ed. (Basingstoke, 2010).

M. Costambeys, *The Carolingian World* (Cambridge, 2011).

F. Curta, *Southeastern Europe in the Middle Ages, 500–1250* (Cambridge, 2006).

T. Daryaee, *Sasanian Persia: The Rise and Fall of an Empire* (London, 2009).

G. Fowden, *Empire to Commonwealth: Consequences of Monotheism in Late Antiquity* (Princeton, 1993).

G. Fowden, *Before and After Muhammad: the First Millennium Refocused* (Princeton, 2014).

G. Halsall, *Barbarian Migrations and the Roman West, 376–568* (Cambridge, 2007).

J. Herrin, *The Formation of Christendom*, rev. ed. (Princeton, 2001).

H. Kennedy, *The Prophet and the Age of the Caliphates*, 3rd ed. (Abingdon, 2016).

I. Lapidus, *A History of Islamic Societies*, 3rd ed. (Cambridge, 2014).

C. Loveluck, *Northwest Europe in the Early Middle Ages, c. AD 600–1150: A Comparative Archaeology* (Cambridge, 2013).

M. McCormick, *Origins of the European Economy: Communications and Commerce AD 300–900* (Cambridge, 2001).

L. Olson, *The Early Middle Ages* (Houndmills, 2007).

J. Smith, *Europe after Rome: A New Cultural History 500–1000* (Oxford, 2005).

D. Stathakopoulos, *A Short History of the Byzantine Empire* (London, 2014).

B. Ward-Perkins, *The Fall of Rome and the End of Civilization* (Oxford, 2005).

M. Whittow, *The Making of Byzantium 600–1025* (Berkeley, 1996).

C. Wickham, *The Inheritance of Rome: Illuminating the Dark Ages, 400–1000* (Harmondsworth, 2009).

Philosophical Approaches to Matter and Materialism

A. Appadurai, "The Thing Itself," *Public Culture* 18 (2006): 15–22, contains the thoughts on the field by an early adopter of the "material turn."

J. Bennett, *Vibrant Matter. A Political Ecology of Things* (Durham, 2010), stakes a claim for the vitality of things, and the moral-ecological benefits of thinking that way.

B. Brown, *Other Things* (Chicago, 2015), includes Brown's later thinking on "thingness" in literature and the arts, especially 1850–1950.

B. Brown, "Thing Theory," *Critical Inquiry* 28 (2001): 1–22, is virtually "the face that launched a thousand ships" of materiality studies in literary circles and also witty and insightful.

G. Cross, *Consumed by Nostalgia: Memory in the Age of Fast Capitalism* (New York, 2015), offers an Americanist's take on contemporary obsessions with old stuff.

L. Daston, "Speechless," in *Things That Talk: Object Lessons from Art and Science*, edited by L. Daston (New York, 2004), 9–24, lucidly introduces a collection of essays that presents things as knit together of matter and meaning, and able to teach history.

M. Douglas and B. Isherwood, *The World of Goods* (New York, 1979), was a visionary (in hindsight) intervention in consumption theory by leading anthropologists.

H. Hahn, "Words and Things," in *Materiality and Social Practice*, edited by J. Maran and P. Stockhammer (Oxford, 2012), 4–12, locates the real "material turn" in the 1800s rise of consumer culture and describe the rise of material culture studies.

C. Hesse, "The New Empiricism," *Cultural and Social History* 1 (2004): 201–7, explains the intellectual genealogy of the "material turn" among historians.

I. Hodder, *Entangled: An Archaeology of the Relationships between Humans and Things* (Chichester, 2012), argues things oblige people to take care of them, with the benefit of Hodder's "deep-time" archaeological view of the process.

I. Hodder, *Studies in Human-Thing Entanglement* (Creative Commons, 2016), complicates Hodder's earlier work, but includes his German critics' views.

T. Ingold, "Materials Against Materiality," *Archaeological Dialogues* 14 (2007): 1–16 (with a response to criticisms on 31–38), suggests that the "material turn" forgot the materials that constitute things.

J. Joy, "Reinvigorating the Object Biography," *World Archaeology* 41 (2009): 540–66, tries to revamp the notion that artifacts have a life history.

C. Knappett, *An Archaeology of Interaction: Network Perspectives on Material Culture and Society* (Oxford, 2011), thoughtfully applies ANT to archaeology.

B. Latour, "Can We Get Our Materialism Back, Please?" *Isis* 98 (2007): 138–42, reminds readers of the difference between things and their scholarly representations.

In *Reassembling the Social: An Introduction to Actor Network Theory* (Oxford, 2005), Bruno Latour, one of the leading lights of French critical theory in the late twentieth century, articulates his ideas on the equality of people and things.

T. LeCain, *The Matter of History* (Cambridge, 2017), seeks to convince historians that adopting a "new materialist" outlook is productive.

B. Meyer and D. Houtman, "Material Religion—How Things Matter," in *Things: Religion and the Question of Materiality*, edited by B. Meyer and D. Houtman (New York, 2012), 1–23, is a forthright confrontation of immaterial things' materialization.

D. Miller, *Stuff* (Cambridge, 2010), is an uncommonly lucid, philosophically sophisticated treatment of modern materiality by an anthropologist who formed this field of study.

C. Renfrew, "Toward a Theory of Material Engagement," in *Rethinking Materiality*, edited by D. De Marrais et al. (Cambridge, 2004), 23–31, attempts to theorize the oneness of human and thing.

K. Robertson, "Medieval Materialism: A Manifesto," *Exemplaria* 22 (2010): 99–118, explores medievalists' investment in the "material turn."

D. Smail, "Neurohistory in Action: Hoarding and the Human Past," *Isis* 105 (2014): 110–22, seeks to connect brain evolution to consumption patterns.

D. Smail et al., "Goods," in *Deep History*, edited by A. Shryock and D. Smail (Berkeley, 2011), 219–41, presents a global and multilayered analysis of things and human investment in them.

M. van der Veen, "The Materiality of Plants: Plant-People Entanglements," *World Archaeology* 46 (2014), 799–812, attempts to apply entanglement theory to premodern archaeologically discovered plants.

For thoughts on how art historians have assimilated the "material turn" into their study of visual and plastic arts, C. Wood, "Image and Theory, a Modern Romance," *Representations* 133 (2016):130–51.

Premodern Histories of Matter and Materialism

R. Ago, "Denaturalizing Things," in *Early Modern Things*, edited by P. Findlen (London, 2013), 363–67, is a master practitioner's assessment of the state of the early modern field.

R. Ago, *Gusto for Things: A History of Objects in Seventeenth-Century Rome* (Chicago, 2013), is the English translation of a 2006 masterpiece about wills, inventories, and material culture in the 1600s that provides a model for interpreting premodern texts about things.

C. Walker Bynum, *Christian Materiality: An Essay on Religion in Late Medieval Europe* (New York, 2011), is the published version of three 2007 lectures that pinpoint the special features of medieval European Christians' engagement with the material world.

A. Cutler, "Reuse or Use? Theoretical and Practical Attitudes toward Objects in the Early Middle Ages," *Settimane di studio del centro di studi italiano sull'alto medioevo* 46 (1999): 1055–79, discusses reuse of things in cross-cultural perspective.

P. Findlen, "Objects in Motion, 1500–1800," in *Early Modern Things*, edited by P. Findlen (London, 2013), 3–27, elegantly introduces a fine collection of essays, arguing for the special place in consumption history of the Renaissance.

E. Gertsman and A. Mittman, "Rocks of Jerusalem," in *Natural Materials of the Holy Land and the Visual Translation of Place, 500–1500*, edited by R. Bartal et al. (London, 2017), 157–71.

PART I

Things of the Fourth Century

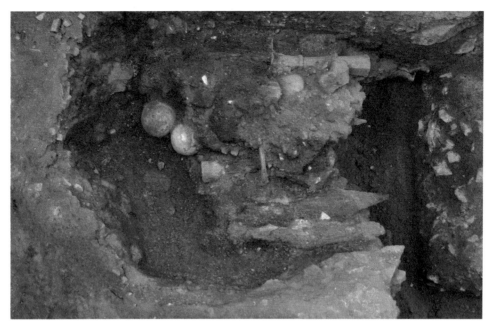

Thing 1A. The ceremonial regalia of emperor Maxentius during excavation in 2005. Photo courtesy of Clementina Pannella.

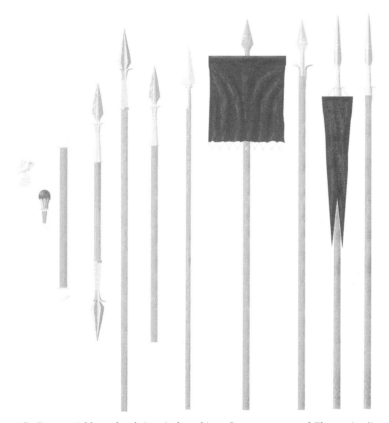

Thing 1C. Ceremonial lance heads in oricalc and iron. Image courtesy of Clementina Pannella.

1. The Ceremonial Regalia of Emperor Maxentius (?)

Rome, early fourth century

In July 2005, archaeologists excavating at the base of the Palatine Hill in Rome, just below the palace of the Roman emperors, made the discovery of a lifetime. In the packed-clay floor of a basement room built almost two thousand years ago,

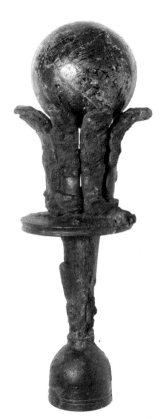

Thing 1B. Oricalc and iron scepter head with glass sphere. Photo courtesy of Clementina Pannella.

they found the ceremonial regalia of a Roman emperor, hastily buried in a hole dug into the floor and never recovered. There were ten objects, three of them scepters of varying shapes and sizes. One featured a gilded green globe cradled in a floral setting of iron and oricalc (a golden-colored alloy of copper and zinc similar to brass); the second was crowned with a large (10 centimeters diameter) sphere of chalcedony, a milky-blue, semiprecious stone; the third apparently consisted of a wooden shaft capped at both ends with globes of greenish glass speckled with gold, of which only the globes remain. Alongside the scepters were two six-bladed spearheads of iron and oricalc, and an assortment of smaller spearheads in iron or a combination of iron and oricalc, most with projecting "winglets" at the base designed for attaching banners and pendants. The objects themselves were apparently wrapped in such banners, judging by the fossilized remains of purplish silk and linen found clinging to most of the items, and then buried inside leather-lined wooden cases.

The dirt used to fill and cover the hole contained a coin of the emperor Diocletian minted in AD 298, as well as shards of pottery datable to around AD 300, placing the moment of the objects' burial in the early fourth century. During this period, only one emperor lived at Rome who was neither in a position to pass on the symbols of his office to a successor, nor to be buried with them. This was Maxentius, the son of the retired tetrarch Maximian, who ruled over Italy and North Africa between 306 and 312, when he was disastrously defeated and killed by the army of the rival emperor Constantine at the Battle of the Milvian Bridge. Probably in the immediate aftermath of the battle, someone close to the defeated emperor took the scepters and other ceremonial insignia from the palace and hastily buried them nearby.

What is perhaps most surprising about the imperial regalia is the relative cheapness of their materials. Oricalc was hardly inexpensive (and a relatively difficult alloy to make), but it was far less costly than gold and even silver; its golden color made it an attractive substitute, evidently, for the real thing. While there are traces of gold leaf probably from the wooden shafts of some of the items, the quantity of precious metals used was minimal, and among the remaining finds only the unusually large Chalcedony sphere was really valuable. The workmanship is highly competent, but certainly nothing unusual by the standards of the age.

In order to understand these objects better, we might try to see them as the product of their particular time and place, and of the changed political circumstances that had prevailed in the Roman Empire since the murder of the last member of the Severan dynasty, Alexander Severus, in 235. Over the ensuing fifty years, we know of nearly fifty individuals who were acclaimed emperor and supported by enough troops to make their claim viable. Many never achieved widespread recognition and were quickly killed, and even most of those recognized as legitimate by their contemporaries also died violently within a few years. The result was near-anarchy: recurring civil wars raged across the empire. Following the return of relative stability with the reign of Diocletian (284–305) and the establishment of the Tetrarchy in 293, there remained four emperors and four separate imperial courts, and further pretenders to the throne. Hence, supplies of resources continued to be strained to the limit, especially the precious metals needed to pay the troops and maintain the infrastructure of the empire.

Yet emperors sought, more than ever, to bolster their tenuous authority by every means possible, including wearing rich costumes and participating in elaborate court ceremonies. When Maxentius was (illegally) proclaimed emperor in 306 by troops loyal to his father, he found himself, like so many others over the preceding seventy-five years, needing to convince all who saw him, and ultimately his rival claimants to power, that he was a "real" emperor. To do so, he needed to act the part.

But since Maxentius was proclaimed in Rome, where no emperors had ruled for decades, suitable imperial regalia may not have been available. In an age when emperors were primarily distinguished by their purple cloaks and crowns, other accoutrements of power such as scepters and standards may simply not have been hoarded or preserved with great care. There is little to suggest that Roman emperors passed down such objects to their successors, or that they became more prized and sought-after with age and the legacy of past owners. Nonetheless, Maxentius needed ceremonial regalia to play his role to the fullest. At a time when precious metals were badly needed to pay the army and fund his grand new public buildings in Rome, he evidently settled on cheaper materials. The best craftsmen in

the city were doubtless employed, skilled laborers to be sure, but with no prior experience of making such things.

We might see the finished products as, essentially, props, objects whose value lay in the means of their display and their connection to the person of the emperor, rather than their intrinsic worth. Hence, when Constantine's troops entered Rome, their main value would have been as trophies, symbols of Maxentius's defeat. Those loyal to Maxentius buried them instead, to save their ruler a final disgrace.

Further Reading

The only publication of the remarkable 2005 find is C. Panella, ed., *I segni di potere. Realtà e immaginario della sovranità nella Roma imperiale* (Bari, 2011). S. MacCormack, *Art and Ceremony in Late Antiquity* (Berkeley, 1981) is a masterful overview of the choreography of power. On the reign of Maxentius and his rapport with the citizens of Rome, M. Cullhed, *Conservator urbis suae: Studies in the Politics and Propaganda of the Emperor Maxentius* (Stockholm, 1994), is fundamental. J. Curran, *Pagan City and Christian Capital* (Oxford, 2001), analyzes Rome's fourth-century transition from a Maxentian to Constantinian city.

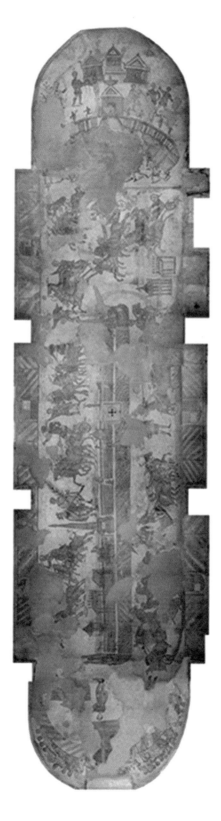

Thing 2A. Circus races mosaic pavement from the Villa del Casale, overview. Image courtesy of Enrico Gallocchio/the University of Pennsylvania Museum of Archaeology and Anthropology.

2. Circus Races Mosaic Pavement

Villa del Casale, near Piazza Armerina, Sicily, ca. 300–350

The most popular spectator sport across the Roman Empire was chariot racing, a fast-paced, chaotic, and dangerous mad dash of seven laps around a long, hairpin-shaped track inside a stadium called a *circus*. The largest and most famous racetrack in the Roman Empire, the Circus Maximus in Rome, was located adjacent to the palace of the Roman emperors on the Palatine Hill. It had a track 580 meters long, with room for more than 100,000 spectators in the stands. (Some estimates put capacity higher still, at 200,000 or more.) Races typically featured chariots with a single driver pulled by a team of four horses, called a *quadriga*, usually competing in groups of four. At Rome, where chariot racing began at least as early as the sixth century BC, there were four principal teams, known as "factions" and distinguished by their colors: red, white, green and blue, each with many thousands of supporters. By the second and third centuries AD, these factions had become empirewide entertainment corporations, organizing games and spectacles and attracting local supporters in cities across the empire.

Fans of these teams were bitter rivals, and the streets of cities such as Rome, Constantinople, Antioch, and Alexandria were often the scene of bloody clashes between hundreds or even thousands of especially die-hard supporters. (Comparisons to modern soccer hooliganism are in some ways apt, though today's hooligans are tame in comparison to their late Roman and Byzantine predecessors.) Especially successful charioteers, such as Porphyrius of Constantinople (ca. 500), were the leading celebrities of their day, megastars whose names and images appeared on cups, plates, medallions, children's toys, and countless other accoutrements of daily life found in households from one end of the Mediterranean to the other.

Some people even decorated their houses with chariot-racing scenes. By the early fourth century, wealthy members of the Roman elite customarily owned one or more large country houses, or villas, furnished with heating systems, bath complexes, and large reception and dining halls, and decorated opulently with marble, paintings, statues, and mosaics. Mosaics were made of tiny cubes of glass or stone, called tesserae, inserted into a mortar backing; multicolored tesserae were often arranged to form decorative patterns or figural imagery, with each individual tessera functioning much like a single pixel in a modern digital screen. Because mosaics were durable, resistant to abrasion and wear, and waterproof, they were especially common on floors. This floor-mosaic depicting chariot-racing scenes was laid around AD 300–350 in a monumental villa at Piazza Armerina, high in the hills of central Sicily. It covers the whole floor of a rectangular vestibule, situated between the residential wing and the bathing complex.

Our mosaic is exceptionally large—23.5 by 5.75 meters, with millions of tesserae!—appropriately since it depicts the Circus Maximus of Rome. At the far right, there is a triangular group of three temples located outside the circus proper. Just to the left appears the curving line of the starting gates, or *carceres*, with twelve arched bays. In the center of the racetrack, we see the raised divider around which the teams circled, the *euripus*, its sides sheathed in colored marbles and bristling with statues, with groups of three conical posts (*metae*) marking the turn at each end. At far left, in the curved end of the stadium (the best seats, where the most accidents occurred), a few spectators appear.

The mosaic actually comprises a composite sequence of four different scenes. At far right, behind the *carceres*, two charioteers, red and green, prepare for the race; the green driver at left receives his helmet and a whip from an attendant. Moving left, we see the start of the race: the red, white, green, and blue chariots dash from the starting gates and head for the right-hand side of the *euripus*. Then, midway along the upper straightaway, the scene changes abruptly to show the winning charioteer, his whip-arm raised in celebration. A trumpeter salutes him with a flourish, and a second man waits to hand him a palm frond, the traditional symbol of victory. The other three teams walk slowly behind, the red just behind the green, the blue and white directly beneath them, yet to round the turning post. Finally, at the far (left) end of the track, the chariots are shown in the midst of the race. The white and blue teams, to the left of the obelisk, trail behind the green and red teams, which have already made the turn around the far post onto the bottom straightaway. The red team has just crashed, the driver sprawling face-first into the dirt in a tangle of reins, while the green chariot squeaks past, swerving dangerously.

The size and unusually rich interior décor of the Piazza Armerina villa have led some to suggest that it was built by an emperor, perhaps Maximian or his son, Maxentius. However, it may just as well have been the country residence of a rich Roman senator, the most ambitious of whom continued into the fifth century to fund races in the Circus Maximus as a means of enhancing their family's prestige and popularity, and achieving high political office for themselves and their offspring.

Such entertainments, which were often accompanied by distributions of food, money, and prizes to the spectators, were one of the few ways in which the ruling class—the empire's "one percent" who controlled most of its wealth—gave back to the urban masses. They also provided a rare channel for direct communication between rulers and ruled, a venue where an emperor, provincial governor, or other high official could address (via a herald), and actually be heard by, tens of thousands of people, and where those multitudes, chanting in unison, could express their views with relative impunity. Following the model of Rome, the circuses at the cities where the emperors most often resided beginning in the later third century (Trier, Milan, Thessaloniki, Sirmium, Constantinople, Nicomedia, Antioch, perhaps Ravenna) were also placed next to palaces, allowing rulers to proceed directly

to their box in the circus. In AD 331, the emperor Constantine even decreed that he be sent transcripts of the chants voiced by crowds in attendance at games and other public spectacles, so that he might judge the performance of the local governors and other imperial officials at whom such choruses were usually directed, as well as the prevailing mood of the people (*Codex of Theodosius* 1.16.6).

Further Reading

Useful discussions of the circus mosaic include K. M. D. Dunbabin, *The Mosaics of Roman North Africa: Studies in Iconography and Patronage* (Oxford, 1978), 196–212; K. M. D. Dunbabin, *Mosaics of the Greek and Roman World* (Cambridge, 1999), 130–43; J. Humphrey, *Roman Circuses: Arenas for Chariot Racing* (London, 1986), 223–33 (this last is also the best source for the architecture and archaeology of circuses). For the archaeology and architecture of the villa at Piazza Armerina, see A. Carandini, A. Ricci, and M. de Vos, *Filosofiana–The Villa of Piazza Armerina: The Image of a Roman Aristocrat at the Time of Constantine* (Palermo, 1982). On the career of Porphyrius, see A. Cameron, *Porphryius the Charioteer* (Oxford, 1973); and on circus factions and their sociopolitical milieu, A. Cameron, *Circus Factions: Blues and Greens at Rome and Byzantium* (Oxford, 1976). More broadly on the culture of mass spectacles in the later Roman Empire, see R. Lim, "People as Power: Games, Munificence, and Contested Topography," in *The Transformations of* Urbs Roma *in Late Antiquity*, edited by W. Harris (Portsmouth, 1999), 265–81; K. M. D. Dunbabin, *Theater and Spectacle in the Art of the Roman Empire* (Ithaca, NY, 2016).

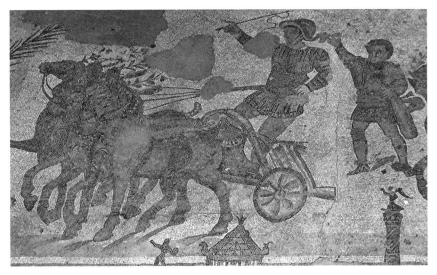

Thing 2B. Circus races mosaic pavement from the Villa del Casale, detail of victorious charioteer. Wikimedia Commons.

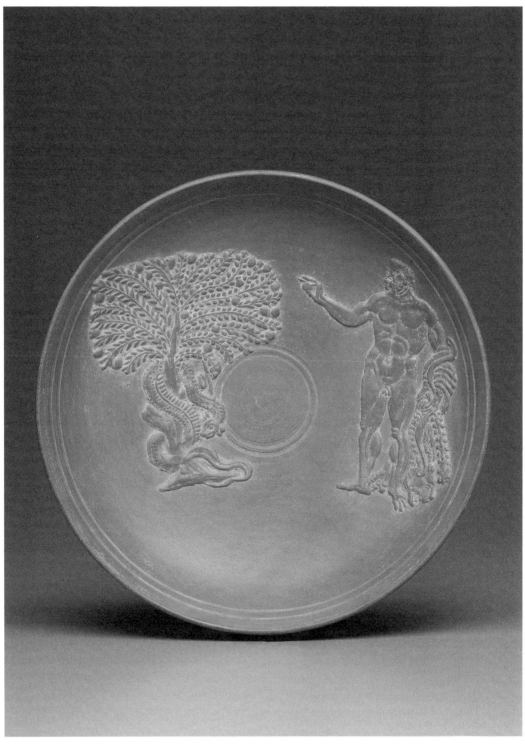

Thing 3. ARS bowl with applied decoration depicting Hercules. Photograph © 2018 Museum of Fine Arts, Boston. Museum purchase with funds donated by Shelby White in honor of John J. Herrmann, Jr., curator of classical art, 1978–2004.

3. African Red Slip Bowl

Tunisia, ca. 350–430

This small, shallow bowl, 19 centimeters in diameter by 3.5 centimeters high (7½ by 1⅜ inches), is a characteristic example of a style of high-quality tableware found across much of the Roman Empire for some seven centuries, from the first century BC into the seventh century AD. The principal distinguishing feature of this class of ceramics is the slip, or surface coating, that gives such vessels their distinctively glossy, reddish-orange finish. This slip consisted of a water-diluted clay paste from which all but the finest particles had been filtered out (only those fine enough to float on the surface of water were used). The potter brushed this solution onto the bowl's exterior surfaces before it was fired in order to impart a polished sheen to the finished product when it emerged from the kiln, so that it recalled the luster of far more valuable vessels made of metal. The relief-decoration on the interior of the bowl was made separately in molds, and then attached before the slip was applied and the bowl was fired. Based on its style and especially its shape, archaeologists can place the origin of this particular bowl with some confidence in North Africa, between about AD 350 and 430.

The appliqués on the bowl depict the legendary hero Hercules picking the golden apples of the Hesperides, the eleventh of his twelve labors. The mighty Hercules, identified by his bow and the lion skin draped over his arm, as well as his hypertrophied physique, uses his right thumb and forefinger to pluck a tiny apple with incongruous delicacy. A plump, scaly serpent coils around the trunk of the tree. This is Ladon, the serpentlike monster that guarded the tree whose golden apples granted immortality to whoever ate them. Readers of the Old Testament, however, might note that the creature in the tree looks very much like the one in the Garden of Eden that convinced Eve to eat the apple of knowledge. The well-known biblical scene from the Book of Genesis was in fact depicted on other North African ceramics produced at the same time, featuring trees and snakes indistinguishable from the ones shown here. The same snake-wrapped tree, but two very different stories; different worlds do not so much collide as casually intermingle.

An explanation for this curious visual overlap is easily imagined. In the period in which this bowl was made, both Christians and worshippers of traditional Greco-Roman gods (derisively called *pagani*—"rustics"—by Christians) were present in large numbers in North Africa, and throughout the Roman Empire. In teeming North African cities like Carthage, Lepcis Magna, and Alexandria, adherents of the two religious traditions lived cheek-by-jowl: they washed in the same baths, went to the same entertainment venues, and shopped in the same

markets. The workshop that produced this bowl catered to consumers both pagan and Christian, and offered decorative schemes designed to appeal to each (business, after all, was business). The potter who set out to depict Hercules in the garden of the Hesperides had a mold for an apple tree inhabited by a snake that worked as well for the Garden of the Hesperides as for the Garden of Eden. This sharing of visual motifs is known for many other pagan and Christian artworks from this era, in depictions, for example, of Jonah/Endymion, David/Orpheus, and Christ/Jupiter.

In fact, the potter was probably too busy turning out industrial quantities of dishware to pause long to reflect on the visual nuances of the scene. Red-slipped bowls, plates, cups, jugs, and storage containers were in everyday use in households from one end of the Mediterranean to the other; countless millions of vessels were produced, most in factories staffed by full-time employees. From the third century until the seventh, most glossy red tableware was produced in modern-day Tunisia and eastern Algeria, whence it is known to archaeologists as African Red Slip ware, ARS for short.

Because ARS was produced in vast quantities for more than five centuries, in styles and shapes that changed enough over time to allow for relatively precise dating (a fifty- to hundred-year range is common for many vessel-types), it is an invaluable tool for the study of trade, commerce, and the economy. By creating distribution maps of ARS finds, archaeologists can trace the course of trade routes and, by dating the finds, document growth or decline in the volume of shipments along those routes over time. Because pottery survives far better in the ground than nearly all the other objects of long-distance trade, ARS is also an excellent proxy for the circulation of other, long-vanished commodities, from textiles and papyrus to foodstuffs like oil, grain, and wine.

In the third and fourth centuries, when the empire was still politically and economically unified, and the central government remained active in requisitioning supplies to feed the troops stationed around its borders, ARS went nearly everywhere, from northwest Europe, to the Balkans, to Asia Minor and the Levant. Yet even after the breakup of the empire in the fifth century, ARS continued to travel widely: it still shows up in the sixth century in Britain and France, and at Rome up until the very end of the seventh century, disappearing only when Muslim armies conquered the traditional areas of manufacture in Tunisia and Algeria (the capital of Byzantine Africa, Carthage, fell in 698). The glossy red plates found on late Roman tables, from Syria to Britain, ultimately proved more resilient than the empire itself, a telling reminder that regime change often occurs faster than changes in taste, culture, and household-management.

Further Reading

J. Hayes's *Late Roman Pottery* (London, 1972) and *A Supplement to Late Roman Pottery* (London, 1980) established the basic parameters for classifying and dating ARS that remain in use today. For a more discursive overview of Roman pottery and the sorts of questions that archaeologists and historians ask of it, J. T. Peña, *Roman Pottery in the Archaeological Record* (Cambridge, 2007) is a good place to start. On pagans and Christians in North African cities, see A. Leone, *The End of the Pagan City: Religion, Economy, and Urbanism in Late Antique North Africa* (Oxford, 2013). For Mediterranean trade routes, commerce, and the economy in late antiquity and the early Middle Ages, M. McCormick's *The Origins of the European Economy: Communications and Commerce AD 300–900* (Cambridge, MA, 2001) is fundamental.

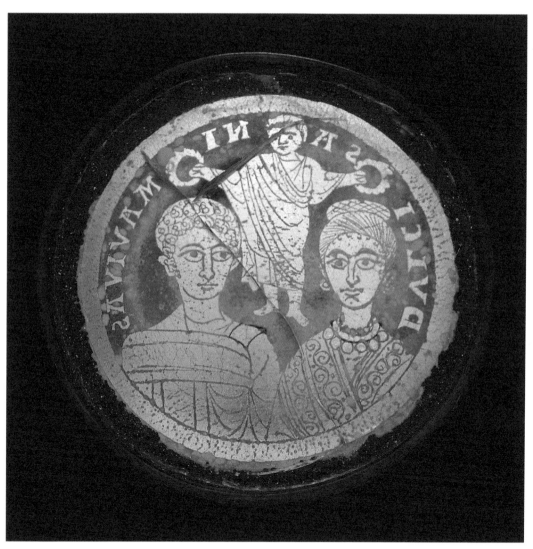

Thing 4. Bottom of a Roman glass vessel depicting gilded busts of a bride and groom. Above them is a small figure of Christ in tunic and pallium with arms extended, holding a wreath over each of their heads, fourth century. Diameter: 56.1 millimeters, depth: 6.7 millimeters, Museum ID 1898, 0719.1. British Museum, London, © The Trustees of the British Museum/Art Resource, NY.

4. Gold-Glass Medallion

Rome, fourth century

In the late second century, glassmakers in Rome revived a technique that sandwiched very thin sheets of gold foil between sheets of glass, to create an attractive yet relatively affordable art form that could be individualized or mass-produced. Gold-glass, as it is known, was created in (usually) round medallions that would then be used as the base of a wide glass bowl or attached to some other kind of vessel, and had its peak of popularity in the fourth century. Over four hundred of these objects have survived from the fourth century, many of them because they were pressed into the plaster that covered tombs in the catacombs of Rome. However, while the workshops that produced gold-glass objects were located in Rome, examples have been found as far away as Germany, indicating that these objects were quite widely disseminated.

The gold leaf in these medallions was cut into designs that reflected owners' taste and interests. Fifty-three surviving examples include single and family portraits, while others depict a wide range of subjects, including Christian saints and religious motifs, Jewish symbols, Roman gods and religious motifs, gladiators and famous actors. Some are finely detailed, while others seem quite crude, but all are done using the same kinds of imagery, suggesting that a few workshops produced all the objects. Some contain the names of individuals (including persons known to have been wealthy and powerful), but most of the glasses do not name their subjects. Some have inscriptions with generic good wishes (e.g., "long life"), but each seems intended to commemorate a specific event in someone's life. The fact that they were used on tombs to commemorate the deceased suggests that they were valued personal items in late Roman homes.

This medallion was made to commemorate a marriage, perhaps given as a wedding gift. Twenty-three such examples survive, most of which contain bust-pictures of a bride and groom, sometimes with their names. Since all examples in this group employ similar dress and hair, there probably was a stock model for this kind of vessel. The man is always short-haired and beardless, the woman always has a necklace and a heavy braid on the top of her head. In this example, the man wears a *toga contabulata* with a *clavus* on the right shoulder, which is a sign that he holds high status as a public officeholder, and the jewelry and richly embroidered fabric of the woman's *palla* also signify wealth.

The average age at marriage in the late Roman Empire is unknown. According to Roman law, boys had to be at least fifteen years old to be married, and girls twelve. Scholars have analyzed funerary inscriptions from various parts of the

Roman Empire and propose that actually girls were married in their late teens, and men in their late twenties. This might explain why the gold-glass pictures of couples, such as the one shown here, depict a young-looking man and a post-pubescent woman.

On this medallion, a full-length figure floats between the couple: a beardless man wearing a toga and holding crowns over their heads. This figure is thought, by comparison with some other glass medallions, to depict Christ, although he is not named here. Other surviving glasses have similar figures, like a beardless man, a cupid, or Hercules. Around the rim is written the phrase, "DULCIS ANIMA VIVAS," which means "may you live, sweet soul," a generic good wish.

This medallion's imagery is deliberately ambiguous, reflecting the values of the society in which it was produced. In the late fourth century, there were many married couples in which one partner was a Christian and the other was not, among them the parents of Saint Augustine of Hippo. Craftsmen produced commodities like this medallion in order to appeal to customers from a variety of religious backgrounds, all of whom participated in late Roman social institutions such as marriage.

Further Reading

This medallion is published in Daniel Thomas Howells, *A Catalogue of the Late Antique Gold Glass in the British Museum* (London, 2015). A short description of these objects is David Whitehouse, "Glass, Gold, and Gold-Glasses," *Expedition* 38 (1996): 4–12. See also Stephanie Leigh Smith, *Gold-Glass Vessels of the Late Roman Empire: Production, Context, and Function* (Ph.D. diss., Rutgers University, 2000), and Susan Walker, "Gold-glass in Late Antiquity," in *The Routledge Handbook of Early Christian Art*, edited by Robin M. Jensen and Mark D. Ellison (Abingdon, 2018), 124–40. A succinct survey of early Christian household formation and marriage practices is in K. Cooper, "The Household as a Venue for Religious Conversion," in *A Companion to Families in the Greek and Roman World*, edited by B. Rawson (Chichester, 2011), 183–97. In the same volume, S. Dixon, "From Ceremonial to Sexualities," 245–61, discusses the historiography on Roman marriage.

PART II

Things of the Fifth Century

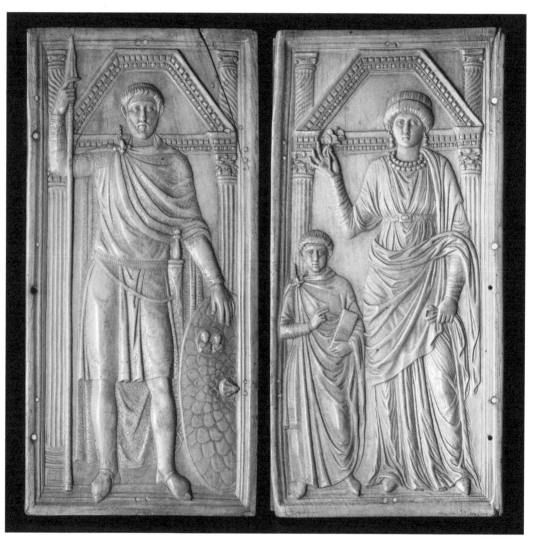

Thing 5. Late Roman workshop, Diptych of Stilicho, Ivory with traces of paint, ca. 400, Monza, Museo e Tesoro del Duomo di Monza, ©Museo e Tesoro del Duomo di Monza/photo: Piero Pozzi.

5. Ivory Diptych of Stilicho

Italy, late fourth/early fifth century

In the late Roman Empire, diptychs made of two sheets of ivory, connected together with hinges, were produced for and distributed by aristocrats in order to confirm and promote notable events in the lives and careers of their family members, including (but not limited to) celebrating appointment to government offices such as the consulship. The exterior faces of a diptych were often carved with portraits of the honoree that showed him dressed and/or acting in an official capacity, with his name and perhaps also a record of his political career. Datable commemorative diptychs survive from 406 to 540, and later imitations of them were made long after the office of the consul ceased to matter in politics. Indeed, the format of the diptych (or, if three leaves were used, the triptych) was adapted for religious purposes and continued to be reproduced into the ninth century.

Ivory comes from the tusks of African elephants. Since before the third millennium BC, it had been traded to the Mediterranean, where it was carved into functional and decorative objects. The supply of ivory in the Mediterranean depended on many factors (economic, political, environmental) which today are unknown; especially in the fourth to sixth centuries AD, ivory seems to have been cheap and plentiful, and many large objects were produced from it for both secular and religious purposes, including diptychs.

This diptych is usually assumed to depict Stilicho, his wife Serena, and their son. Stilicho was one of the most powerful men in the Roman Empire in the late fourth and early fifth centuries. He is said to have been the son of a Vandal father and a Roman mother, and thus was considered a "barbarian." By 400, the Roman army, including many of the senior officers, was largely made up of men like Stilicho. As he rose through the ranks, he encountered Theodosius, an officer who became the eastern Roman emperor in 379, and sole ruler of the reunited empire in 392. Theodosius respected and trusted Stilicho, and in 385 Stilicho married Theodosius's niece, Serena; they went on to have two daughters and one son. In 395 Stilicho became commander of the armies of the western Roman Empire. Prior to his death in 395, Theodosius divided the empire between his two sons, and entrusted to Stilicho the care of his younger son Honorius, emperor of the West. Three years later, Stilicho married his daughter Maria to Honorius and, after her death, married his second daughter Thermantia to the young emperor in 408.

Stilicho commanded the armies of the West during very difficult years. In 395–97, the Visigoths in the Balkans ravaged Greece, worryingly close to the

borders of the western empire, and in 397 a Roman army rebelled in North Africa. In 401 the Visigoths entered Italy, where Stilicho's headquarters lay, and were only pushed out in 402; in 405 another barbarian army invaded Italy, and finally in 405 or 406, other barbarian groups crossed the Rhine River and traversed Gaul into Spain. Locked in power struggles with his counterparts in the eastern Roman Empire, Stilicho found it impossible to hold all these frontiers, and his habit of recruiting "barbarian" Huns had apparently made him enemies. In 408, with the situation at its most precarious everywhere, Stilicho was accused of treason, and together with his son Eucherius was executed by Honorius; Thermantia was sent back to her mother.

This diptych depicts Stilicho and his family in happier days. Each leaf measures about 32.4 by 15.9 centimeters (12.75 by 16.25 inches). On the left panel we see a mature man with a mustache and short beard, wearing a sleeved tunic and long cloak (*chlamys*) fastened at the shoulder by an elaborate brooch (a "crossbow" fibula; see Thing 18), girded with a belt and sword and holding a tall spear and large shield that bears the portraits of emperors, possibly the brothers Arcadius and Honorius. Such items characterized high-ranking imperial military officials of this period. On the right panel, a mature woman is dressed elegantly in a *tunica manicata*, a long, wide-sleeved *dalmatica*, and a *palla* thrown across her left shoulder, holding a flower in one hand and a handkerchief in the other. Her hair is covered by an elaborate headdress-scarf, a fashion of the late fourth century. Next to her, and thus between her and the man, is a boy, dressed like the man, including a fibula but minus the military equipment, raising his right hand in a gesture of speech and carrying a tablet in his left hand. The group is clearly a family of high Roman rank, and since 1882 has been presumed to represent Stilicho, Serena, and Eucherius, because the style of the fibulae, the hairstyles, and the carving of the piece can be dated to the 380s and 390s, namely the reign of Theodosius I. As the emperor had given young Eucherius the honorary title "tribune and notary," it is possible that the diptych celebrates the moment of his appointment.

On the one hand, this diptych is typical of a class of artifacts that was popular in the fifth and sixth centuries; on the other hand, it is unique among those that survive. If this is indeed Stilicho, then it is the only portrait of any "barbarian" Roman general. This may not have been as unusual as the lack of other surviving examples implies: Stilicho was also the subject of a Latin eulogy by Claudian, the only barbarian general so honored in extant sources. Though this is the only late antique diptych that pictures a family group, Stilicho's family *was* unusual. Perhaps this diptych served to emphasize the general's unique place in Roman society.

Note: in many reproductions of this diptych, the panels are reversed, with Stilicho on the right. This is because there are holes for hinges on these panels that imply

that arrangement. Those holes are now thought to be of later date, and the view seen here, with the boy in the middle, is presumed to be the original layout.

Further Reading

A comprehensive study of the diptych is B. Kiilerich and H. Torp, "*Hic est: hic Stilicho*: The Date and Interpretation of a Notable Diptych," *Jahrbuch des Deutschen archäologischen Instituts* 104 (1989): 319–71. A. Cameron, "The Status of Serena and the Stilicho Diptych," *Journal of Roman Archaeology* 29 (2016): 509–16, is a lucid attempt to sort out the attribution of this item. More broadly on consular diptychs, see A. Cameron, "The Origin, Context, and Function of Consular Diptychs," *Journal of Roman Studies* 103 (2013): 174–207. On ivory in general, see A. Cutler, "Ivory," in *Late Antiquity: A Guide to the Postclassical World*, edited by G. W. Bowersock, P. Brown, and O. Grabar (Cambridge, MA, 1999). Stilicho's career is covered in G. Halsall, *Barbarian Migrations and the Roman West, 376–568* (Cambridge, 2007), 199–214.

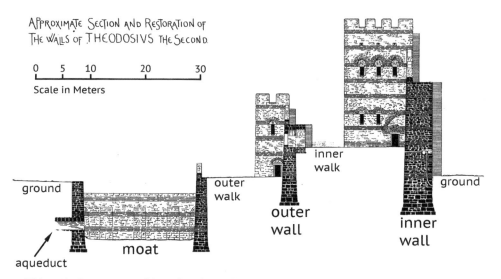

APPROXIMATE SECTION AND RESTORATION OF
THE WALLS OF THEODOSIVS THE SECOND.

Scale in Meters

ground

aqueduct

moat

outer
walk

outer
wall

inner
walk

inner
wall

ground

Thing 6A. Cross section of the walls, adapted from Alexander Van Milligen, *Byzantine Constantinople* (London, 1899).

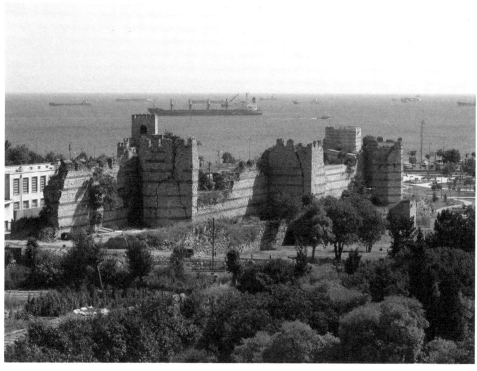

Thing 6B. View of the Thedosian Walls of Constantinople, looking to the harbor. Wikimedia Commons.

6. The Triple Walls

Constantinople, early fifth century

Later Byzantines considered their capital city "well guarded by God," but when Constantinople was young, people were not so sure. The first Christian emperor, Constantine (d. 337), who "founded" his namesake city to celebrate his victory over the other Roman emperor Licinius, had begun a defensive wall from the Golden Horn to the Sea of Marmara. His son Constantius II completed it. Within a generation the boomtown's population outgrew that perimeter. In the 390s a panegyric for the emperor Theodosius I prophesized the construction of additional fortifications to protect the growing suburbs. In fact Theodosius's grandson Theodosius II presided over the massive project: between 405 and 413, 6 kilometers (just over 3 miles) of linear fortifications arose about 1.5 kilometers west of the Constantinian line, doubling the area of Constantinople enclosed by walls.

By the fifth century, standard urban infrastructure included circuits of walls. In a time of military uncertainty, these sometimes came in handy, but mostly they reassured a community that their governors were taking care of things. They provided work for thousands of laborers and were valuable backdrops for the lavish choreographies that late antique rulers staged in order to appear grand and superhuman.

Constantinople's Theodosian walls were the most elaborate defensive structure of the late antique world. The praetorian prefect Anthemius, who ran the eastern empire during Theodosius II's youth, carefully organized the expropriations of land, the millions of tons of bricks, stone, and cement, and the necessary labor, drawing on Roman laws (for example *Codex of Theodosius* 8.22) that obligated citizens to contribute to such public works projects. An inscription records that the circus factions (see Thing 2), supporters of rival chariot racing teams in Constantinople, contributed sixteen thousand laborers to repairs on the Theodosian walls made necessary in 447 by an earthquake.

In combining three levels of defense, the Theodosian "land walls" were unlike earlier urban fortifications (if we include the Long Walls of Thrace situated 65 kilometers [40 miles] west of Constantinople in the calculation, and the earlier Constantinian walls that were not maintained but endured into the 1800s, Constantinople's mural defenses were truly multilayered). Attackers first confronted a moat, 7 meters (22 feet) deep and 18 meters (59 feet) wide. Beyond it a flat open glacis stretched 20 meters (65 feet) to the outer wall, a kill zone exposed to the defenders' fire. The outer wall loomed 9 meters over the glacis. This outer

wall was 3 meters (almost 10 feet) thick at its base, with 96 smaller towers spaced to fit between the inner wall's towers. The outer wall rose only 4 meters (13 feet) over an inner terrace between the two walls, made from the spoil dug out of the moat. This terrace facilitated defenders' movements. An inner wall, 13 meters (42 feet) higher than the city streets, is 5 meters (16 feet) thick at its base, with 96 towers projecting from it that had good visibility from their quite large windows. Its parapet, accessible only from the gates, dominated both the outer wall and the terrace. Thus attackers on the outer edge of the moat faced a barricade almost 70 meters (230 feet) across, and were exposed to projectiles from the inner wall's towers some 30 meters (98 feet) above them, as well as from the outer wall.

There are similarities between the inner and outer walls. Their construction with a mortar and rubble core, faced with local limestone and bands of bricks that cut through the whole structure, the spacing of the towers, and especially the position of posterns linking the two walls suggest the whole complex arose from a unitary design, rather than in two distinct construction phases (in 405 and 447). The famous Golden Gate, the second southernmost of the walls' ten entrances, incorporated a triumphal arch that seems to have been used in 391, so the master plan may date to before Anthemius. But the completion of the Theodosian walls required an extension of the sea walls around Constantinople's promontory, from their original terminus at Constantine's line. This task was only finished in 439. Because of currents in the Sea of Marmara and the difficulty of landing troops and materials under the sea walls, these never needed the refinements the land walls enjoyed, so a single curtain with small towers sufficed.

Other large fifth-century fortifications, like the Hexamilion on the Corinthian Isthmus or the Long Walls in Thrace, were useless, but Constantinople's walls worked. They were tough, for the most part requiring repairs only after earthquakes. A landmark as impressive as Hagia Sophia, they dissuaded some attackers (like Attila) and repulsed others. The first to attempt a siege, the Avars in 626, concentrated on the middle section where the Lycus River penetrated the city and the wall seemed lower than some hills outside it. But like the Arabs in 674–78 and 714, the Bulgars in 813, or the Rus in 860, the Avars failed to breach the land walls. Still, they inspired the emperor Heraclius (d. 641) to adjust the walls' northern perimeter, incorporating the church that guarded the girdle of Mary: the Theotokos, as Mary was known, was reputed to have guarded the city while Heraclius campaigned further east. The pious emperor deemed it wise to include such a potent patron in the city.

Once built, the Theodosian walls refashioned Constantinople. They defined the city conceptually, as well as legally, until modern times. They transformed traffic between city and country, and created easy toll stations where rulers might control what entered and exited the Mediterranean's greatest marketplace. They employed people in guard and maintenance work. They legitimized rulers,

whose dutiful care for them proved their statesmanship. And they offered glorious settings from which to launch imperial ceremonies toward the heart of Constantinople.

Further Reading

J. Crow, "The Infrastructure of a Great City," in *Technology in Transition*, edited by L. Lavan et al. (Leiden, 2008), 251–85, sets the land walls in the context of the 350–450 CE burst of construction activity at Constantinople. H. Dey, "Art, Ceremony, and City Walls," *Journal of Late Antiquity* 3 (2010): 3–37, investigates the utility of walls for imperial ceremonies; his *The Aurelian Wall and the Refashioning of Imperial Rome* (Cambridge, 2011), shows how late antique walls redefined and remade communities. C. Kelly, ed., *Theodosius II* (Cambridge, 2013), contains essays on the religious and political context surrounding the land walls' erection. S. Turnbull, *The Walls of Constantinople* (Oxford, 2004), is a lively and fully illustrated introduction. A. van Millingen, *Byzantine Constantinople: The Walls of the City and Adjoining Historical Sites* (London, 1899), is still useful because meticulously observed. B. Ward-Perkins, "Old and New Rome Compared," in *Two Romes*, edited by L. Grig and G. Kelly (Oxford, 2012), 53–78, comes with excellent diagrams juxtaposing Constantinople's and Rome's fortifications.

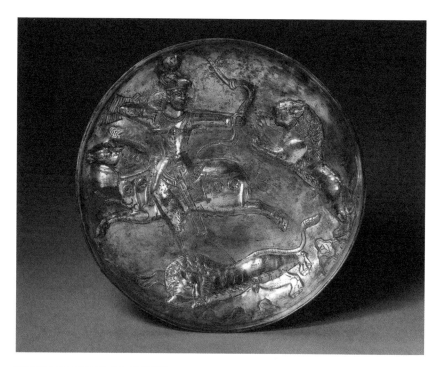

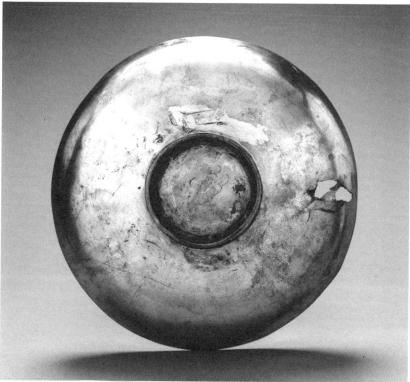

Thing 7. King Hormizd II or Hormizd III Hunting Lions, 400–600, front of dish (top) and back of dish (bottom). Iran, Sasanian, Silver gilt, overall: 4.6 by 20.8 centimeters (1 3/4 by 8 3/16 inches). The Cleveland Museum of Art, John L. Severance Fund 1962.150.

7. The Hormizd Plate

Persia, fifth-sixth century

This silver plate, mottled by oxidation, no longer shines as it did when, freshly polished, it left a royal workshop in Persia. Still, despite a gash before the galloping horse's chest, it is in excellent condition, perfectly legible. Arranged on its flat surface, protected by a high edge, are four figures in a balanced triangular composition thought to reflect Zoroastrian ideas of universal order. The triangle's base is a dead male lion distended with an arrow protruding from its back, its head turned over its left shoulder. Parallel to this lion charges the horse, squat in its proportions and bull-necked. The horse's mane is clipped, and its tail neatly bunched; ornaments dangle from bands in front of and behind the saddle. Its rider is a larger-than-life figure wearing trousers, a long sword, and the typical headgear of a king from the Sasanian dynasty (224–651 CE). This bearded, flowing-haired man, with a faint nimbus around his head, calmly wheels to fire an arrow backward over his left shoulder in a classic "Parthian shot." His bow is shorter below the grip, easier to move from side to side of a horse. His target is a rampant lion, also male, with forepaws outstretched in attack. All four figures are gilt, save the skin portions of the royal archer. The hillocks under the lions are also un-gilt.

With a diameter just under 21 centimeters (8 inches), about as wide as this page, the plate is smaller than some other surviving examples, but it weighs more than a pound (546 grams) and with the lip ring on its back is 4.6 centimeters deep (2 inches). It was made in the traditional Sasanian way, a hammered silver disc onto which were crimped the figural elements, in total sixteen pieces. As in several dozen other silver plates representing Sasanian kings, the silver used to make this one came from a single mine, presumably accessible to royal residences, and was purer than the silver in ordinary Persian coins, called dirhams. Other signs of centralized control over the manufacture of this object are in the style and design of the figures. Together with the less popular "enthroned sovereign" and the rare "portrait bust," the "royal hunt" iconography recurs consistently for three centuries after about 350, suggesting a royal monopoly. Other similar plates with different alloys, styles, and symbols are deemed "provincial" copies that prove the immense impact of such objects in Central Asia and beyond.

Ardashir, the founder of the Sasanian dynasty, was a famous hunter. Persian texts claim he proved worthy to rule by daily bouts of hunting, and polo matches. Plenty of western Asian rulers had advertised their proficiency as hunters, but for the Sasanians hunting became an emblematic royal activity. They maintained large hunting reserves in imitation of the Achaemenid kings whose imperial

hegemony the dynasty claimed to revive. In these walled "paradises" they and their select guests chased and killed diverse animals, especially boars and lions that had religious significance. In the reserves, a numerous staff carefully choreo-graphed hunts, releasing animals from pens at convenient moments so as to enable spectacular kills. The successful hunt signaled the ruler's fitness to rule, his glory and good fortune, or *xwarrah*. More than the American rodeos to which they have been compared, Sasanian hunts manifested the hunter's control over nature, the hierarchies that sustained the universe, just as the irrigated "paradise" preserved proper order and created green fertility in arid landscapes.

Until about 500 CE, most Sasanian kings changed the design of their crowns on accession. This vanity proves useful to historians, since the silver dirhams with portraits become thereby invaluable identifiers of the protagonists in "royal hunt" scenes who, as here, appear incongruously attired in full regalia. Unfortunately, the crown worn by the hunter in this plate is ambiguous. It seems to be the crown of Hormizd II (d. 309). But other characteristics of this plate (style, silver alloy) suggest it was made after about 450. Hormizd III's short reign (457–59) over a politically troubled Persia, when association with a prestigious ancestor may have conferred much-needed legitimacy, is a more likely context for this beautiful object's production. Later Sasanian rulers downplayed the individuality of crowns in favor of generic forms to stress dynastic continuity. Thus, Hormizd III coin portraits resemble Hormizd II's.

The wide dissemination across Eurasia of Sasanian silver plates, or their imitations, and of the "royal hunt" motif in its heroic Sasanian version, likely derive from the Sasanian habit of presenting such plates as diplomatic gifts to Persian nobles, client kings, rivals, and allies. Close control over the produc-tion of the plates suggests how important they were to the dynasty's self-image and in the propagation of its ideology. Unlike monumental rock carvings, the other major medium of Sasanian propaganda, plates were portable. Kushan rul-ers in Afghanistan and Roman emperors in Constantinople demonstrably were impressed by the message of power and prowess the "royal hunt" plates conveyed, even if the finer points of Zoroastrian cosmology got lost in translation. Courts studied gifts like this Hormizd plate closely, deciphering their meaning in order to prepare appropriate countergifts. The weight of some plates, including this one, was expressed in dirhams in Middle Persian inscriptions on their backs and suggest such a plate was worth more than ten sheep or three oxen. Indeed, some plates circulated for centuries as treasured antiques: in the early seventh century a plate made around 300 CE was buried in a tomb in northern China. But natu-rally only a tiny fraction of Sasanian production, like the Hormizd plate, eluded the smelter. Silver was valuable, and easy to recycle.

Further Reading

T. Allsen, *The Royal Hunt in Eurasian History* (Philadelphia, 2006), is a refreshingly broad treatment of hunting from China to Britain, with due attention to Iran. M. Canepa, *The Two Eyes of the World* (Berkeley, 2009), delineates the intimate diplomatic dialogue between late antique rulers of Rome and Persia. P. Harper, *In Search of Cultural Identity* (New York, 2006), offers the leading expert on Sasanian silverware's thoughts on the social use of these items. P. Harper and P. Meyer, *Silver Vessels of the Sasanian Period*, vol. 1 (New York, 1981), is still the most compendious treatment of the genre. B. Marshak, "The Decoration of Some Late Sasanian Silver Vessels and Its Subject Matter," in *The Art and Archaeology of Ancient Persia*, edited by V. Sarkhosh Curtis et al. (London, 1998), 84–92, offers pointed considerations. In the same volume, K. Tanabe, "A Newly Located Kushano-Sasanian Silver Plate," 93–102, explains lion symbolism. M. Moussavi Kouhpar and T. Taylor, "A Metamorphosis in Sasanian Silverwork," in *Current Research in Sasanian Archaeology, Art, and History*, edited by D. Kennet and P. Luft (Oxford, 2008), updates thinking on cultural transmission in silver.

PART III

Things of the Sixth Century

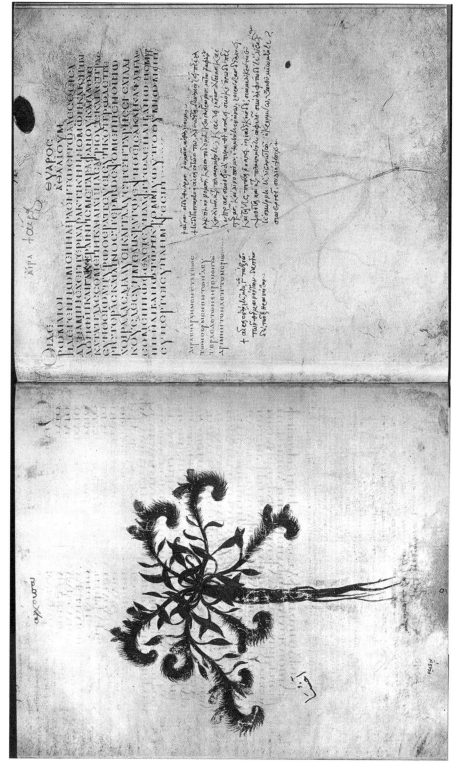

Thing 8. Vienna Dioscurides folio 70v–71r. Photo courtesy Oesterreichischen Nationalbibliothek, Wien, Cod. Med. Gr. 1.

8. The Vienna Dioscurides, Fol. 70v–71r

Constantinople, 512

The two pages shown here are representative of the quality found throughout a large-format manuscript, a codex considered one of the masterpieces of late antique bookmaking, that experts call "the Vienna Dioscurides." On the left-hand side (f 70v) is a fairly accurate painting of alkanet (*Anchusa tinctoria*) with roots, stem, leaves, and flowers meticulously delineated and colored. It complements eleven lines of regular capital-lettered (majuscule) Greek text, plus four less boldly delineated ones, on the right (f 71r), that describe the picture overleaf, of darnel, a common grain-field weed. Both pages are larger than a standard sheet of modern paper (30 by 37 centimeters as opposed to 21.5 by 28) and the whole codex weighs almost 7 kilograms (15.5 pounds). Marginal markings border both pages: scribes used them to position their writing correctly on the light beige parchment. The striations and wrinkles toward the bottom, and a small hole at the top right are evidence of parchment's origin as animal skin. So is a slight transparency: the picture of darnel from folio 71v shows through the thin parchment below the text, as do letters from the preceding botanical description around the image of alkanet.

These were often-thumbed pages, as revealed by the discoloration on their edges. Readers, accustomed to text with no spaces between words or much punctuation, consulted an entry that combined data from the Greek physician of the late first century, Dioscurides, and details from another source (likely Galen, the famed Roman doctor of the second century AD); the entry began with the plant's identification (in red ink: here "AIRA"), gave other, regional names for it (here only two), described darnel's habitat and then how, mixed with other substances and ground up, it relieves boils and promotes conception. Such information was standard in "herbals," texts about plants and their curative powers.

Today this codex, kept in the Austrian National Library, consists of 485 pages. When it was completed about AD 512, there were 546 pages on calf (some unborn, so suppler) and sheep skin. Lavish full-page author portraits, as well as an image of the book's dedicatee, were followed by 375 pages with large-format pictures of plants like this one, with (usually) some dozen lines of Greek text describing the plant and its medicinal properties, as well as how to extract and administer them. Similar data on animals, or parts thereof, and minerals, appear in the second and fifth books (the text has ten). In this part of the codex, text and image are fused, an invention of late ancient book designers. Beginning on folio 388r the scribe copied an anonymous poem about the medical virtues of plants (much annotated in eighth-century handwriting), and four

paraphrases of ancient works on the pharmaceutical qualities in animals and minerals. These texts have far fewer pictures.

Even for sixth-century Constantinople, where it was made, this was a luxurious volume. It was produced to impress a member of the highest aristocracy, a woman who founded a church on the outskirts of the east Roman capital. Juliana Anicia, to whom a grateful group of clergymen presented the magnificent codex gift, was portrayed on folio 6v. Juliana Anicia was daughter and granddaughter of former emperors, married to the army chief of staff, and a pious patron of churches. Her learning and interests ranged beyond Christian readings. The Vienna Dioscurides thus reflected the refined classicizing tastes of urban elites, their commitment to classical knowledge and aesthetics. The original majuscule writing and the naturalistic representation of plants (and animals and minerals) were deliberately old-fashioned and traditional looking, some drawn from nature, others copied from earlier books. But while the book reflected Juliana's support for Greek cultural attainments, a family tradition that set her apart from early sixth-century emperors, it also contained practical information: like all women, Juliana was responsible for medical care in her household.

Into the Renaissance Greek speakers considered Dioscurides *the* authority on drugs and pharmacology. Though the Vienna Dioscurides is the oldest illustrated copy of the famous physician's *On Medicines*, numerous other versions circulated in the early Middle Ages that better represent the original: for example, the Viennese manuscript arranges its plants alphabetically, while Dioscurides had insisted that his material be organized by "property," or according to the active ingredients in the plants, minerals, and animals he listed, so medical practitioners could handily find related cures clustered together in the same section of the book. In addition, the Byzantine tradition of illuminating this manual almost certainly strayed from the original, which was a scroll and so difficult to illustrate, at any rate with the kind of large, thickly painted pictures seen in the Viennese manuscript.

Translated into Latin in the third century, and into Syriac and Arabic later on, *On Medicines* led doctors and healers to organic and inorganic substances that mitigated each ailment. Because it was so useful, *On Medicines* was a "living text," open to users' continuous updating, annotation, corrections, and additions (such as details from Galen, in the case of folio 71r): in this sense, it was like a medical Wikipedia, though the distinction between original and annotation remained firm. The tidy cursive Greek handwriting below the sixth-century text is part of this process, as are the Arabic, Persian, and Turkish notes visible on most pages. For this precious codex often changed owners during its long life. Between 1204 and 1261 a few Latin notes (and an Old French identification) were made in some margins, a result of Latin crusaders' control of Constantinople. In 1406 an Orthodox monk rewrote the text in cursive handwriting below the

elegant late antique majuscule he found hard to read, and while the book belonged to Ottoman sultans their doctors made notes on its pages. In 1569 a Hapsburg ambassador in Istanbul bought the book for the Holy Roman emperor and transferred it to the Viennese palace library, where it had page numbers written on its edges and became the "Vienna Dioscurides."

Further Reading

L. Beck, trans., *Pedanius Dioscurides of Anazarbus "De Materia Medica"* (Hildesheim, 2011), is an excellent English rendition of the first-century Greek text, with lavish botanical and lexicological apparatus. L. Brubaker, "The Vienna Dioskorides and Anicia Juliana," in *Byzantine Garden Culture*, edited by A. Littlewood, H. Maguire, and J. Wolschke-Bulmahn (Washington, 2002), 189–214, has a good discussion of Byzantine sixth-century aristocratic cultural interests. M. Collins, *Medieval Herbals: The Illustrative Tradition* (London, 2000), sets the Vienna manuscript (39–50) in the context of the Greek, Latin, and Arabic herbal traditions. N. Everett, *The Alphabet of Galen* (Toronto, 2012), is a useful introduction to early medieval herbal lore and its literary traditions, with up-to-date bibliography. O. Mazal, *Der Wiener Dioskurides* (Graz, 1998–99), is a superlative facsimile reproduction of the entire manuscript. C. Singer, "The Herbal in Antiquity and its Transmission to Later Ages," *Journal of Hellenic Studies* 47 (1927): 1–52, tracks the medieval reception of ancient medicine writings. K. Weitzmann, *Late Antique and Early Christian Book Illumination* (London, 1977), remains a stimulating introduction to early books with pictures and contains much on the Vienna Dioscurides at 60–71.

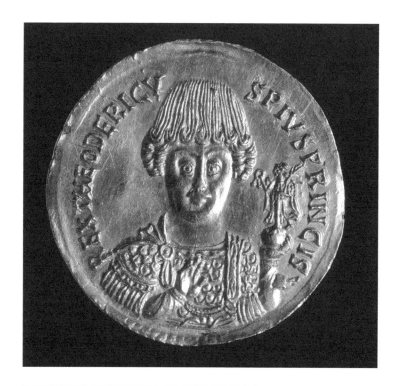

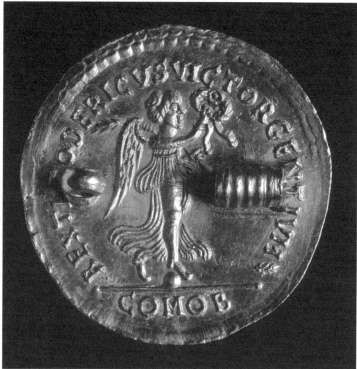

Thing 9. Senigallia Medallion, front (top) and back (bottom). Medagliere del Museo Nazionale Romano, Collezione Gnecchi, Inv. #125913. Photo courtesy Ministerio dei beni e delle attività culturali e del turismo—Museo Nazionale Romano.

9. The Senigallia Medallion

Italy, early sixth century

Coins are an invaluable source of information about Roman economics, politics, and culture. The Roman government relied on the taxation of land, in coins and in kind, producing income that was spent on maintaining state infrastructure, especially the army, but also the judicial system, roads, and communications networks. To facilitate this system, as well as to support the broader economy, the imperial government minted quite uniform coins in gold, silver, and bronze, at official mints located in major cities.

Following an inflationary crisis in the third century AD, the emperors Diocletian (284–305) and Constantine (306–37) reorganized the coinage. Thereafter, the gold coin, called the solidus, was to weigh 4.55 grams (0.16 ounces) and be 2 centimeters (0.75 inch) in diameter; the reforms also introduced half-size (*semissis*) and third-size (*tremissis*) gold coins. The silver coin, called the *siliqua*, was much less common in the Mediterranean before the seventh century. The copper coin, called the *nummus*, was originally 1/7200 to 1/12,000 of a solidus; a second copper coin, the *follis* = 40 *nummi* = 1/180 solidus, was introduced around 500, and there were other coins representing different multiples of nummi as well. Though it sputtered out in the western provinces by 700, this monetary system lasted in the eastern Roman Empire until the eleventh century. The reforms of Diocletian and Constantine attempted to rebuild trust in the state's monetary instruments by using the appropriate alloys of metals, and thereby stabilizing the value of the various coins. It succeeded enough that late Roman coinage circulated not only inside the empire, but also outside of it, notably in "barbarian" Europe. More reliable exchange rates also enabled those with highest rank, and access to fiscal policymaking, to manipulate taxation in silver and gold coins for their own benefit.

Roman coins, especially the gold coinage, always included a portrait of the current emperor on the obverse ("heads" side), while the reverse might include a variety of equally propagandistic images that included divinities, symbols of victory, or pictures of rulers' accomplishments. Indeed, minting coins was not only one of the prerogatives of emperors, but an important way of establishing a new emperor's legitimacy; a usurper usually rushed to get control of a mint and to produce coins with his picture on them immediately after his accession.

When a series of kingdoms ruled by "barbarian" kings replaced the Roman Empire in the West, the tax and coinage systems were radically transformed, and mints disappeared in many places. However, in Italy, the Ostrogothic ruler Theoderic (r. 490–526) ruled according to Roman customs, including the collection of Roman taxes, and kept the mints operating as they had under the empire.

In the fifth century, the main imperial mint had been located at Ravenna, the preferred residence of the last western Roman emperors; Theoderic likewise established himself in the palace there, which was adjacent to the mint.

Theoderic controlled all Italy, much of southern France, and a big slice of the northern Balkans. He attempted to position himself as the leader of the western rulers. But Theoderic never called himself emperor; he ruled as *rex* (king). He deliberately minted gold and silver coins in the name of the emperors of Constantinople, to imply that he ruled in the West with their approval. Though it is not properly a coin designed to circulate on the marketplace, the Senigallia medallion, which bears the only named portrait of him, was a special commemorative issue whose weight was equivalent to three *solidi* and whose manufacture required the same techniques used in the mint. There is only one surviving example of this issue, but the crafting of the dies to strike it would have been laborious enough to justify the supposition that others were made. The medallion is thought to have been issued either in 500, to celebrate Theoderic's thirtieth year as king, or in 509 to commemorate recent military victories.

As a rare picture of a barbarian king, the medallion's representation of Theoderic is important. In the first place, the legend on the obverse reads "Rex Theodericvs Pivs Princ[eps] I[nvictissimvs] S[emper]," or "King Theoderic, pious leader, most invincible always," while the legend on the reverse reads "Rex Theodericvs Victor Gentivm," meaning "King Theoderic conqueror of (foreign) peoples." On Roman imperial coins of the late fifth and early sixth centuries, the ruler is called "Our Lord [name] pious leader augustus." Theoderic was deliberately avoiding the titles of an emperor.

In the portrait on the obverse, Theoderic is dressed like a Roman general. He resembles the emperors portrayed on Roman coins of the period. However, there are two oddities: one is the monumental cap of hair, and the other is the bushy mustache. It used to be thought that neither feature was "Roman," and that these elements distinguish Theoderic as a barbarian, most notably because the Latin language does not have a word for "mustache." But it now seems that mustaches and large caps of hair are found on other contemporary Roman portraits, and thus are not necessarily signs of a barbarian. While we therefore cannot tell exactly how this portrait would have been interpreted by Theoderic's various subjects, Romans and Ostrogoths, we assume that it was designed to appeal to all groups, as a symbol of Theoderic's multifaceted rule.

Further Reading

For a discussion of late Roman fiscal policy and the politics of coin production, see J. Banaji, *Agrarian Change in Late Antiquity* (Cambridge, 2002). Late antique coinage is comprehensively discussed in P. Grierson and M. Blackburn, *Medieval European Coinage: With a Catalogue of the Coins in the Fitzwilliam Museum, Cambridge*, vol. 1, *The Early Middle Ages (5th–10th centuries)* (Cambridge, 1986), esp. 24–38. A more specific study of Ostrogothic coinage is M. A. Metlich, *The Coinage of Ostrogothic Italy* (London, 2004). An introduction to Theoderic's political ideology is found in J. J. Arnold, *Theoderic and the Roman Imperial Restoration* (Cambridge, 2014), while the same author has also published "Theoderic's Invincible Mustache," *Journal of Late Antiquity* 6, no. 1 (2013): 152–83.

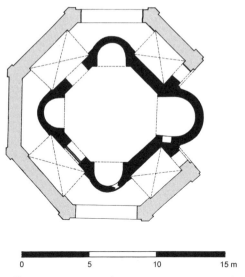

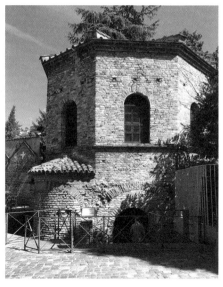

Thing 10A. Ravenna, the Arian Baptistery, ground plan. Reproduced from D. M. Deliyannis, *Ravenna in Late Antiquity* (Cambridge, 2010), 177.

Thing 10B. Ravenna, the Arian Baptistery, exterior view. Photo: Giles Knox.

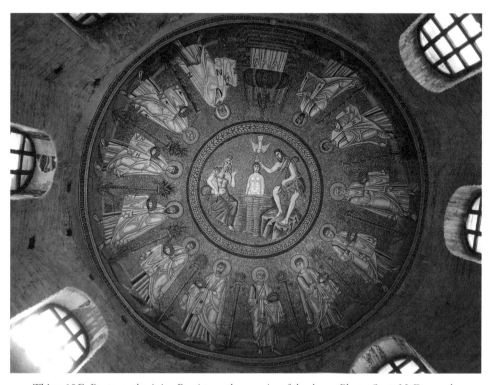

Thing 10C. Ravenna, the Arian Baptistery, the mosaics of the dome. Photo: Scott McDonough.

10. The Arian Baptistery, Ravenna

Ravenna, Italy, early sixth century

The Arian Baptistery of Ravenna is an octagonal structure made of brick, much of it recycled from ancient buildings, 6.85 meters (22.5 feet) in interior diameter and 11 meters (36 feet) from floor to the summit of the dome. As was typical in this period, it was built adjacent to a cathedral and used for baptismal ceremonies. Its interior was richly decorated with marble and mosaic; today only the mosaic of the dome still survives, nearly intact. Made of stone and glass tesserae (see Thing 2), with plentiful use of gold, the mosaics depict images appropriate to the building's function. In the central medallion John the Baptist (on the right) baptizes Christ in the River Jordan (the figure on the left is the river god, a motif commonly found even in Christian baptismal art in late antiquity), with the dove of the Holy Spirit hovering above. Around the central medallion, the twelve apostles form a procession, headed by Saints Peter and Paul, facing a throne on which there is a jeweled cross. None of the saints is labeled, but viewers identified them by their attributes. For instance, Peter holds a key, and Paul holds a scroll; the other apostles hold victors' crowns, symbols of their martyrdom.

The baptistery was built between 500 and 520, during the reign of Theoderic, the Ostrogothic king of Italy (see Thing 9), in his capital city of Ravenna. Ravenna had been one of the main residences of the Roman emperors in the fifth century; when the Roman emperors moved to Ravenna shortly after AD 400, a large cathedral church was built with an equally richly decorated octagonal baptistery (known as the Orthodox Baptistery), which also still survives. Baptisteries were often octagonal because the number eight was associated with rebirth (earth's creation took seven days, the eighth launched life). However, Theoderic did not subscribe to the emperors' kind of Christianity; as an Arian Christian he required separate churches and baptismal facilities.

In the late third century, a deacon named Arius had proposed that Jesus was a creation of God the Father and, like the Holy Spirit, had not always existed; this form of Christian belief, which prioritized God the Father within the Trinity, took the name Arianism. Arius's opponents countered that although Jesus only appeared on earth in historical time, he had existed throughout eternity and was coequal with the Father. At the Council of Nicaea, convened by the emperor Constantine in 325, Christian clerics condemned Arianism as a heresy and upheld the eternity of Christ as orthodox doctrine. Nevertheless, many late antique people, even at the highest levels of church and state, continued to profess Arian Christianity, and indeed Arian missionaries went outside

the empire and converted several "barbarian" tribes in the fourth and fifth centuries, including the Ostrogoths.

Many written sources from Ostrogothic Italy agree that a hallmark of Theoderic's rule was his tolerance of ethnic and religious diversity. He ruled his kingdom with the assistance of Roman aristocrats, and he maintained good relations with the Orthodox Church in Rome; he was even asked to adjudicate in the contested election of a pope! Some Christian authors complained that Theoderic was too accommodating to the Jews who lived in Italy, punishing Christians who burned down a synagogue. In a diplomatic letter addressed to the Jews of Genoa, preserved by the Roman official Cassiodorus, who served as Theoderic's chancellor, Theoderic says, "I cannot command your faith, for no-one is forced to believe against his will" (*Variae* 2.27).

The Arian Baptistery provides another example of Theoderic's religious sensitivity. When he took up residence in Ravenna, he did not displace the orthodox bishop from his cathedral; instead, Theoderic built a second cathedral for the Arian bishop, with its own baptistery. The mosaic of the Arian baptistery's dome in many ways copies that in the Orthodox Baptistery, which also portrays the baptism scene surrounded by the Apostles. However, there are some interesting differences. In the Orthodox Baptistery, John the Baptist is on the left, whereas in the Arian Baptistery John is on the right; in the Orthodox Baptistery the god of the River Jordan is small, whereas in the Arian Baptistery he is as large as the other figures; in the Orthodox Baptistery the figures of Peter and Paul, who lead the procession of apostles (all duly labeled), are aligned with the baptism scene, whereas in the Arian Baptistery they are oriented in the opposite direction. Scholars have debated whether these differences were deliberate, and somehow reflective of Arian theology, or whether they were simply due to the aesthetics and talents of the mosaicists. Because very few Arian texts survive, what Arians actually believed around the year 500 is obscure, and thus no convincing explanation has been produced. Along with some mosaics in Theoderic's palace church in Ravenna (Sant'Apollinare Nuovo), these are the only Arian images to survive anywhere, so they provide important evidence of Arian beliefs and practices, and of how Theoderic peacefully ruled a country in which there were competing versions of Christianity.

Further Reading

A comprehensive introduction to the Arian Baptistery is found in D. M. Deliyannis, *Ravenna in Late Antiquity* (Cambridge, 2010), 174–87. An excellent account of baptismal ceremonies in late antique Ravenna is A. Wharton, "Ritual and Reconstructed Meaning: The Neonian Baptistery in Ravenna," *Art Bulletin* 69 (1987): 358–75. For more on the Arian church, see R. Mathisen, "Barbarian Bishops and the Churches 'in Barbaricis Gentibus' during Late Antiquity," *Speculum* 72 (1997): 664–97.

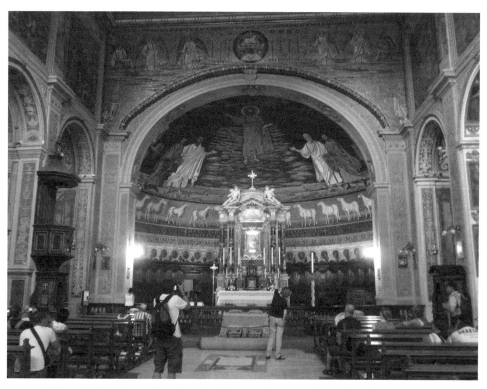

Thing 11. SS. Cosma e Damiano, interior nave, view toward east. Photo by P. Squatriti.

11. The Basilica of SS. Cosma e Damiano

Rome, early sixth century

Santi Cosma e Damiano was not born a standard, axial Christian church. It became one, and took over a millennium to do so. Much of what we see today dates to seventeenth-century restorations, but already at its foundation in the 520s the church was an adaptation of older, nonreligious buildings for Christian services. Sixteenth-century drawings show that the patron, Pope Felix IV (d. 530), had kept the original marble inlay on the flat side walls, although today those walls are pierced with chapels. Felix filled the apse with the still-impressive glass-tessera mosaics, some of which survived centuries of Tiber floods, dampness, and over-enthusiastic restoration. The church's proportions are skewed by the fact that the current baroque pavement is about six meters (almost twenty feet) higher than the original, a result of the accumulation of debris in the area between circa 530 and 1630: today we see only half of the apse's original height.

The mosaic represents a stately, toga-wearing Jesus, flanked by Rome's principal saintly protectors, Peter and Paul. They introduce to the scene Cosmas and Damian, two martyred Christian doctors popular in the eastern Mediterranean by the 400s. Next to Cosmas stood Pope Felix (the existing one is a modern restoration), while another holy easterner often associated with the physicians in eastern churches, the soldier-saint Theodore, stands on Peter and Damian's left. The banks of fiery clouds in the background, the starry sky above the figures' heads, the labeled river Jordan, the New Jerusalem in the lowest register, and the Mystical Lamb atop the triumphal arch signal that the scene is set in post-Apocalyptic time (see Revelations 1:7, 1:12, 5:6, 21:2–27, 22:1). Running along the mosaic's lower border, below twelve sheep symbolizing the apostles (Revelations 21:14), is a Latin inscription alluding to this. It celebrates the basilica's splendor, its association with healing, its conversion to more honorable purposes, and the pope's involvement in all of these. "Felix has made this offering to the Lord . . . so that he may be granted life in the lofty vault of the heavenly city."

SS. Cosma e Damiano was a small church by late antique Roman standards, but there was nothing modest about its location. It occupied prime real estate in Rome's most symbolically charged area, the Forum. The church's original entrance lay on the Via Sacra, the main thoroughfare in the Forum over which loomed imperial Rome's grandest buildings. Before Felix, Christian builders shied away from this zone, concentrating their efforts on suburbs, especially around Christian burial grounds.

In a space crowded with centuries' worth of sculptural and architectural display, the church was necessarily a retrofit. It was inserted into a brick hall from the first century, one of whose walls displayed a huge marble map of the city. The emperor Maxentius (d. 312; see Thing 1) gave that space a circular, domed entrance hall and (likely) its apse. The complex offered a shortcut from Via Sacra to the Temple of Peace, part of Maxentius's program to revitalize Rome's downtown and pride in its past. Judging from a fragmentary inscription, Maxentius's conqueror, Constantine, took the credit for the new entryway, as he did for the massive basilica just up the Via Sacra, Maxentius's major contribution to the Forum. Associations with the first Christian emperor may have drawn Felix to begin the Forum's Christianization at this spot. That late antique writers believed the Temple of Peace to have housed the loot the Roman general Titus took from the Temple of Solomon in AD 70 may have strengthened the attraction: Rome became the New Jerusalem of the mosaic, with Felix standing in it.

Sixth-century Rome was affected by many diseases, including possibly the early medieval pandemic (after 541–42), and welcomed healing saints. Cosmas and Damian were twins and Christian doctors, martyred around 300, maybe in Asia Minor. A florid but much later hagiographic tradition documents their mounting popularity in the fifth century. Their cult reached Rome under Pope Symmachus (d. 518), and in the early sixth century their names were added to lists of saints celebrated in Rome's liturgy, the sole easterners to achieve this honor. Doctors had a bad reputation in early Christian circles, but Cosmas and Damian, who cured people for free, out of charity, rehabilitated the profession. Their posthumous miracles and healings perpetuated what seems to have been a highly successful practice (probably in northern Syria). The twins' cult was an effective Christian response to the pagan health-bringing devotions associated with the Forum, particularly with the corner where their church arose in the 520s. In the 490s, the Lupercalia, pagan rituals designed to bring fertility and health on the community, and which involved young men chasing naked older women, still took place on the Via Sacra. The temple of the pagan health-dealing twins Castor and Pollux, with whom late antique people sometimes confused Cosmas and Damian, was not far away.

Felix's mosaic in some sense replaced the nearby marble map of Rome: now Jesus, not Rome, was the center of the universe, and deserved monumental representation. Elegant inscriptions below more-than-life-size images of important personages were traditional in the Forum. Less so was the appropriation of public buildings by citizens, but the Ostrogothic rulers of Italy may have granted the spaces to the papacy in the context of negotiations surrounding the Acacian Schism, a theological dispute between Roman and Constantinopolitan sees that brought a brief rapprochement between Arian Ostrogoths and bishops of Rome.

SS. Cosma e Damiano certainly was an early insertion of papal authority into the urban fabric of the imperial city.

Further Reading

On this church, G. Kalas, "Conservation, Erasure, and Intervention: Rome's Ancient Heritage and the History of SS. Cosma e Damiano," *Arris* 16 (2005): 1–11. P. Brown, *Through the Eye of a Needle* (Princeton, 2012), contributes a documented survey of papal patronage and its discontents in fifth and sixth centuries. I. Csepregi, "The Miracles of Saints Cosmas and Damian," *Annual of Medieval Studies at the Central European University* 8 (2002): 89–121, is an extensive discussion of the healing miracle in the sixth–seventh century hagiographical texts. C. Goodson, "Roman Archaeology in Medieval Rome," in *Rome: Continuing Encounters between Past and Present*, edited by D. and L. Caldwell (Farnham, 2011), 17–34, uses archaeology to trace the evolution of evergetism AD 300–900 in the ideologically loaded heart of Rome. G. Kalas, *The Restoration of the Roman Forum in Late Antiquity* (Austin, 2015), provides an up-to-date synthesis on how late Roman elites used the monumental center. J. Moorhead, "Western Approaches (500–600)," in *The Cambridge History of the Byzantine Empire, 500–1492*, edited by J. Shephard (Cambridge, 2008), 196–220, is full of excellent detail on sixth-century theopolitics.

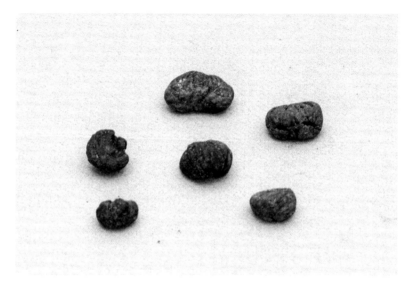

Thing 12. Carbonized chestnuts from Monte Barro.
Photo courtesy of Lanfredo Castelletti.

12. Chestnuts from Monte Barro

Italy, sixth century

Brownish-green from carbonization, but showing the characteristic deep wrinkles of all chestnuts, these tear-shaped fruits of the tree *Castanea sativa* are thoroughly dry, hence light. They measure between 9 and 20 millimeters (1/3 and 3/4 inches) long by 13 to 24 millimeters (1/2 to 1 inch) wide, larger than the (extremely few) chestnuts found at Pompeii and environs but smaller than most commercial chestnuts today. Their shells have been removed, as well as their inner, furry peel (fragments of both emerged from archaeobotanists' sieves). These finicky preparations mean that the chestnuts had probably been dried shortly after harvest in order to prolong their edibility in storage. Soaked in water, they would soften and easily cook into porridge, but even without that step they could be ground into meal and, mixed with some flour, baked into a savory bread.

Monte Barro, where archaeologists working in the 1980s and 1990s found these charred chestnuts in the pantry of the site's most imposing structure, lies on the western branch of Lake Como, on a strategic spur overlooking the Lombard plain. Milan, sometimes residence of late antique emperors and home to important Christian bishops, lies just forty kilometers (twenty-four miles) away. To the north, along the lake and other serviceable routes, are several of the Alps' most forgiving passes (Splügen, Maloja, S. Bernardino), providing access to (and, more worrisome, from) central Europe. It therefore made sense to station here a garrison of perhaps a hundred soldiers in the century around 450–550. Monte Barro was part of a network of strongholds situated well behind the frontier, a late Roman "defense in depth," in this sector centered on Como. Judging from the ceramic and coin finds, this fortified settlement burned and was abandoned sometime between 540 and 580, probably during the Byzantine conquest of the Ostrogothic kingdom of Italy (the "Gothic Wars," 535–54). The fire that carbonized these chestnuts seems to have taken place around 540.

At Monte Barro, servicing the military kept a substantial community, maybe three hundred strong, busy. Managing the woodland was an important part of the services, for the place was expected to supply its own needs. The fuel that warmed bodies, food, and forges depended on sophisticated local selection and processing of trees, as did the construction of all housing and storage facilities, especially the roofing. On hillsides exposed to the southwest the Monte Barrans fostered chestnut woods. Chestnut trees supplied stout lumber for roofs and floors, highly resistant poles for farmers' fences and trellises, hot-burning charcoal for fireplaces and forges, and nuts to eat. The cultivation of chestnuts as food on a significant

scale was a late antique innovation: despite their excellent nutritional value, in classical times few knew or ate chestnuts: to the Romans, chestnuts at most fed isolated highlanders or galley slaves. The storage chamber where archaeologists found these chestnuts seems to have been hastily cleared out before the building burned down, so these nuts represent the dregs, the smallest and least desirable part of the crop. But the respectable size of Monte Barro's leftover chestnuts, and their careful preparation for consumption in the grandest building on the site, shows that this was a food the locals valued. They had other choices, for five types of grain, six of legumes, as well as several types of fruit have left traces in Monte Barro's abandoned pantries. Thus, growing chestnuts was a strategy well-adapted to local ecology. Similar finds from late antique sites in Italy confirm that *Castanea sativa* was a winning species in late Roman times.

The dissemination of a new food always involves a cultural shift for the adopters. But late antique willingness to eat chestnuts ultimately seems to have depended on economics. Growing chestnuts is a low-labor activity, especially compared to growing grain, and in the increasingly depopulated western Mediterranean, farmers and landowners embraced a plant that offered a lot of benefits without requiring much maintenance.

Further Reading

E. Allevato, et al., "The Contribution of Archaeological Plant Remains in Tracing the Cultural History of Mediterranean Trees," *The Holocene* 26, 4 (2016), 603–13 describes recent chestnut finds in the Roman harbor of Naples. M. Buonicontri, et al., "The Transition of Chestnut (*Castanea sativa* Miller) from Timber to Fruit Tree," *The Holocene* 25, 7 (2015), 1111–23 on the basis of shell finds postulate a Carolingian-era expansion of chestnut consumption in most areas of Italy. M. Conedera, et al., "The Distribution of *Castanea sativa* (Mill.) in Europe, from its Origin to its Diffusion on a Continental Scale," *Vegetation History and Archaeobotany* 13 (2004): 161–79, gives the big picture on European chestnuts' history. A. Martínez Jiménez, "Monte Barro: An Ostrogothic Fortified Site in the Alps," *Assemblage* 11 (2011): 34–46, tidily describes the site and its function. P. Squatriti, *Landscape and Change in Early Medieval Italy: Chestnuts, Economy, and Culture* (Cambridge, 2013): everything you wanted to know but never dared to ask about early medieval chestnut cultivation in Italy.

1: Jerusalem
2: Bethlehem
3: Dead Sea
4: River Jordan
5: Jericho
6: Jacob's Well
7: Mediterranean Sea
8: Mount Sinai
9: Nile Delta
10: Hebron

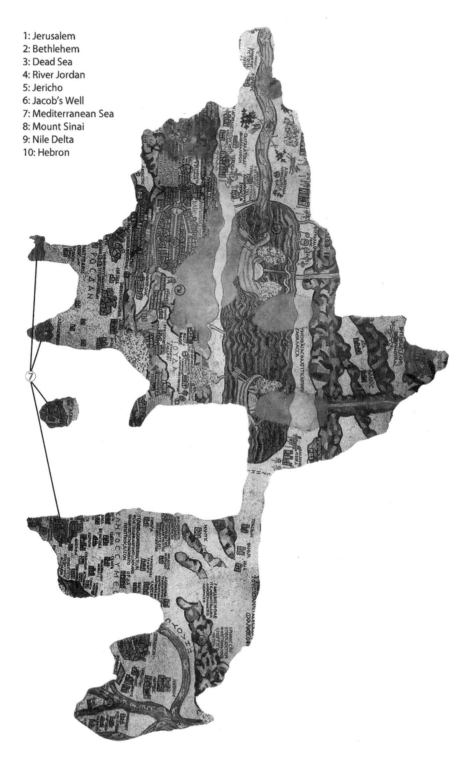

Thing 13A. The Madaba Map Mosaic, overview. By Bernard Gagnon,
Wikimedia Commons, modified by the authors.

13. The Madaba Map Mosaic

Church of St. George, Madaba, Jordan, ca. 550 (after 543)

At the end of the nineteenth century, workers uncovered parts of a once-vast mosaic pavement lying beneath the modern floor of the dilapidated Church of St. George in Madaba, a vividly colored carpet of geographical features, mountains and rivers, cities and towns and landmarks, meticulously labeled with their names in Greek. It was an illustrated map, which originally spanned the full sixteen-meter (fifty-two-foot) width of the underlying sixth-century church. Though much of it was damaged beyond repair, the surviving sections depicted a vast sweep of territory, stretching from the Nile Delta to the biblical lands of modern Israel, Lebanon, Jordan, and Syria. People entering the church from the west and heading in the direction of the altar and apse in the east would have encountered the geographical panorama at their feet as though approaching the east coast of the Mediterranean by ship from the west.

The dating of the pavement depends on the date of the Basilica of St. Mary at Jerusalem, funded by the emperor Justianian and completed in 542 or 543. The church provides what scholars call a *terminus post quem*, Latin for "date after which"; because the makers of the map knew to show it in its proper place in Jerusalem, the whole mosaic must have been completed sometime after 543 (probably quite soon after, within the next fifty years or so).

Jerusalem is shown larger and in greater detail than any other city on the map. Prominently labeled (in Greek) "The Holy City Jerusalem," it stood in the very center of the mosaic pavement, reflecting the Christian conception of Jerusalem as the navel (*omphalos* in Greek), the center, of the universe. In the very center of Jerusalem there appears the complex of buildings erected by the emperor Constantine in the fourth century on the site of the Holy Sepulcher, the cave at the foot of the rocky outcrop (Golgotha) associated with the burial and resurrection of Jesus. The principal features of the Holy Sepulcher complex are clearly distinguishable. From the bottom (west) up, we see the dome of the octagonal Rotunda of the Anastasis ("resurrection"), built over the tomb. Across an open courtyard, there is the larger, rectangular basilica dedicated to Christ the Savior, fronted by a wide stairway leading from the main street to three entrances in its front porch, or *narthex*.

This layout of Jerusalem with the Holy Sepulcher at its center does not, in fact, match the real layout of the city. The Temple Mount, the prominent plateau on which the Hebrew Temple had stood until the Romans destroyed it in AD 70, is not shown; and the Holy Sepulcher was moved south of its actual location so that it forms the geometrical center of the oval. Other features of the city, however,

are quite accurately represented. This is especially true of the most prominent architectural feature, the wishbone-shaped profile of two principal streets converging on the north (left) gate of the city, today the Damascus Gate. The mosaic reproduces the actual configuration of these streets, which still follow the same course today as in the sixth century, almost perfectly. Especially prominent is the *cardo maximus* (main north-south street). Lined along both sides with white columns supporting a red-tile roof, it is a typical example of the grand, colonnaded avenues found in the greatest cities of the Byzantine Empire in the sixth century. Called *plateiai* in Greek, these streets were very wide—twenty meters (sixty-five feet) and more in some cases—and paved with stone slabs. The colonnades along the sides supported a roof over a covered sidewalk, which provided shelter from winter storms and summer sun. Behind stood continuous rows of shops, facing outward onto the covered sidewalks.

The shopping arcades of their day, these streets were also the heart of civic life, the routes that attracted the greatest crowds and a constant flow of traffic traversing the city center. Statues of the emperors and their families, imperial officials, and the most prominent local celebrities clustered along them, as did larger monuments: fountains, triumphal arches, freestanding columns, palaces, and churches. The size and grandeur of the plateiai also made them the preferred location for public events and ceremonies, especially the processions celebrating occasions such as the anniversary of a city's founding, the birthday of the reigning emperor, the arrival of a governor or bishop, and religious holidays such as Christmas, Easter, and the feast days of prominent saints.

At Jerusalem, these religious processions often began from the churches at the Holy Sepulcher; when Justinian built the church of Mary, the location chosen for the magnificent structure, the biggest church in the city, was the opposite end of the same street. The central plateia of Jerusalem thus became a grand parade route linking the city's two most important Christian shrines, just as it is presented in the Madaba mosaic.

The decision to show Jerusalem as an ensemble of characteristic and symbolically significant features, depicted at an exaggerated scale matching their perceived importance more than their physical reality, is an important clue with regard to the purpose and inspiration of this unique map as a whole, about which there is still no consensus. As it pays little attention to roads, makes no attempt to give an accurate sense of distances, and operates at many different scales, it is hard to imagine it as a road map, a practical tool designed to facilitate travel or pilgrimage (such maps did exist). It delights in cities and towns, some shown with recognizable landmarks, and famous natural features, such as the Nile Delta and Mount Ararat. It seems a kind of picture book of the eastern Mediterranean, a cheerful compendium that presents the places and things known to the residents of Madaba in the guise of an orderly and triumphant Christian world, centered

on Jerusalem. To behold the mosaic as a churchgoing Christian was to know one belonged to this world; to understand, literally, where one stood.

Further Reading

On the mosaic itself, see M. Avi-Yonah, *The Madaba Mosaic Map with Introduction and Commentary* (Jerusalem, 1954); H. Donner, *The Mosaic Map of Madaba: An Introductory Guide* (Kampen, 1992); M. Piccirillo and E. Alliata, eds., *The Madaba Map Centenary, 1897–1997* (Jerusalem, 1999). More generally on cartography and pilgrims' maps in late antiquity, see Y. Tsafrir, "The Maps Used by Theodosius: On the Pilgrim Maps of the Holy Land and Jerusalem in the Sixth Century C.E.," *Dumbarton Oaks Papers* 40 (1986): 129–45. On colonnaded main streets in late antique cities, see H. Dey, *The Afterlife of the Roman City* (Cambridge, 2015): 65–126, along with Libanius's evocative late-fourth-century description of Antioch's main streets: G. Downey, "Libanius' Oration in Praise of Antioch," *Proceedings of the American Philosophical Society* 103 (1959): 652–86.

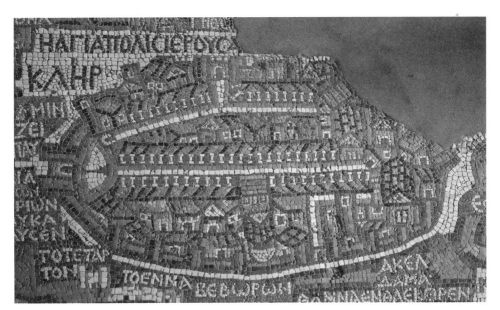

Thing 13B. Madaba Map Mosaic: the city of Jerusalem. Photo H. Dey.

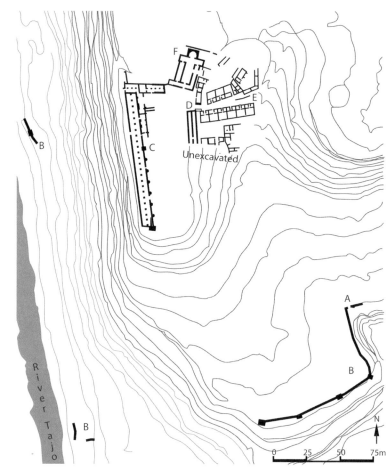

Thing 14A. Recopolis, city plan.

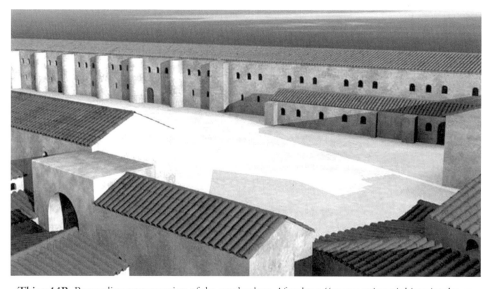

Thing 14B. Recopolis: reconstruction of the royal palace. After http://www.patrimoniohistoricoclm.es.

14. The City of Recopolis

Spain, late sixth century

In the arid upland plains of central Spain, on a bluff overlooking the river Tajo, the Visigothic king Leovigild (r. 569–86) began a project traditionally reserved for Roman (and Byzantine) emperors, especially the great ones: he built a city from scratch. Lest anyone miss the connection, he named it after his son and heir, Reccared (r. 586–601). Recopolis (the *polis*, Greek for "city," of Reccared) thus took its place alongside cities such as Alexandria, founded by Alexander the Great, Hadrianopolis, and most famously of all, Constantinopolis, the Byzantine capital, dedicated in the name of Emperor Constantine in AD 330.

Work at Recopolis began in or shortly after AD 578, when Leovigild triumphantly concluded a series of military campaigns that consolidated his rule over most of the Iberian Peninsula, with the exception of a Byzantine-held coastal strip in the southeast. While work continued over many years, probably decades, Recopolis was conceived and laid out according to a single master plan: the contours of its principal structures were outlined by ditches before construction started, as the archaeologists working on the site have shown. The heart of the city was the palatial quarter situated at the crest of the bluff, looming over the residential neighborhoods on the lower slopes below and the surrounding plain. The palace itself centered on a long, rectangular courtyard flanked by two-story structures on both long sides. The north hall, the best-preserved and excavated of the two wings, measured 133 meters long by more than 9 meters wide (about 540 by 30 feet). Like the rest of the palace, it was built of sturdy, mortared stone, with concrete vaults covering the less opulent ground floor, which was apparently reserved for administrative activities. The upper floor, adorned with sculptures and ornate columns, appears to be where the city's rulers lived and conducted official business. The other building facing onto the plaza at its short, eastern end was the city's principal church, a basilica built in mortared masonry, whose cruciform plan recalled, probably not coincidentally, the Church of the Apostles in Constantinople.

The palatial quarter was accessed by a grand gateway, like a Roman triumphal arch, at the end of the city's main street, which ran upslope from the one known gate in the lower city wall. Like the main street at Constantinople, the Mese, the final tract of the street before it reached the palace gateway was lined with stores and workshops. Below stretched residential and commercial neighborhoods, all contained within the sweep of the city walls, thickly built, studded with towers, and, like the palace, covered with a layer of whitish mortar that glowed like marble in sunlight. Cisterns supplied the dwellers in the lower city with water, while an

aqueduct brought fresh water to the palace quarter from springs some two kilometers away.

Recopolis was both the result and the proof of Leovigild's success in establishing himself as the ruler of a centralized state. His government could provide the infrastructure, logistical support, and above all the money, derived both from efficient taxation and tribute exacted from subdued enemies, necessary to launch such an ambitious project. There were undoubtedly practical reasons for undertaking such a costly and labor-intensive initiative, among them projecting royal authority in an under-urbanized area of the kingdom, and creating a new capital far removed (and safe) from the traditional power bases of the church and the nobility. In this sense, Recopolis might be said to resemble "artificial" modern capitals such as Washington, DC, Brasilia, and Canberra, or tsarist St. Petersburg. But symbolic and ceremonial considerations were clearly also important, maybe even preeminent. In addition to likening himself to other illustrious city founders, Leovigild promoted his own family dynasty by naming the place after his son and heir. Further, by modeling Recopolis on Constantinople, he created an urban stage on which he and his successors could emulate the pageantry of the Byzantine imperial court, the ultimate model and inspiration for western European kings in the sixth century.

For Bishop Isidore of Seville, writing fifty years after the foundation of Recopolis, all these factors were implicitly connected: "[Leovigild] first swelled the treasury with the plunder of the citizens and the spoils of war. He also founded a city in Celtiberia, which he called Recopolis from the name of his son. And he was the first to sit on a throne covered in royal garb among his people, while prior to him kings did not set themselves apart from the people by their clothing or their conduct" (*History of the Goths*, chap. 51). Military, political, and economic domination, followed by a new city, followed by ceremony: it is hard not to think that the main street culminating in the triumphal archlike gateway to the palace at Recopolis was conceived as a space for Leovigild and his successors to parade in ceremonial splendor, just as their imperial Byzantine archetypes did along the Mese and through the Chalke Gate at Constantinople.

Nor is Recopolis an isolated case. Leovigild himself founded another city, Victoriacum ("Victoryville"), and King Suintila (r. 621–32) later celebrated a victory over the Basques in the Pyrenees by forcing the losers to build another new city, Ologicus. All testify to the continuing, even increasing symbolic and ideological prominence of cities in Visigothic Spain. This point needs to be emphasized because until recently, most scholars viewed the so-called Dark Ages following the fifth-century breakup of the Roman Empire as a period when cities everywhere disintegrated and a rural world of small villages and farms arose. True, Spanish cities were fewer and smaller in the sixth and seventh centuries than in the first and second, but they retained their urban functions: leading

civic and religious leaders continued to live in them, even during the particularly chaotic period between the end of Roman government in Spain in the mid-fifth century and the consolidation of the Visigothic kingdom in the mid-sixth. Rulers found that they could still function best, and *look* most like rulers, in cities, in front of crowds. Long after Rome's "fall," Mediterranean history continued to be made in cities.

Further Reading

The most accessible English-language description of Recopolis and the ongoing excavations there is L. Olmo Enciso, "The Royal Foundation of Recópolis and the Urban Renewal in Iberia during the Second Half of the Sixth Century," in *Post-Roman Towns, Trade and Settlement in Europe and Byzantium*, edited by J. Henning (Berlin, 2007), vol. 1, 181–96. The essays in G. Ripoll and J. Gurt, eds., *Sedes Regiae (ann. 400–800)* (Barcelona, 2000), discuss barbarian kings' residences and sites of power. Generally on cities and urbanism in Spain in late antiquity, see M. Kulikowski, *Late Roman Spain and Its Cities* (Baltimore, 2004). For the persistence of cities during the "Dark Ages" across much of the former Roman Empire, see H. Dey, *The Afterlife of the Roman City: Architecture and Ceremony in Late Antiquity and the Early Middle Ages* (Cambridge, 2015), chap. 4. For the history of the Visigothic kingdom, R. Collins, *Early Medieval Spain: Unity in Diversity, 400–1000* (New York, 1983), has yet to be surpassed.

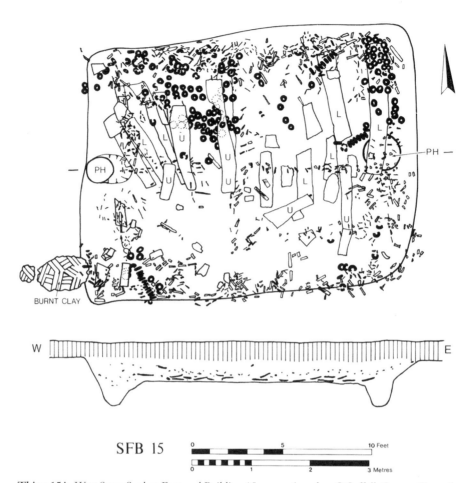

SFB 15

Thing 15A. West Stow, Sunken Featured Building 15, excavation plan. © Suffolk County Council.

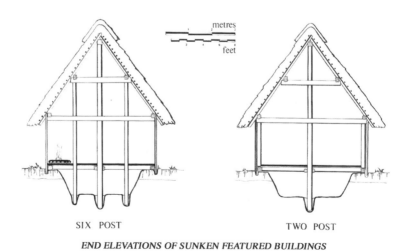

SIX POST TWO POST

END ELEVATIONS OF SUNKEN FEATURED BUILDINGS

Thing 15B. Reconstruction of a sunken-featured building at West Stow. From S. E. West and V. Cooper, *West Stow: The Anglo-Saxon Village* (Ipswich, 1985). © Suffolk County Council.

15. Sunken Featured Building from West Stow

England, late sixth/early seventh centuries

Sunken Featured Building (SFB) 15 was a structure excavated at West Stow, in eastern England, where an early Anglo-Saxon village once stood. The village was occupied from the early fifth to the late seventh centuries AD, after which it was abandoned. In the fourteenth century, a storm buried the site in a meter (three feet) of sand, preserving the remains, which were discovered in the nineteenth century and scientifically excavated between 1957 and 1972. SFB 15 had burned down in the late sixth or early seventh century and was not rebuilt, which means that its carbonized contents were well preserved.

In Anglo-Saxon England, as in much of early medieval Europe, most buildings were made of wood. In many parts of Europe, the Roman quarrying, brick- and cement-making industries had disappeared after the fourth century, so those materials could only be obtained by reusing Roman materials from abandoned buildings. Wooden buildings could be very large and elaborate, or they could be simple and temporary. Because wood decays, no wooden buildings survive from this period, but they can be hypothetically reconstructed thanks mostly to archaeological excavation of the holes that once held their upright posts (postholes).

SFB 15 represents a type of building that is found in many parts of Europe from the fifth to the ninth centuries, known also by the German word *Grubenhaus*. Archaeologically, all that remains of these structures is a roughly rectangular pit, typically measuring some four meters long by three meters wide (ten by thirteen feet), and 0.3–0.5 meters (1–1.5 feet) deep. Within the pit are two to six postholes.

The SFB emerged in central and eastern Europe and around the North Sea in the late Roman period. SFBs of a fairly uniform type found in central and eastern Europe from the early sixth century on were used as houses (see Thing 37). A different type appeared in northern Europe outside the Roman Empire from the first century AD, and then spread into Roman or formerly Roman areas, including England, France, Italy, and Spain; they became especially common from the mid-fifth century on. This sort of structure continued to be used until the tenth century, after which it largely disappeared. Archaeologists have often associated these two types with "Slavic" and "Germanic" cultures, respectively, not least because they proliferated at the same time as the Slavic and Germanic peoples are documented in these territories.

What type of building is represented by these remains? Interpretation has been controversial. Until the 1960s, it was thought that the floor of the pit was the floor of the building, perhaps lined with boards or skins, and covered with an

A-frame-type roof. Because the roof material would have contact with the damp ground, it was assumed that such structures were fairly short lived.

However, findings at West Stow, such as pit floors with no evidence of wear, entrances, or linings, and experimental reconstruction of such buildings, convinced Stanley West, the director of the West Stow excavation, that actually the pits were covered with floors made of wooden planks, and that the posts held up a roof constructed over side walls that did not utilize posts. West suggested that the purpose of the pit was to improve air-circulation, to keep the floor drier, or perhaps to be used for storage. SFB 15, which had burned down, contained the remains of various layers of planks, some of which may have been used on the walls, but some of which he interpreted as having constituted the floors. However, other scholars have noted that the evidence for plank floors is by no means conclusive, and that making such floors would have represented a large investment of labor and materials. Also, on the European continent, there is evidence for hearths, trampling, and other use of the pit's floor as a floor. Thus, the jury is still out on exactly what average SFBs looked like, and the reconstructions of West Stow's SFB 15 are not accepted by all specialists.

West Stow's layout is typical of other early Anglo-Saxon settlements: at any given time, it probably had two or three larger hall-type buildings without a pit, each of which was surrounded by several SFBs. The assumption is that such an arrangement housed two or three families. SFB 15, a two-posthole SFB, was associated with Hall 2, which, at various points during its history, had about 12 SFBs surrounding it. These SFBs were not only used as living quarters. Some contained hearths, indicating their use in cooking or metalworking; in others, burned grain implies that they were used for storage.

SFB 15 appears to have been used as a weaving house. When it was destroyed, the structure contained at least 150 clay loomweights, doughnut-shaped objects that were tied to the warp threads of looms to weigh them down. Some of the loomweights were in use on looms when the building caught fire, others were being kept in reserve. Contemporary law codes from the continent mention *screona*, or buildings where women worked, which are often interpreted as this type of weaving shed. Thus, the sheep whose bones were found at West Stow were probably used for wool as well as meat, and cloth was woven here, presumably for domestic consumption.

Further Reading

Publication of the West Stow excavations is found in S. E. West and V. Cooper, *West Stow: The Anglo-Saxon Village* (Ipswich, 1985). On the varied interpretations of SFBs, see especially H. Hamerow, "Anglo-Saxon Timber Buildings and Their Social Context," in *The Oxford Handbook of Anglo-Saxon Archaeology*, edited by H. Hamerow, D. A. Hinton, and S. Crawford (Oxford, 2011), 130–57.

PART IV

Things of the Seventh Century

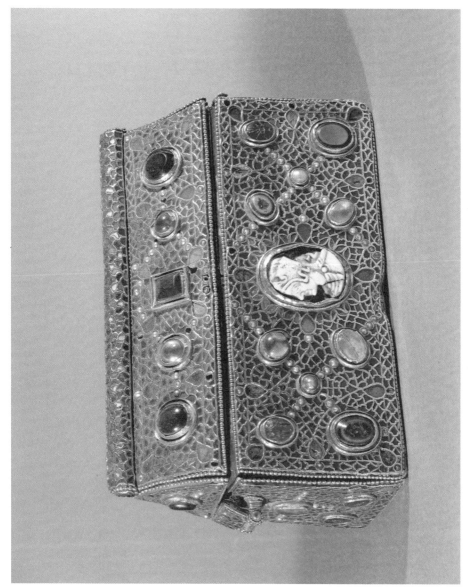

Thing 16. Theuderic Reliquary from Abbaye St. Maurice, Agaune. Photo Credit: Erich Lessing/Art Resource, NY.

16. The Reliquary Casket of Teuderic

Agaune, Switzerland, seventh century

One of the most stunning objects to have survived from early medieval France is the so-called Reliquary Casket of Teuderic, which belongs to the monastery of Saint Maurice in Agaune in Switzerland. Saint Maurice was the leader of the Theban Legion in the Roman army; according to tradition, the entire legion converted to Christianity and all were martyred at Agaune in the year 286 when they refused to sacrifice to the emperor. A shrine existed in Agaune to these martyrs by the mid-fifth century, and in 515 King Sigismund of Burgundy founded a monastery there and richly endowed it with gifts and property, which helped to ensure its success throughout the early Middle Ages. Saint Maurice's endurance as a religious community down to the present has enabled the abbey to preserve a number of precious medieval objects in its treasury.

The Casket of Teuderic is a reliquary, that is, a casket designed to hold the relics of a saint, presumably of Saint Maurice. We do not know what relics were kept in the casket, whether parts of the saint's body or fragments of his clothing or other objects associated with him; in late antique Christian circles, all of these became powerful tokens of dead holy people's continued presence among the living. The casket's function as a container of things that were part of or had touched the body of Saint Maurice is confirmed by the inscription made on its back side, with each letter set into squares of a grid, reading as follows:

TEVDERIGVS PRESBITER IN HONVRE SCI MAVRICII FIERI IVSSIT. AMEN. NORDOALAVS ET RIHLINDIS ORDENARVNT FABRIGARE. VNDIHO ET ELLO FICERVNT.

The priest Teuderigus ordered this to be made in honor of St. Maurice. Amen. Nordoalaus and Rihlindis arranged for it to be fabricated. Undiho and Ello made it.

Three sets of people are honored here: the priest Teuderic who had the idea to make the reliquary; the couple Nordoalaus (a man) and Rihlindis (a woman) who paid for it, and Undiho and Ello who were presumably the artisans who actually made it. None of these individuals is known from any other source, although their names are not unusual for this region. The casket is thought to date to the mid-seventh century, based on the forms of the letters in this inscription as well as the techniques of manufacture of the object.

The casket itself measures 12.5 by 19 by 6.5 centimeters (5 by 7.25 by 2.5 inches). Its core is silver, but the sides are covered with thin gold plates with gold strips welded to form a cell-pattern of a symmetrical cloisonné design. On three sides and the lid, the cells are set with thin slices of garnet and blue and green glass, with some white and green enamel and pearls. Set within this pattern are larger cabochons of red glass, quartz, sapphire, garnet, and also carved intaglios of carnelian, chalcedony, and onyx. At the center of the front face is a large "pseudo-cameo" of white glass upon black ("pseudo" because it was made in two layers of glass rather than cut from one piece of stone). Many of the larger stones and intaglios are reused from older, even Roman-era, jeweled objects, but the pseudo-cameo was made in the early seventh century. Perhaps the person depicted on the cameo was intended to represent Saint Maurice.

By the seventh century, theological interpretations of gemstones were widely known, and objects like this would have been thought similar to objects mentioned in the Old Testament's description of the Temple of Solomon; indeed, many of the specific gems on the reliquary are mentioned in the Bible (Ex. 28:17–20, Ex. 39:10–13, and Rev. 21:19–20). The almost contemporary Crown of Recceswinth (see Thing 23) also featured garnet cloisonné and reused gemstones, but while that crown was donated by a king, this reliquary seems to have been the fruit of less exalted (although perhaps no less wealthy) patrons. It is particularly notable that this object uses so many garnets, because by the seventh century, the garnet trade from India had dried up and garnets came from Bohemia.

This splendid reliquary was intended for display; it, and the relics in it, would probably have been kept it the treasury of the monastery, and placed on feast days on the altar of the church. The wealth displayed on a reliquary such as this visually demonstrated the holiness of the relics, representing their power through the wonder evoked by the value of the gold and gems. An object such as this also testified to the importance of the relics to a broad sector of society, including wealthy patrons such as Nordoalaus and Rihlindis, and secured lasting praise for them as donors.

Further Reading

Very little has been published on this casket in English; for some discussion, see C.J. Hahn, *Strange Beauty: Issues in the Making and Meaning of Reliquaries, 400–circa 1204* (State College, PA, 2012), esp. 103–10. The main publication is E. Antoine-König and D. Antille (eds.), *Le Trésor de l'abbaye de Saint-Maurice d'Agaune* (Paris, 2014). On the cult of relics in this period, see P. Brown, *The Cult of the Saints* (Chicago, 1981).

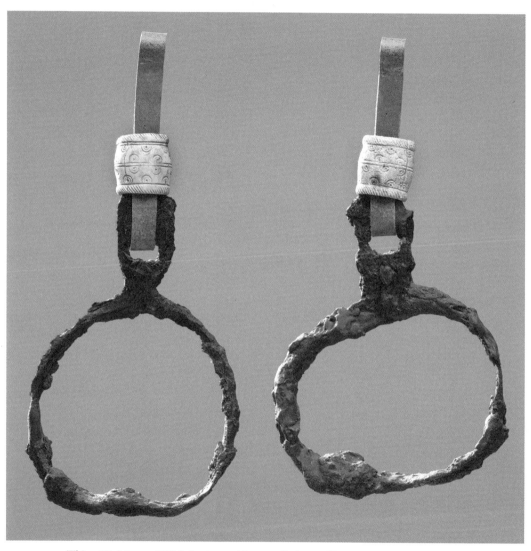

Thing 17. Stirrups. BHM, Aquincum Museum, Budapest, Hungary. Inv. no.: 83.1.66–67.
Photo: Bence Tihanyi.

17. Stirrups

Hungary, seventh–eighth centuries

This pair of dull steel stirrups, shown with recreated leather straps and original red deer antler strap loops in the Budapest History Museum, dates to the seventh–eighth centuries. Since they were interred with a man and a horse at a site along the Szőlő utca in Budapest, corrosion and compression have much altered their original appearance, contributing to lumpy, irregular surfaces and asymmetries. The left stirrup's footrest incorporates a metal gob and its hanging "ring" is not tapered. They were asymmetrical to begin with, because production was not standardized: the larger one weighs 190 grams (6.7 ounces), the smaller one just 130 grams (4.5 ounces). But these unornamented stirrups were likely working instruments, not made just for burial display, as even the smaller one's internal diameter of over 10 centimeters (over 4 inches) is sufficient for a human foot. Their "apple" shape is typical of an early design that seems to have originated in central Asia but is often excavated in modern Hungary, where the Avar steppe nomad confederation ruled from the late sixth century until routed in the 790s by the armies of the successful Frankish king, and empire builder, Charlemagne (d. 814). Whether the Avars imported smiths and techniques, or only equipment, when they settled in central Europe, the quality of their steel was exceptionally high. Though this initial quality deteriorated over the course of the seventh century, Avar stirrups were expected to endure the strain of a rider's weight and force. These were not mere aids to mounting and represented an evolution from earlier models with narrower footrests and slight construction, of wood or leather. Strung over the flank of a horse from a saddle, "apple" shaped steel stirrups afforded a solid base to a human foot, stabilizing the rider and permitting many maneuvers that the stirrupless found very challenging.

Until Lynn White Jr. noticed it, few had paid attention to this innovation. In a lecture that became the first and most famous chapter in his 1962 classic *Medieval Technology and Social Change*, White argued that the introduction of the stirrup to Francia around 730 made "mounted shock combat" possible for the first time in European history. To White, a small technological adjustment turned Frankish horsemen into a new fighting "organism" that fused the potential of two creatures into one fearsome force. Stirrups, he thought, not only gave cavalry a lasting tactical advantage over infantry, but also caused a social and cultural revolution that much later was called feudalism. According to White, the high costs of training and equipping an armored knight were sustainable only through a complex system of land grants to the rider by his ruler, who expected mounted military service in

return. Europe's medieval aristocracy, in effect, emerged from the peculiar chain of interdependence between men, horses, and fodder plants that the stirrup catalyzed, and which the Frankish Carolingian dynasty first exploited.

White's bold stirrup hypothesis, lucidly outlined in a prize-winning book, attracted much attention, as well as skepticism. While archaeologists have carped at White's vagueness on the process of this technology's dissemination, military historians have wondered how decisive the stirrup was to Frankish success. Stefan Weiss agreed with White about the revolutionary potential of military technology but argued that he had focused on the wrong one: eighth-century Frankish armies repeatedly crushed their enemies because they had long swords, made cheaply of reasonable quality steel thanks to social and environmental conditions leveraged by the Carolingian dynasty. Other scholars of medieval combat pointed out that at least two hundred years separated the diffusion of stirrups in Western Europe and effective use of the heavy cavalry charges that made eleventh-century European aristocrats so formidable. Therefore, they reasoned, stirrups were not a Byzantine-mediated introduction to Francia of the eighth century, as White postulated. Rather, they were a late sixth-century importation to central Europe from the steppes: Alamannic, Bavarian, and Lombard elites in the hybrid "middle ground" of the mid-Danube valley eagerly adopted them, presumably from the Avars, and included them in their tombs, often along with favored horses. The appearance of stirrups occasioned no sweeping military or social changes around the Danube during the seventh or later centuries.

It is indeed difficult to discern causal connections between technology, fighting style, and social mutations like the rise of a new-style aristocracy. Stirrups have been found on numerous Balkan sites from around 600, and Maurice's *Strategikon*, a military manual written exactly then, confirms that Byzantine troops with no penchant for inter-aristocratic agreements (for White, the basis of European feudal relations) used this bit of equipment. The Avars, the first European users of stirrups, fought excellently with neither "mounted shock combat" nor exchanges between elite men of land for military service, while heavy Sasanian cavalry was highly effective in late antiquity without the benefit of stirrups, which thus could not alone have catapulted cavalry to supremacy. In fact improved saddles with high pommels and cantles, available in Europe long before the Frankish rise to power, were a more important technology for giving riders the ability to fight from horseback.

Even those who accepted that stirrups might spark social change have doubted it would happen as mechanically as White imagined. They showed that the arrival in China of the same technology in the fourth to sixth centuries did not produce the sweeping shifts White's model predicted. After an initial period when a new military elite gained power, China's central government reasserted control over security and defense, and nothing remotely resembling the decentralization of

power often associated with European feudalism ensued from the introduction of the new riding equipment.

Yet more than half a century after its publication, White's correlation of technology and social power still enlivens debate on the social and technological differences between ancient and medieval times. During the early Middle Ages, stirrups made real, as White put it, the ancient myth of the Centaur, a man-horse. But they did so between about 550 and 1050 in a messy process of dissemination and adaptation, not in a flash of Carolingian genius.

Further Reading

R. Abels, "The Historiography of a Construct: 'Feudalism' and the Medieval Historian," *History Compass* 7 (2009): 1008–31, is a handy introduction to scholarly disagreements about feudalism and its relevance for medieval history. P. Contamine, *War in the Middle Ages* (Oxford, 1984), now in its sixth French edition (2003), contains five lucid pages on the "problem" of the stirrup. F. Curta, "The Earliest Avar-age Stirrups, Or the Stirrup Controversy Revisited," in *The Other Europe in the Middle Ages*, edited by F. Curta and R. Kovalev (Leiden, 2008), 297–326, clears up uncertainty on Avar archaeology. M. Decker, *The Byzantine Art of War* (Yardley, 2013), discusses Byzantine cavalry and their adaptation of steppe nomad equipment. V. La Salvia, "Germanic Populations and Steppe People, an Example of Integration of Material Cultures," *Chronica* 11 (2011): 78–95, contains meticulous description of stirrup-laden burials from Bavaria, the Alps, and Italy, and reconstructs their provenance. J. Sloan, "The Stirrup Controversy," legacy. fordham.edu/halsall/med/sloan.asp, is a thoughtful 1994 University of Kansas post, with bibliography, on postclassical war and stirrups. L. White, *Medieval Technology and Social Change* (Oxford, 1962), 1–38, the most stimulating pages ever written about stirrups, in the book that launched the study of medieval technology. For Weiss's critique of White, see Stefan Weiss, "Le fer et l'acier. Remarques sur l'innovation technique et la conduite de la guerre au début de l'époque carolingienne," *Francia* 35 (2008): 33–47. S. Worthen, "The Influence of Lynn White Jr.'s *Medieval Technology and Social Change*," *History Compass* 7 (2009): 1201–17, nicely surveys the literature.

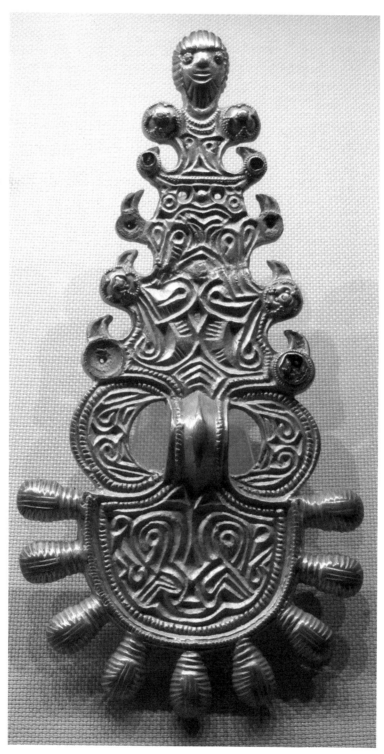

Thing 18. Coşovenii de Jos fibula. Photo by Sailko,
Wikimedia Commons.

18. The Coşovenii de Jos Bow Fibula

Coşovenii de Jos, Romania, sixth–seventh centuries

Sometime before 1932, a deposit of objects including this brooch was unearthed on a farm in the south Romanian village of Coşovenii de Jos. The mayor of nearby Craiova acquired it, so when the objects were published in 1938 the find was called the Negrescu Treasure after him (they have since made their way to the National History Museum in Bucharest). Because of the informal circumstances of its excavation, important details about the deposit's context are now lost, but it likely accompanied a burial. Regardless, the Coşovenii de Jos hoard included several rings, earrings, and a necklace, though its most impressive content was this fibula, or brooch. The brooch is unusually large, measuring almost ten centimeters (four inches) across and twenty centimeters in length (eight inches, a little longer than a new pencil). Many other fibulas exist from the Danube region, but are bronze, not gilt silver like this one. The Coşovenii de Jos fibula is also decorated to more exacting standards than normal. Its headplate (the wider, oval portion) is incised with a delicate geometrical interlace and marked off by an elegant string of dots that continues onto the raised "bow" linking the headplate to the triangular footplate. Two crescents flank the "bow," also incised with matching P-shaped geometries. Around the headplate radiate nine knobs, carefully etched with lines. In contrast, the edges of the footplate end in four elegant, stylized pairs of birds' heads, each pair distinguished by matching eyes (the second and fourth pair's eyes are best preserved), and two jeweled knobs joined by bands of dots just before the terminal bearded human head. The engraving on the footplate is abstract, but evokes bird plumage and wings.

The example from Coşovenii de Jos is exceptional in scale, material, and workmanship, but fibulas were everyday items in the early Middle Ages. A fibula is a glorified safety pin, even if those excavated often have lost the pinning mechanism on the back (as this one has). In the Roman Empire soldiers used simple fibulas to hold their cloaks in the approved position. In late antiquity increasingly elaborate fibulas became fashionable inside and outside the empire, probably affixed at the shoulder to hold peoples' clothes up. Thousands have surfaced and been catalogued, and in 1950 the German archaeologist Joachim Werner proposed an influential classification of their different types that still holds sway. Its form and decoration makes the Coşovenii de Jos brooch a (rather fancy) Werner type I B, which Werner dated to the seventh century and which have been found mostly in the Balkans.

Werner was convinced that such brooches were markers of ethnicity, and in particular that all "bow" fibulas, with their characteristic arch joining head- and

footplate, should be associated with those sixth- and seventh-century immigrants into the Balkans and Central Europe today called Slavs. But since the 1970s archaeologists have tended to avoid ethnic interpretations of early medieval artifacts. Indeed, there is little correlation between textual evidence for the presence of Sclavenes (what early medieval writers called populations we identify as Slavs) and "bow" brooches' find spots. In addition, the material culture of areas where "Slavic" brooches are found is heterogeneous and fibulas characterize it less than do clay ovens and finger-printed earthenware pots.

To replace the ethnic interpretation of the fibulas, scholars have suggested that the brooches allowed early medieval people to signal other aspects of their social identity, in particular status, gender, age, and maybe kinship. If their position in graves is a rough guide to how living people used them, the brooches were worn at shoulder height on the outermost layer of clothing, and so were very visible. Further, when it is possible to tell the gender and age of the deceased, fibulas seem to predominate among adult women, though this correlation is far from perfect. In funerals fibulas would have been visible for a short time, and mostly to the people who handled the body, likely kin. Though the Coşovenii de Jos fibula was broken in two between the second and third pair of birds' heads, it is in fine condition; at burial many others were old and worn, perhaps reminding family members of particular, intimate aspects of the deceased's life.

In the region north of the lower Danube, sixth- and seventh-century burial rites have left very scant traces. Instead, excavators find brooches in the tiny rural settlements of the period, hamlets that moved every few years in search of more fertile land. In such communities few households had fibulas. This reinforces archaeologists' belief that "bow" fibulas reflected high social status. A fibula as big and lovely as the one from Coşovenii de Jos could have worked like a flashily displayed latest-model designer handbag, making public an individual's wealth, power, and awareness of fashion.

Stone molds found in Sweden and Ukraine help to account for early medieval fibulas' diversity: no two are exactly alike. In molds, jewelers shaped wax models to use in casting. Thus head- and footplates could be mass produced, and then finished with chip carving, or filigree (as around the bird eyes in this fibula), or gilding, according to a patron's desire. Patterns in the distribution of particular styles and ornamentation in the lower Danube area, and nearby, suggest that fashions in fibulas, and the fibulas themselves, moved fast over large distances in the decades around 600. Whether merchants carried these special, very personalized wares, or whether they moved in the clothing of women who married outside of their home communities, it is evident that "Slavic bow fibulas" had little to do with any invasions. But a fibula like the gorgeous one discovered at Coşovenii de Jos definitely spoke to all who saw it about the economic, social, and technological resources of the woman adorned with it.

Further Reading

F. Curta, *The Making of the Slavs* (Cambridge, 2001), has a wide-ranging overview of early medieval ethnicity studies (chap. 1) and the author's original reading of the bow fibulas (chap. 6), while his "'Slavic' Bow Fibulae," *Bericht der römisch-germanischen Kommission* 93 (2012): 235–38, surveys research of the previous twenty years. B. Effros, "Dressing Conservatively," in *Gender in the Early Medieval World*, edited by L. Brubaker and J. Smith (Cambridge, 2004), 165–84, genders brooch analysis. N. Wicker, "Inspiring the Barbarians?" in *Rome Beyond Its Frontiers*, edited by P. Wells (Portsmouth, 2013), 105–20, discusses the dissemination of "exotic" decorative motifs in barbarian metalwork. H. Williams, *Death and Memory in Early Medieval Britain* (Cambridge, 2006), dedicates a section (chap. 2) to the funeral use of brooches as memory prompts.

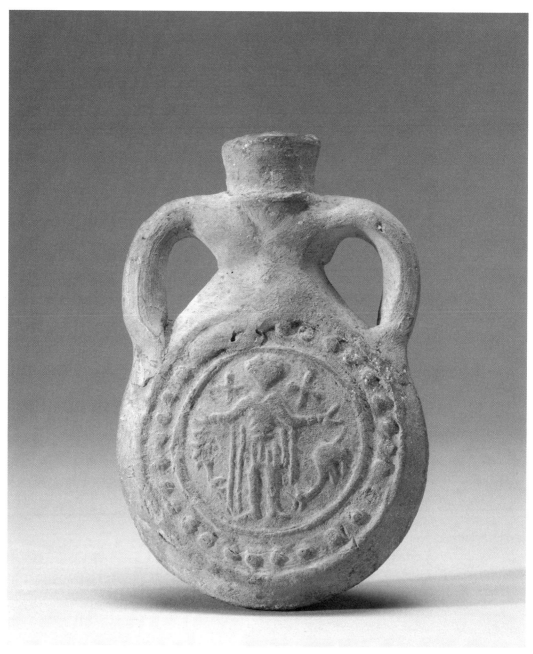

Thing 19. Pilgrims' flask (ampulla) from the Shrine of St. Menas. Photo courtesy of the Walters Art Museum, Baltimore, MD.

19. Pilgrims' Flask (Ampulla) from the Shrine of St. Menas

Abu Mina, Egypt, late sixth–early seventh centuries

This flask was made at the Shrine of St. Menas, located in the Egyptian desert about 45 kilometers (28 miles) southwest of Alexandria, by the modern town of Abu Mina. It is a small thing, 10 centimeters high by 6.7 centimeters wide (about 4 by 2.6 inches) and 2.4 centimeters (just under an inch) thick, fashioned from inexpensive terracotta and designed to be mass produced. It was made by joining two identical, frisbee-shaped disks made from a mold, to which a short handmade spout and two handles were then added before firing. Each side depicts a standing man clad in a skirt of armor with a military cloak (*paludamentum*) over his shoulders, arms extended with palms facing outward in the so-called *orans* position used by late antique Christians to denote the act of prayer. The head of the man is bracketed by two Greek crosses, and two kneeling camels appear beneath his arms; a circular border studded with raised dots frames the composition.

The praying soldier flanked by camels was the most common of all the motifs used to adorn this type of flask from the mid-fifth century to the mid-seventh. Hundreds of examples have been found: they are especially common in Egypt, the Levant, and Turkey (we have more than 150 from Alexandria alone!), but other examples have turned up as far away as western Asia, the Balkans, France, and even northern England. The soldier is Saint Menas, an Egyptian Christian serving in the Roman army in Asia Minor, who, according to legend, was executed in the early fourth century for refusing to renounce his Christianity during the last great persecution of Christians. His remains were thought to have been returned to Egypt and buried near his home at modern-day Abu Mina.

In the late fourth century, a shrine rose around the grave of Menas, which eventually grew into a sort of miniature city, complete with two churches (one of them located above the grave), a baptistery, and hostels (*xenodochia*) to house visiting pilgrims and the sick, all grouped around a large, colonnaded square at the center of the complex. Beyond sprawled houses and workshops, among them the potters' studios, complete with kilns, where Menas flasks and other ceramics were fired. During the ensuing two centuries, the cult of Saint Menas grew rapidly in popularity, judging by the large number of "Menas flasks" found throughout the eastern Mediterranean and beyond, in quantities that steadily increase over the course of the sixth and early seventh century. The type shown here was produced in the later sixth century, about a half-century before the Arab conquest of Egypt in the 640s, after which no more flasks were made at Abu Mina.

This flask was a small, inexpensive object, of no practical use to desert travelers, as it could hold only an ounce or two of liquid. Its value lay primarily in the liquid it contained: olive oil taken from lamps and other receptacles in the church built over the grave of Menas (compare Thing 29). The tradition of producing flasks to hold liquids from Christian holy places is known from dozens of other shrines starting in the fourth century. The flask advertised its contents as authentic oil from the shrine of Menas, prominently identified by the image of the saint with kneeling camels. This motif, which occurs exclusively in connection with Menas, thus functioned as a logo, a bit like a modern trademark. In addition to evoking the desert location of the shrine, it may also have invited metaphorical reflection on the flask's contents: as camels store precious water almost miraculously to sustain them in their desert wandering, so too might pilgrims retain the even more precious oil from the saint's shrine on their own travels, thanks to the flask.

The discovery of Menas flasks everywhere from western Asia to northwestern Europe powerfully illustrates the exploding popularity of what we might call "Christian tourism." Beginning in the fourth century, Christians, wealthy and humble alike, traveled in growing numbers to visit holy places, chiefly those where bones and other relics of Christian saints and martyrs resided, and returned with souvenirs of their travels. In addition to *ampullae* containing holy oil or water, these objects included glass cups and bowls with designs in gold foil layered into the base (see Thing 4), figurines, and simple metal or clay tokens bearing images and inscriptions, sometimes pierced to be sewn onto garments or worn as pendants around the neck.

The pilgrims who collected them were doubtless motivated by the prospect of adventure, by curiosity, by the longing to walk in the footsteps of legendary saints and biblical figures. Local guides were available at these sites to point visitors to everything from the charred bush in the Sinai Peninsula from which God spoke to Moses, to the manger in Bethlehem where the Christ-child was born. But most pilgrims wanted above all to approach the bodies of the saints. Proximity to bones and other relics was thought to cure sickness, banish demons, and open up a direct channel of communication between the living and the saints in heaven, for unlike the ordinary Christian dead who had to await the Last Judgment before ascending to heaven, the saints were already at God's side, even as they remained present at their earthly graves. They were intercessors who aided the living by conveying to God the prayers voiced at their shrines. While visitors to such shrines were naturally forbidden to take precious relics away with them, they could instead acquire a "contact relic," an object with little intrinsic value—bits of cloth were a popular choice, in addition to oil—that had been placed close enough to the saint's relics to absorb something of their aura.

There is no better testament to the perceived power and efficacy of Menas-infused oil than its distribution from one end of the Christian world to the other, in thousands upon thousands of flasks. The flasks also provide a valuable physical index of trade routes and movements of people in the post-Roman period: the sixth-century example discovered in 1954 at Meols in northwest England, for example, reminds us that contacts between northwest Europe and the Mediterranean continued long after the dissolution of the Roman Empire. Individual pilgrims doubtless carried many or even most of these flasks, but they traveled in other ways, too. Some may have been sent as diplomatic gifts to western leaders by the Byzantine rulers of Egypt; others were likely shipped abroad to be sold in markets like other valuable commodities, which may explain why Menas flasks in Western Europe are often found together with other imports from the eastern Mediterranean. However and wherever they traveled, these deceptively humble objects made Saint Menas a household name and extended the perceived reach of his healing powers thousands of miles from the Egyptian desert where his bones lay.

Further Reading

This particular flask is in the collection of the Walters Art Museum in Baltimore: see http://art.thewalters.org/detail/17342. For the site of Abu Mina, see P. Grossman, "The Pilgrimage Center of Abu Mina," in *Pilgrimage and Holy Space in Late Antique Egypt*, edited by D. Frankfurter (Leiden, 1998), 281–302. The UNESCO website entry on Abu Mina is also rich in useful information and photographs of the site; at the time this book was printed, the URL is http://whc.unesco.org/en/list/90. W. Anderson, "Menas Flasks in the West: Pilgrimage and Trade at the End of Antiquity," *Ancient West and East* 6 (2007): 221–43, gives a sense of how widely Menas flasks traveled, and the contexts in which they appear. On the Menas flask from Meols, see E. Campbell, *Continental and Mediterranean Imports to Atlantic Britain and Ireland, AD 400–800* (York, 2007), 74 and plate 38. G. Vikan, "Early Byzantine Pilgrimage 'Devotionalia' as Evidence of the Appearance of Pilgrimage Shrines," in *Akten des XII Internationalen Kongresses für Christliche Archäologie, Bonn, 22–28 September 1991* (Münster, 1995), 77–88, addresses the various types of pilgrims' souvenirs. On the worship of saints in late antiquity, P. Brown, *The Cult of the Saints: Its Rise and Function in Latin Christianity* (Chicago, 1982), remains fundamental.

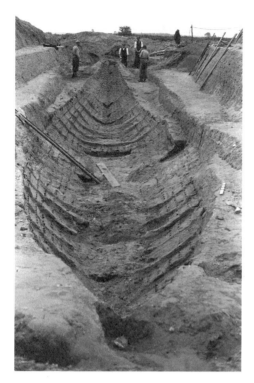

Thing 20A. Sutton Hoo, Suffolk, England. Photograph of the excavation of the ship burial in Mound 1, in 1939, looking west. © The Trustees of the British Museum/Art Resource, NY.

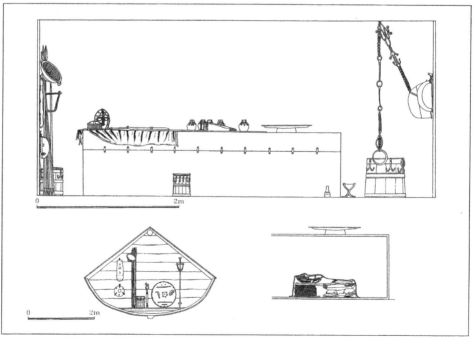

Thing 20B. Sutton Hoo, Mound 1, reconstruction of the burial. Artist: James Brennan. Reproduced from Martin Carver, *The Sutton Hoo Story: Encounters from Early England* (Woodbridge, Suffolk, 2017), 140.

20. Sutton Hoo, Mound 1 Ship Burial

Sutton Hoo, England, early seventh century

In 1939, archaeologists investigated the largest in an assembly of seventeen mounds on a ridge that overlooks the River Deben, in East Anglia, England. They discovered an intact burial site dating to sometime after 613, of what had clearly been a high-status man. The body had been buried in a wooden chamber in a ship that was 27 meters (88.5 feet) long, and over 4.5 meters (15 feet) wide. Neither the body nor the wood from the ship survived in the acid soil, but the outlines of the beams and planks could be clearly seen against the sand, and its more than three thousand iron rivets were still in place. While some scholars have proposed that there never was a body in the mound, later analysis of the soil showed elements that must have come from a human body, and it is now accepted that the remains had simply not been visible during the initial excavation.

While most of Sutton Hoo's mounds had been robbed at some time in the distant past (one other undisturbed burial was found in Mound 17), Mound 1's funerary assemblage was intact, and contained a stunning array of objects, which the mounds' owner, Mrs. Edith Pretty, donated to the British Museum. The objects represent every aspect of the life of a rich and powerful man, who had been able to accumulate things through far-flung trading networks and also from highly skilled local artisans. Many of the items seem to have had symbolic value, although we do not know exactly what they meant to those who organized the burial.

First there were objects of daily life: three iron cauldrons, three iron-bound wooden buckets and a wooden tub, a pottery bottle, a bronze bowl and a bronze hanging bowl (with chains for suspending it), and wooden bottles and drinking horns, all of which may have contained food and drink. There was clothing, shoes, combs, and furs. These were set off by elaborate gold jewelry: a solid gold belt buckle, 13.2 centimeters (5.25 inches) long, decorated with a pattern of interlaced birds and snakes; the two shoulder-clasps pictured here, made of gold, garnet, and enameled glass, 5.4 centimeters wide (2.25 inches); and a number of smaller buckles, strap-ends, and belt fittings in gold and cloisonnée garnet, probably from belts and harnesses.

This man was buried with an array of weapons: spear pieces; a pattern-welded sword 84 centimeters (33 inches) long, with a gold and jeweled hilt (cf. Thing 35); a wooden shield approximately 91.5 centimeters (36 inches) across, with an iron boss and fittings of gilt bronze that depict a bird and a dragon; and a coat of mail. An iron helmet survives in fragments; featured down the center of the faceplate were a gilt-bronze snake, eyebrows, nose, and mustachioed mouth.

Then there were objects made of silver, most of which was manufactured in the Mediterranean: a large dish, 72.5 centimeters (28.5 inches) in diameter, made in Constantinople during the reign of the emperor Anastasius I (491–518); a fluted bowl, 40 centimeters (16 inches) across, with a woman's head at the center; a set of ten matching bowls, 22.5 centimeters (9 inches) in diameter, engraved with cross-patterns; a silver ladle; and two silver spoons, 25.5 centimeters (10 inches) long, inscribed on their handles "Σaulos" and "Paulos," possibly referring to the name of the apostle Paul before (Saul) and after (Paul) his baptism.

Finally, there were some unusual objects. The "scepter" is a never-used whetstone (stone for sharpening knives), 58.3 centimeters (23 inches) long, with four bearded faces carved at each end. A bronze finial consisting of a ring with a stag on top seems to have belonged to this object. An iron stand, consisting of a long narrow bar with a set of concentric squares toward the top, may have originally been used to display banners; it is sometimes called the "tufa" because the eighth-century Anglo-Saxon historian Bede names such an object that was carried in royal processions. Four small fragments of a bridge and a plectrum indicate that there was a wooden harp among the objects. Several nuggets of bitumen from the Dead Sea region lay scattered on the hull, exotic trophy-minerals from far-off lands. And finally, there are fittings originally from the lid of a leather/wooden purse, 19 centimeters (7.5 inches) wide, with hinges and decoration all of gold, glass, and garnet with spectacular representations of birds, beasts, and men. Inside the purse there were 37 gold coins, 3 blank gold roundels, and 2 ingots. Each coin comes from a different mint in Merovingian France, the latest dates to sometime from 613 to possibly as late as 640, which provides a *terminus post quem* for the burial.

Since its discovery, the Mound 1 burial has been the subject of intense speculation: who was buried here, and what is the significance of all these objects? Ship burials are known from Scandinavia (see Thing 42), and the later Anglo-Saxon epic poem *Beowulf*, which is set in Denmark, describes burials rich in treasure. Was a Scandinavian buried here? Or was this Raedwald, the powerful king of East Anglia who died c. 625? Bede tells us that Raedwald had been baptized as a Christian but then relapsed to the pagan religion of his ancestors. Is this why the tomb included baptismal spoons?

It used to be assumed that a burial with treasure was a manifestation of pagan beliefs, with the items intended to be used in the afterlife. However, archaeological excavation has shown that in this period, burial with jewelry, weapons, and other objects took place even inside churches. Thus, a treasure-filled burial such as Mound 1 must be a public manifestation of the power and wealth of the deceased and of his far-flung economic contacts, rather than a statement of his religious beliefs.

Further Reading

The finds from Mound 1 are kept at the British Museum, which has detailed pictures and studies of each object in its online Research Collection website. An accessible introduction to the Sutton Hoo site and to Mound 1 in particular is M.O.H. Carver, *Sutton Hoo: Burial Ground of Kings?* (Philadelphia, 1998). The same author edited a collection of articles that places Sutton Hoo in its historical context: *The Age of Sutton Hoo: The Seventh Century in North-western Europe* (Woodbridge, Suffolk, 1992). On the date, see A. Stahl and W. A. Oddy, "The Date of the Sutton Hoo Coins," in the very useful volume *Sutton Hoo: Fifty Years After*, edited by R. T. Farrell and C. Neuman de Vegvar (Oxford, 1992), 129–47. Another collection of articles is C. B. Kendall and P. S. Wells, eds., *Voyage to the Other World: the Legacy of Sutton Hoo* (Minneapolis, 1992).

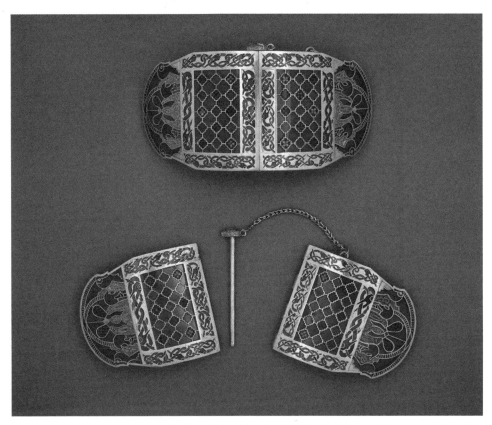

Thing 20C. Sutton Hoo, one half of a gold shoulder clasp inlaid with cloisonné filled alternately with millefiori glass (blue and white) and garnets. Length, 12.7 centimeters; width, 5.4 centimeters; weight, 95.96 grams. Museum no. 1939, 1010.4. © The Trustees of the British Museum/Art Resource, NY.

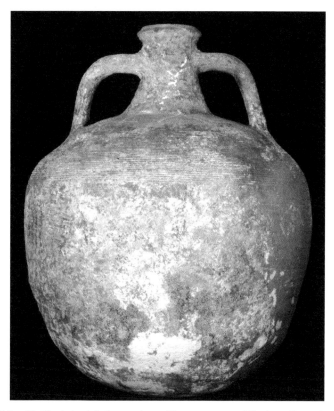

Thing 21. Yassiada globular amphora. Photo courtesy of Fred van Doorninck.

21. "Globular" Amphora from the Yassiada Shipwreck

Yassiada, Turkey, 625

Soon after September 625, judging from the dates of the coins the crew carried, a Byzantine merchantman struck a reef just off the tiny island of Yassiada in the Aegean Sea, near Bodrum in Turkey. The fate of the crew is unknown, but the 21-meter (68-foot) ship sank, nestling into the sands some 32 meters (105 feet) below the water's surface. The bow found a less protective environment there, but the stern was in good condition in the early 1960s when an American team of underwater archaeologists began intensive excavation of the wreck. The 1982 publication of their findings is still considered a model work, and the techniques they pioneered for recording, raising, and preserving the wreck continue in use today.

The Yassiada ship was small by the standards of Roman Mediterranean commerce, but was exceptionally nicely equipped. This suggests that although it was at cargo capacity (60 tons) when it sank, the boat was not designed simply to haul goods, but instead respected travelers who would appreciate its full kitchen and well-stocked pantry. The crew carried many tools for foraging on land and fishing at sea, as well as paraphernalia for weighing and measuring that Mediterranean sailors always found handy (the biggest steelyard was inscribed in Greek "[belonging to] Georgios elder captain," maybe implying the captain was a clergyman). Their boat was built of rough-hewn pine planks using a technique that saved lumber and labor, apparently intermediate between classical planking-first and medieval frame-first construction. Medieval shipwrights and shipowners spared themselves many costs by using these techniques, and perhaps made it easier for people to invest in maritime activity. If Georgios was the owner-operator, his ship would have cost him 460 gold solidi, and his cargo 70 solidi, when shipyard caulkers earned 18 solidi a year, calculating with numbers from the seventh-century Rhodian Sea Law.

About nine hundred clay jars, called amphoras, filled the ship's hull. Gradually replaced by wooden containers after the fifth century, such jars were the plastic bottles of the first millennium Mediterranean. In the seventh century they still dominated the shipment of liquids. The pips and seeds found in about a hundred Yassiada amphoras show some had olive products in them, but most contained cheap unfiltered wine. On the shoulder of this one are the (foreshortened, white) Greek letters ELE, the beginning of the word "olive."

This "globular" amphora is of a type archaeologists call LR2 (Late Roman 2), on the basis of its shape. About eight hundred amphoras aboard the Yassiada ship

were LR2s (subtype a or b). This example's light tan fabric is even, lined with slight comb marks that signal the care the potter took in manufacturing it. Potters assembled such vessels from three components (handles, neck, body) before firing, but the joints do not show. The amphora is about 54 centimeters (24 inches) high and at its widest 44 centimeters (17 inches) across. It is lined with pine resin to prevent its contents seeping into the jar walls. A resin-and-fir-bark stopper plugged most Yassiada amphoras, but only one such stopper survived.

When inscriptions indicating ownership and contents of the amphoras were noticed, divers raised most of the jars for study. Analysis is ongoing, but it seems this cargo included both new and old containers of several types. Some of the older ones had been used for storage, not shipment, before being consigned to the ship's hull. This suggests the jars were gathered hastily from different sources. But scholars have wondered at the high degree of standardization in the Yassiada wreck's amphoras, particularly in the more meticulously made "globular" ones. Until late antiquity, Mediterranean traders used containers of disparate types and sizes, so Yassiada's large cache of quite uniform amphoras made in different centers in the eastern Mediterranean indicates that sixth- to seventh-century shippers had begun to worry about transaction costs. A process of standardization was under way in this period that would make it easier and faster to evaluate a container's contents.

The context for this important conceptual, as well as economic, shift seems to be growing state involvement in moving foods around the eastern Mediterranean. Containers' more regular capacities and linear measurements could facilitate state appropriation and redistribution activities. There are signs of increasing standardization in the supply vessels found at Byzantine military sites. Indeed, Aegean LR2 jars are common in sixth-century military sites along the Danube; this suggests that provisioning the Byzantine army motivated the imposition of more standard blueprints on Aegean pottery makers. In the case of the Yassiada cargo, the low-grade wine and the less abundant oil products in the amphoras may have been supplies for the emperor Heraclius's army in Asia Minor. In response to Sasanian occupation of Byzantine territory after 603 and a coordinated attack on Constantinople, in 624 Heraclius (d. 641) launched a counteroffensive that produced total victory in late 627. Thus, at the time when the Yassiada ship sank, the Byzantine state would have been exploiting its naval superiority to provision troops engaged in a difficult campaign against its Persian enemies and their Avar allies.

Further Reading

G. Bass and F. van Doorninck, eds., *Yassi Ada 1* (College Station, TX, 1982) is the original publication of the discovery, with pioneering studies of the coins, lamps, weighing instruments, iron objects, etc., and Bass's valuable "Conclusions." E. Greene and M. Lawall, "Amphora Standardization and Economic Activity," in *Maritime Studies in the Wake of the Byzantine Shipwreck at Yassiada, Turkey*, edited by D. Carlson et al. (College Station, TX, 2015) [hereafter MSWBSY], 3–16, contrasts ancient and medieval transactions. W. Kaegi, *Heraclius* (Cambridge, 2003), has ample military detail on the 620s. A. Laiou and C. Morrisson, *The Byzantine Economy* (Cambridge 2007), chap. 2, is a quick guide to Byzantine economic history 500–650. J. Leidwanger, "A Preliminary Archaeometric Analysis of the Late Roman 1 Amphoras from the Cargo of the Seventh-century Yassiada Shipwreck, Turkey," in *Late Roman Coarse Wares, Cooking Wares and Amphorae in the Mediterranean*, edited by N. Poulou-Papadimitrou et al. (Oxford, 2014), 897–903, describes the main types of jar from Yassiada, and their fabric. P. van Alfen, "The Restudy of the LR2 Amphoras from the Seventh-century Yassiada Shipwreck," MSWBSY, 17–34, discusses the "conceptual turning point" represented by standardized jars. F. van Doorninck, "Byzantine Shipwrecks," in *The Economic History of Byzantium*, vol. 2, edited by A. Laiou (Washington, 2002), 899–905, draws the big picture. F. van Doorninck, "The Seventh-century Byzantine Shipwreck at Yassiada and Her Final Voyage," MSWBSY, 205–16, gives one of the main excavators' boldest interpretation of the wreck. C. Ward, "Plant Remains from the Old Wine Jars on the Byzantine Ship at Yassiada," MSWBSY, 55–62, is cautious about where the pips and seeds associated with the amphoras came from.

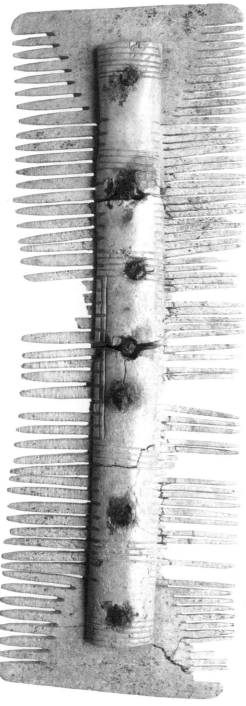

Thing 22. Comb made of bone or antler, excavated at Santo Stefano, Garlate, Italy. Sistema Museale Urbano Lecchese-Museo Archeologico, Lecco. Photo by Giuseppe Giudici.

22. Bone Comb from Lombard Italy

Santo Stefano, Garlate, Italy, early seventh century

Most people have hair on their heads, and the way it is cut and styled can denote fashion, ethnicity, class, gender, age, or other cultural statuses. We know from early medieval written texts that hair and hairstyles could be understood as important signifiers of identity. Latin had words for "a comb" (*pecten*) and "to comb" (*pectere*); Latin authors specifically mention that men wear their hair in different ways, and barbarian men are often described by Romans as having long hair. Combs to style hair were therefore important personal possessions.

Combs were used by people at every level of society and are found on archaeological sites from the Roman period to the end of the Middle Ages (and beyond), from the Mediterranean to Scandinavia. Because they usually were made of widely available materials, they are archaeologically ubiquitous, found in burials, but also in settlement sites and waste pits, where they might be thrown when they were too broken to be used.

Before plastic, a comb was made by taking a flat piece of wood, antler, or bone (or, more rarely, ivory or walrus tusk), cutting it to the desired shape (a rectangle or half-circle in most cases), and then cutting slits from the edge to create the teeth of the comb, which have to be aligned with the grain of the material. Sometimes a second piece of bone or antler was attached to the central spine of the comb, to strengthen it. This was especially true of combs with two different widths of teeth, such as the one shown here. Combs could be plain, or they might be decorated with carved images or shapes.

In the seventh century, many male and female graves in Italy contained combs, both in the Lombard kingdom and in Byzantine-ruled areas. Indeed, a comb made an ideal grave deposit, as it was both a very personal item yet was relatively inexpensive.

The comb shown here is of a type known as a double-sided composite comb; it measures 13.1 by 4.5 centimeters (5.25 by 1.5 inches). It was found in a tomb excavated under the floor of the church of Santo Stefano at Garlate, in northern Italy (tomb 27/2), dating to around 625–650. The tomb belonged to a young man around twenty years old; in addition to the comb, the grave also contained an iron belt buckle and belt tip, a small bronze ring, an iron knife in a leather sheath, and fragments of cloth with some interwoven gold threads, so this youth was presumably a member of his town's elite class (as the location of his tomb inside the church confirms).

The people we know as the Lombards were called *Langobardi*, which means "long beards," and texts bear out the evidence of grave goods in showing that

hairstyles were important to them. Paul the Deacon, a Lombard who wrote a history of his people in the late eighth century, describes a wall-painting of old-style Lombards, in which he says, "They shave the neck to the back of the head down to the skin, the hair hangs down in the face to the mouth, being divided in two at the parting" (*History of the Lombards* 4.22). A law in the seventh-century Lombard law code states, "If anyone in a quarrel with a freeman drags him by the beard or hair, he shall pay six solidi [gold coins] as a fine. If he drags a half-freeman or a household slave or a field slave by the beard or hair, he shall pay the fine for one blow" (*Edict of Rothari*, 383). Some pictures of Lombards (on jewelry, for example) show them with long hair or beards, but others do not.

Whether the young occupant of this tomb used a comb for his hair or his beard, or both, its presence indicates the importance of well-groomed hair to the Lombard man.

Further Reading

An examination of the comb and the tomb in which it was found are published in Italian: E. Possenti, "La tipologia delle sepolture tardoantiche-altomedievali: I corredi delle sepolture tardoantiche-altomedievali," in *Testimonianze archeologiche a S. Stefano di Garlate*, edited by G. P. Brogiolo, G. Bellosi, and L. Doratiotto (Lecco, 2002), 200–209. S. Ashby, *A Viking Way of Life: Combs and Communities in Early Medieval Britain* (Stroud, 2014), puts early medieval combing into a broad cultural context. For hair in the early Middle Ages, see P. E. Dutton, *Charlemagne's Mustache: And Other Cultural Clusters of a Dark Age* (New York, 2004). For hair and its relationship to ethnic identity, see W. Pohl, "Telling the Difference: Signs of Ethnic Identity," in *Strategies of Distinction: The Construction of Ethnic Communities, 300–800*, edited by W. Pohl and H. Reimitz (Leiden, 1998), 17–69. Finally, for bone technology, see A. MacGregor, *Bone, Antler, Ivory and Horn—The Technology of Skeletal Materials since the Roman Period* (Croom Helm, 1985), esp. 73–96.

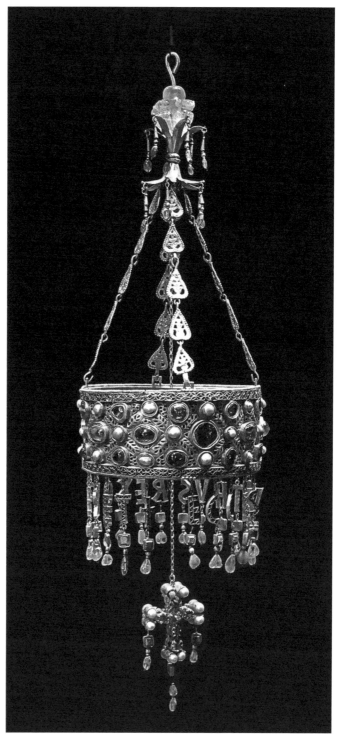

Thing 23. The Crown of Recceswinth. National Archaeological Museum, Madrid.
Photo by Jacinta Lluch Valero, Wikimedia Commons.

23. The Crown of Recceswinth

Spain, ca. 639–72

From at least the time of the emperor Constantine, pious people patronized the construction and decoration of churches, often in as splendid a fashion as they could afford, to signal to God and to their fellow believers the value they placed on Christian worship. Donations of money and precious objects were encouraged, and by the seventh century were viewed as a way of accumulating merit for the soul in the afterlife.

Individual churches therefore accumulated, over time, collections of precious objects, some of which had practical functions in the liturgy, such as chalices, candles, crosses, candlesticks, and reliquaries (see Thing 16). Some items, however, were purely decorative, and it is to this category that the Crown of Recceswinth belongs. Produced in seventh-century Spain, it is a "votive" crown, that is, a cylinder designed to be hung from chains over the altar of a church (not worn on the head like a crown). This one is among the most splendid of the many medieval votive crowns surviving from throughout the Christian world.

Recceswinth's crown is 20.60 centimeters (8 inches) in diameter and 10 centimeters (4 inches) high; its chain is 26.5 centimeters (10.5 inches) long, and with the pendants, the total height is 80 centimeters (31.5 inches). It consists of two semicylinders linked by hinges made of gold; the outer face is set with large sapphires and pearls, and the intricate border of gold cloisonné was set with thin slices of garnet, now lost. The twenty-four pendants that hang from the circumference of the crown each include a jeweled letter, which together spell out the phrase +RECCESVINTHVS REX OFFERET ("King Recceswinth offers [this]"). Recceswinth inherited the Visigothic kingdom of Spain from his father in 649 and reigned until his death in 672, which gives us the date of the object. The letters of the pendants and the larger cross that hangs below them were set with garnet slivers, and below each letter dangles a square of green glass, a pearl, and a sapphire. At the top of the suspension chain is a large rock crystal carved in the shape of a column capital.

This crown was part of a treasure that was buried in the early eighth century and rediscovered in 1858 at a place known as Huertas de Guarrazar, just southwest of Toledo. The Treasure of Guarrazar contained many crowns, hanging crosses, and pendant chains; they almost certainly represent treasure from a church or churches of Toledo, the capital city of Visigothic Spain. It is usually suggested that the pieces were buried to hide them from the Muslim conquerors of Spain, who arrived from North Africa in 711.

Much of the treasure was sold and melted down in the nineteenth century; surviving objects include ten crowns, nine crosses, sixteen pendants, and various chains and other pieces. One large processional cross, of which only pieces remain, was designed to match Recceswinth's crown. Some of the other crowns also contained the names of their donors. One, similar to Recceswinth's, had letters that spell the name of King Suinthila (r. 621–31), while another was donated by an abbot named Theodosius, and a cross that probably once hung from a crown has an inscription with the name of a man named Sonnica. The last two examples show that this type of object was donated as an act of homage to God (it was a "crown of victory," such as those worn by martyrs or the Elders of the Apocalypse), not because the donor was royal.

Scientific analyses of the gold and gems have been carried out on the Guarrazar treasure. They show that the gold was probably mined in southern Spain, the garnets had a European origin, but the sapphires came originally from Sri Lanka. Craftsmen took great care to match the colors and sizes of the crown's gemstones. Indeed, several of the large sapphires are pierced and/or engraved, and may well have been reused from earlier, even Roman, pieces of jewelry. Recceswinth's crown had a gold content of over 90 percent, which was the highest of any object in the Guarrazar Treasure. The fact that the king could donate this splendid, and undoubtedly expensive, crown is a testament to the wealth of the Visigothic kingdom in his day.

Further Reading

The National Archaeological Museum, Madrid, which has the Crown of Recceswinth in its collection, has a virtual view of the crown, which provides a rotating three-dimensional view of it; at the time this book was printed, the URL is http://www.spainisculture.com/en/obras_de_excelencia/museo_arqueo logico_nacional/corona_de_recesvinto.html. Most of the available bibliography is in Spanish, including the complete publication of the treasure: Alicia Perea, *El tesoro visigodo de Guarrazar* (Madrid, 2001). A scientific analysis of the gold in English is M. F. Guerra and T. Calligaro, "The Treasure of Guarrazar: Tracing the Gold Supplies in the Visigothic Iberian Peninsula," *Archaeometry* 49, no. 1 (2007): 53–74.

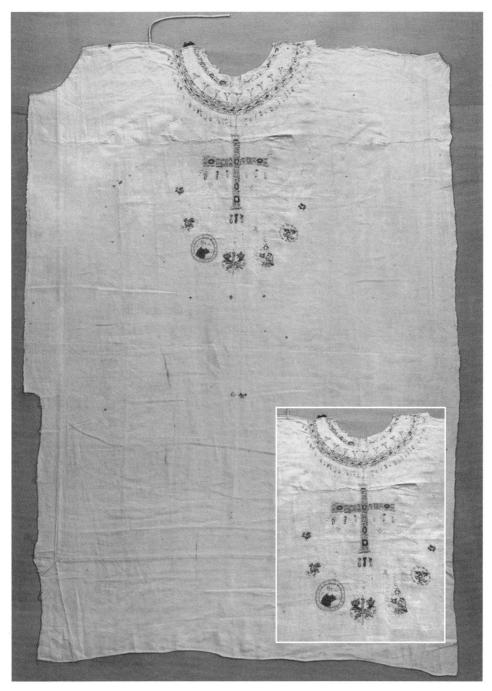

Thing 24. Chelles, Musée Alfred Bonno: Tunic of Balthild, full view and inset detail of center portion with embroidery. © Genevra Kornbluth.

24. The Tunic of Balthild (Chasuble de Chelles)

France, ca. 664–80

The life of Balthild—slave girl, queen of the Franks, nun, and saint—opens a window onto Merovingian society, and the surviving relic of an elaborately embroidered piece of clothing supposedly worn by her sheds fascinating light on several aspects of early medieval religion and society.

Because she was later venerated as a saint, we have a biography of Balthild, written by a nun of her monastery. According to the biography, she was born in England and was captured and sold into slavery in Merovingian Francia in her youth. She was owned by Erchinoald, who was the *maior domus* ("mayor of the palace," or chief administrative officer) of the Frankish king Clovis II (r. 639–57). Because of her beauty, modesty, and piety, Erchinoald wanted to marry her, but she didn't like the idea, so she avoided him until he married someone else. Subsequently, King Clovis II married her himself, and they had three sons; when Clovis died, their eldest son Clothar III succeeded to the throne. Since he was still a child, Balthild became regent, ruling until Clothar reached adulthood in 664. She seems to have been quite controversial as a queen; her biography says that she was entirely virtuous, but other sources claim she was responsible for the deaths of several bishops! After 664, Balthild retired to the monastery at Chelles, which she had founded; even in her biography, the circumstances that required her to retire to Chelles are discreetly glossed over (and may represent a power struggle). She lived at Chelles as a nun until her death in 680.

Chelles had been the location of a royal Frankish estate. Balthild donated the property to support a female monastic house, and as its reputation grew, a men's house was added, also under the authority of the abbess (in the seventh century, such double monasteries were quite common in England and Francia). Chelles remained a monastery with close connections to royal and noble women until it was dissolved in 1790, during the French Revolution.

Objects belonging to Christian saints were venerated as relics, and Balthild apparently left several personal objects at Chelles after her death. She was buried next to the church, and in 833 her body was translated—disinterred and relocated, that is—and placed in a reliquary chest inside the church of the Virgin. The relics were repackaged again in 1544 and in 1792, before they were subjected to scientific inquiry after 1982. Relics associated with Balthild included a large silk mantle, woven belts, and a silk cord wrapped in gold thread, 4.91 meters long, found twined around locks of hair. The associated bones were of a woman in her forties, and the hair showed signs that it had originally been blond, but at the time of burial it was turning white and being dyed blond!

The piece of clothing shown here was associated with Balthild (although probably not buried in her tomb), and was one of the monastery's main relics. It is the front piece of a simple tunic, made out of two rectangles of woven linen, 117 by 84 centimeters (46 by 33 inches) sewn together with holes for the neck and arms. It is embroidered using running, chain, and satin stitches of red, beige, blue, green, and brown threads of silk, which, at this date, would have probably been imported from Constantinople. The design depicts two necklaces, one bearing a large pendant cross, and another, longer necklace with several medallions hanging from it. Necklaces like this are known from pictures and from surviving objects to have been worn by empresses, queens, and other high-status women in the seventh century.

Balthild's biography says that her spiritual adviser Eligius told her to sacrifice her jewels as a sign of her humility. This garment is often interpreted in light of that statement; some scholars see the tunic's embroidery as a commemoration of Balthild's renunciation of her actual jewelry and interpret an embroidered rather than a real necklace as a sign of monastic simplicity. The use of silk threads, rather than gold or silver thread, is also taken to be a sign of humility. Since these necklaces do look like those that queens really wore, however, others have treated their appearance on this garment as a symbol of the former queen's rank and perceived the use of silk, an exotic luxury good, as a sign of high status and wealth.

Did the former slave girl insist, even in her monastic retirement, on displaying the emblems of her later queenship? Or did the humble and pious nun show through simple embroidery that she had given up the rich jewels of her former state?

Further Reading

Most publications about this tunic are in French; see, for example, J.-P. Laporte and R. Boyer, eds., *Trésor de Chelles: sepultures et reliques de la reine Balthilde (+ vers 680) et de l'abbesse Bertille († vers 704), Catalogue de l'exposition organisée au Musée Alfred Bonno* (Chelles, 1991). It is mentioned in scholarship about early medieval gender, e.g., J.L. Nelson, "Gendering Courts in the Early Medieval West," in *Gender in the Early Medieval World: East and West, 300–900*, edited by L. Brubaker and J.M.H. Smith (Cambridge, 2004), 185–97. For a study of early-medieval embroidery, see E. Coatsworth, "Stitches in Time: Establishing a History of Anglo-Saxon Embroidery," *Medieval Clothing and Textiles* 1 (2005): 1–28. The Latin life of Balthild has been translated into English in J. McNamara, J.E. Halborg, and E.G. Whatley, *Sainted Women of the Dark Ages* (Durham, NC, 1992), 264–78.

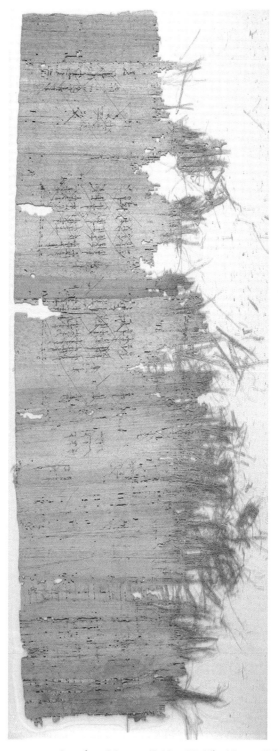

Thing 25. Papyrus account register from Nessana (*P. Ness.* 92). The Morgan Library & Museum, Colt Pap. 92, 93 verso. Photographic credit: The Pierpont Morgan Library, New York.

25. Papyrus Account Register (*P. Ness.* 92)

Nessana, Israel, ca. 685

The archaeologists excavating the Byzantine-era village and military camp near the small village of Auja el-Hafir, in the Negev desert in southern Palestine (now Israel), weren't even supposed to be working there. Only the severity of the drought in the winter of 1937 had forced them to abandon their excavation farther to the north in favor of the modest and unpromising site. While sifting through piles of rubbish covering the floor of a small room in the ruins of a monastic church dedicated to the Byzantine military saints Sergius and Bacchus, they discovered something almost impossibly rare. Mixed in with the decayed remains of the thatched roof, organic waste, and animal bones were hundreds of fragments of papyrus.

Made from the fibrous husks of the reedy papyrus plant native to Egypt, flattened and layered, papyrus was the paper of the ancient Mediterranean. Inexpensive and durable, it was used in loose-leaf form for shorter texts such as letters and administrative records, and in long rolls, or scrolls, for what we today call books. Almost all the ancient papyrus that survives comes from Egypt, preserved thanks to the exceptionally dry climate of the Egyptian desert. Consisting mostly of records from local archives such as letters, tax receipts, contracts, and deeds of sale and lease, these fragments offer a uniquely vivid and detailed picture of everyday life. The trove found at Auja el-Hafir contained nearly a hundred documents well enough preserved to be mostly or entirely legible. As an added bonus, the papyri all dated from around AD 500 to 700, the crucial transitional period when most of the eastern Mediterranean was wrested from Byzantine control by the followers of the prophet Muhammad. The name of the village, given in many of the papyri found there, was Nessana.

P. Ness. 92 (the ninety-second Nessana papyrus catalogued) is a large document, a rectangle measuring 91 by 34 centimeters, mostly complete except for the top and right margins. It is a kind of personnel ledger, arranged in neat columns, comprising a list of names, each followed by a sum of money owed to the nominee or orders for duty. All the names suggest the people involved were Arabs, and the frequent recurrence of terms for military rations and salaries, along with the tasks to which various individuals are assigned, such as guarding transport routes and protecting shipments of food and cash, make it clear that they are soldiers. Upon receipt of the indicated cash or supplies, or completion of the required duty, the account keeper or quartermaster of the unit canceled the relevant entry by crossing it out. A final column contains the names of the officials who authorized each payment or assignment, among them several of the leading figures in the

Umayyad caliphate, beginning with the caliph himself, 'Abd al-Malik (r. 685–705) in his capital of Damascus and his brother, 'Abd-al-'Aziz, governor of Egypt during his brother's reign. The known figures mentioned and the dating formula employed place the date of the papyrus around 685, the first year of 'Abd al-Malik's reign.

All of the high officials named were native speakers of Arabic, as were most or all of the soldiers, yet the ledger—produced a half-century after the beginning of Islamic rule in Nessana—is written not in Arabic, but in Greek, the language of government and administration in the eastern Mediterranean for a thousand years. This fact is less curious than it might appear at first glance. It is a precious reminder that military conquest and "regime change" often happen much faster than cultural change: the arrival of new rulers, in other words, need not have an immediate and profound effect on the rhythms of everyday life, among them language and religion. This is particularly true if the new regime does not seek to eradicate all traces of the previous ruling establishment and its institutional culture. The Umayyad authorities in Palestine inherited from the Byzantines an established bureaucracy and a corps of highly trained civil servants and administrators, whose professional language was Greek. Initially, the way to ensure the continued collection of taxes, the maintenance of roads and infrastructure, the provisioning of the army, the smooth functioning of the postal service, and so on was to reemploy the trained functionaries responsible for all of it, and allow them to use their accustomed language, still shared by most of the inhabitants of the former Byzantine provinces long after the establishment of Muslim rule. 'Abd al-Malik was the caliph who finally, later in his reign, made the momentous decision to substitute Arabic for Greek in official documents across his domains.

In Nessana, the transition to Islamic rule may have seemed especially fluid. From its beginnings in the third century BC, before it ever passed under Roman and then Byzantine control, Nessana—or Nessan in the local Arabic dialect—was populated by Nabataeans, a Semitic people closely related to the tribes of the Arabian peninsula that produced Muhammad and his followers. Some residents may even have welcomed their kindred Arab occupiers in the seventh century; the Roman and Byzantine authorities, in any case, had always been a remote presence in a town where family connections and local networks of patronage figured larger in everyday life than representatives of the imperial government. True, under Islamic rule, non-Muslims were required to pay a range of taxes from which Muslims were exempt, exactions which have left their mark at Nessana in a number of *entagia*—orders to Christians from the Muslim governor to furnish large quantities of grain and oil for the army—preserved among the papyri. Yet the taxes were probably comparable to what was owed under Byzantine rule, when all subjects were taxed, regardless of their faith.

Indeed, the local Christian community evidently prospered under Muslim governance. At the end of the seventh century, when the personnel ledger found at Nessana was written, the largest church ever built in the village was erected. Discovered only in 1989, the basilica, at 45 meters (148 feet) long one of the largest churches in the Negev region, speaks to the continued presence of a flourishing, wealthy, ambitious, and unmolested Christian community. As "people of the book," Christians and Jews were protected under Islamic law, and generally allowed freedom of worship. The ostentatious grandeur of the new church graphically demonstrates that local Christians were neither persecuted, nor financially crippled by the taxes they paid. For two centuries after the end of Byzantine rule, village life in the multilingual, multicultural community of Nessana went on much as before.

Further Reading

The papyri found at Nessana are published in C. J. Kraemer, *Excavations at Nessana*, vol. 3, *Non-Literary Papyri* (Princeton, 1958). *P. Ness.* 92 features prominently in H. Kennedy's "The Financing of the Military in the Early Islamic State," in *The Byzantine and Early Islamic Near East*, vol. 3, *States, Resources and Armies*, edited by A. Cameron (Princeton, 1995), 361–78. The social dynamics of the community at Nessana are explored in R. Stroumsa, *People and Identities in Nessana* (Ph.D. diss., Duke University, 1998) found online at: http://dukespace.lib.duke.edu/dspace/bitstream/handle/10161/619/D_Stroumsa_Rachel_a_200805.pdf?sequence=1. On the architecture and development of the town and its churches, see F. R. Trombley, "From Kastron to Qasr: Nessana between Byzantium and the Umayyad Caliphate ca. 602–689," in *The Levant: Crossroads of Late Antiquity*, edited by E. B. Aitkens and J. M. Fossey (Leiden, 2014), 181–224.

PART V

Things of the Eighth Century

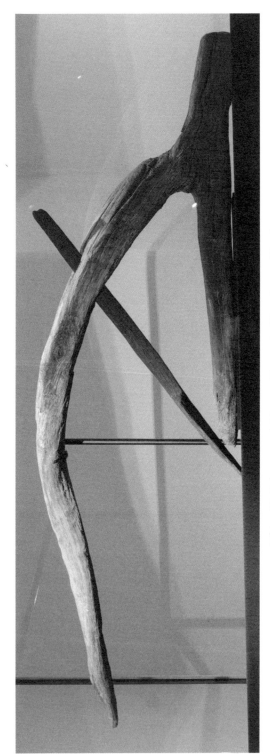

Thing 26. Dabergotz ard, Museum Neuruppin. Photo Lorenz Kienzle.

26. The Dabergotz Ard

Dabergotz, Germany, ca. 653–813

The Dabergotz ard is a rare thing: a well-preserved early medieval agricultural utensil. Wear and tear during use, peasant frugality and consequent recycling of wood and metal parts, and elite indifference to workaday objects (until recently deemed unaesthetic), spelled destruction for most medieval farming tools. But this ard (or "scratch plow") had the good fortune to find its resting place in the peat bogs of Dabergotz, a tiny place near the town of Neuruppin in northeastern Germany, where nineteenth-century wetland drainers discovered it. The peat in effect pickled the plow, today visible in the Museum of Neuruppin.

The Dabergotz ard is small by the standards of modern plows: the horizontal support is 82 centimeters (40 inches) long and about 8 centimeters (3.25 inches) high, with a hole 3 by 7 centimeters (1.5 by 2.75 inches) cut into its rump where the plow's steering pole would have fit: this allowed the driver to control the direction and depth of plowing. Above the support extends, at an angle of almost 45 degrees, the rigging for the beasts (presumably) that pulled the device through the soil: this beam is about 1.45 meters (4 feet, 9 inches) long, and is perforated close to its highest point to accommodate a 65 centimeters (25 inch) wooden plowshare that joined the support below, forming a strong triangle. The function of the smaller hole close to the tip of the beam is uncertain, but related to the hitch for the traction animals, which probably required a further part that is missing. The entire ard is oakwood, radiocarbon dated to AD 733+/-80. Thus, the tool dates sometime between the mid-seventh and the early ninth centuries, though the basic design was far older: similar plows had existed for millennia, since the rise of the riverine civilizations in western Asia.

Both the date and the simplicity of the Dabergotz ard's construction are relevant to scholarly debates about early medieval agricultural innovation. The greatest medieval historian of the twentieth century, Marc Bloch, first divined the sociocultural and economic ramifications of medieval plows. He connected plow design to characteristic field shapes and landscape: long, narrow fields widespread in northern Europe derived from a new, medieval plow, called a "heavy plow" in English, whose limited maneuverability induced operators to turn around as little as possible (thus the elongated fields). After Bloch, such plows, perhaps depicted on folios 49v and 59v of the Carolingian Utrecht Psalter (Thing 40), played a large role in theories of postclassical inventiveness and ancient Roman technological backwardness. For Roman farmers appear to have relied on scratch plows, which explains their square fields (ards push earth to

both sides of the furrow, leaving much ground undisturbed under the displaced dirt until a second plowing at a right angle to the first furrow breaks up what the first furrow merely covered with displaced soil).

Following in Bloch's footsteps the influential Lynn White Jr. proposed an early medieval "agricultural revolution" deriving from innovations in the construction of plows. He considered that a "heavy plow," made with ample use of iron to resist the ground's abrasion, equipped with an extra cutting blade in front of the plowshare, and whose asymmetrical share turned the sod to one side as well as cutting it, had spread through Europe after Rome's fall. This earth-opening tool was suited to north European soils because these were denser and damper than Mediterranean earth and thus resisted the efforts of farmers equipped with ancient ards. According to White, the heavy plow created furrows that not only aerated the soil, but also aided in drainage. It did so with a single linear plowing and, since it capsized the dirt it cut into, unlike the ard it did not require cross-plowing to pulverize the dirt and render it fit to receive seed. This permitted early medieval plowmen (plowing was and remains gendered male) to plow more land in the same time, thus increasing productivity. The new, heavy tool necessitated teams of animals to pull it, which fostered peasant cooperation and the shared resources typical of manors, a new type of farm that crops up in northwestern European documents in the eighth century. For White, a technological innovation changed economy and society in Europe, and robbed the southern lands of their relative productive advantage over the north.

To preserve these orthodoxies about the inadequacy of Roman plowing technology in early medieval north Europe, some scholars have ethnicized the Dabergotz ard, associating it with Slavic immigration into Brandenburg. But an alternative, less teleological view is possible. The simple technology behind the ard could be homegrown and "Germanic." Regardless of which view one prefers, the Dabergotz ard suggests that the early medieval rush to adopt heavy plows was far from universal. It shows that premodern technological innovation was always a process, never an invention event, and that in some regions old-fashioned technologies were preferable, either for social, cultural, or geological reasons. The heavy plow, already described in some late antique texts, was adopted as needed (for example, in the seventh-century Anglo-Saxon royal complex at Lyminge, and indeed Anglo-Saxon riddlers presumed familiarity with such a heavy iron tool). But even in high medieval France, where this technology reached its apogee, some farmers shunned it, preferring the cheaper, easier to repair, wooden scratch plows.

Further Reading

For illustrations with an English summary, see U. Bentzien, "Der Haken von Dabergotz," *Tools and Tillage* 1 (1968): 5–55. BBC, "Anglo-Saxon 7th Century Plough Coulter Found in Kent," www.bbc.co.uk/news/uk-england-12997877 (accessed June 4, 2016). M. Bloch, *French Rural History* (Berkeley, 1966) is a classic of medieval and rural historiography. K. Crossley-Holland, *The Exeter Book Riddles* (Harmondsworth, 1993), 24, has a nice tenth-century riddle whose solution is the heavy plow. J. Henning, "Did the 'Agricultural Revolution' Go East with Carolingian Conquest?" in *The Baiuvarii and Thuringi*, edited by J. Fries-Knoblach et al. (Woodbridge, 2014), 331–59, discusses plow archaeology (339–46). E. Margaritis and M. Jones, "Greek and Roman Agriculture," in *The Oxford Handbook of Engineering and Technology in the Classical World*, edited by J. Oleson (Oxford, 2010), 158–74, frames the question of ancient backwardness. G. Raepsaet, "The Development of Farming Implements between the Seine and the Rhine from the Second to the Twelfth Centuries," in *Medieval Farming and Technology*, edited by G. Astill and J. Langdon (Leiden, 1997), 41–68, proposes a less event-driven technological history. L. White Jr., "The Agricultural Revolution of the Early Middle Ages," in his *Medieval Technology and Social Change* (Oxford, 1962), 39–78, is still a thrilling read, full of insights as well as mistakes.

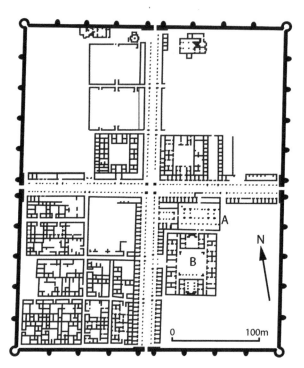

Thing 27A. ʿAnjar, city plan.

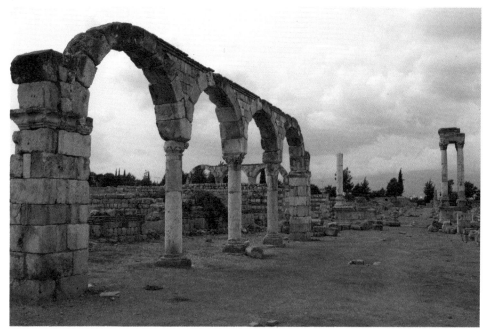

Thing 27B. ʿAnjar, arcades along the cardo, with tetrapylon in background. Photo by Arian Zwegers, Wikimedia Commons.

27. The Palace-City of 'Anjar

Lebanon, early eighth century

In the fertile Beqaa Valley in Lebanon, near the Syrian border, the remains of the miniature city of 'Anjar illuminate a dramatic period of transition in Mediterranean and world history: the century after the death of the Prophet Muhammad in 632. In this period, Muhammad's followers occupied lands from Afghanistan to Spain, including the former eastern provinces of the Byzantine Empire, today's Egypt, Israel, Jordan, Syria, and Lebanon. 'Anjar was established midway along the main road linking the Muslim capital at Damascus with the port city of Beirut on the Mediterranean coast. It was probably founded under the auspices of the caliph al-Walid I (r. 705–15) and his son, al-Abbas ibn al-Walid. A number of inscriptions dating to 714 were scratched by Kurdish workers into the rock of the quarry that provided the high-quality building-stone used on 'Anjar's buildings, when the project must have been in full swing. Work seems to have stopped abruptly upon the death of al-Walid in 715, leaving much of the site unfinished; soon abandoned to the elements, 'Anjar lay vacant until the arrival of twentieth-century archaeologists. Thanks to its construction in a single phase and its almost immediate abandonment, 'Anjar is the best-preserved example of a city founded anywhere under Islamic rule prior to the fall of the Umayyad Dynasty in 750. Because it dates to one moment in time, it provides a uniquely informative window onto city planning in the early Islamic period.

'Anjar's rectangular perimeter wall measures 310 by 370 meters (340 by 405 yards), and bristles with forty closely-spaced towers. Four gates, one in each side of the wall, oriented to the four points of the compass, were traversed by two main streets: straight, twenty-meter-wide boulevards that met at right angles in the center of the city. Immediately adjacent to this central intersection stood 'Anjar's principal (only?) mosque, alongside a palatial residence destined for the city's governor, or perhaps for the caliphs themselves. Elsewhere stood at least two bath buildings, another palatial or administrative complex, and a small residential neighborhood that occupied approximately a quarter of the walled area, with room for perhaps twenty-five families.

Were it not for the archaeological finds, the inscriptions, and the notices in both Byzantine and Arab chronicles, all of which show 'Anjar to be an Umayyad foundation of the early eighth century, the site would surely have been interpreted as a Roman city founded centuries earlier. Its two perpendicular streets—wide, straight, and lined on both sides by continuous arcades fronting long rows of

shops—mimicked the grand, colonnaded avenues at the heart of countless Roman and Byzantine cities in the region, such as Jerusalem (see Thing 13).

Indeed, the perfect symmetry of 'Anjar's urban layout looks so Roman that it has overturned earlier views about Islamic culture and its reception of the Classical past. For generations, scholars (particularly Western, non-Muslim scholars) had maintained that the transition to Islamic rule in the Middle East was a devastating upheaval that caused an ancient, wealthy, and sophisticated Greco-Roman society to collapse at the hands of hordes of uncouth seminomads from the Arabian Peninsula, people with little understanding of, or use for, Classical culture. Proponents of this view insisted that cities lost their ancient grandeur under Muslim rule, when their public buildings crumbled, and their wide streets and grand public spaces devolved into narrow lanes suited to wheel-less modes of transport and into noisy, teeming markets. Thus, some prominent scholars doubted—despite all the evidence to the contrary—that 'Anjar could be an Islamic foundation.

Yet a new generation of archaeologists and historians has recently begun to turn up more and more evidence that the transition to Muslim rule was a more gradual and less traumatic process than was once thought, and that the new rulers of the region often eagerly emulated and assimilated elements of the Classical tradition. 'Anjar is itself powerful evidence to this effect. After nearly a century of Muslim rule in the eastern Mediterranean, the Romano-Byzantine urban ideal was alive and well. The Umayyad patrons of 'Anjar knew exactly what constituted the essence of the great Romano-Byzantine cities that they were striving to reproduce: a circuit wall bristling with largely ornamental towers, pierced by gates opening onto the pristine colonnaded avenues that led straight to the city's most important civic and religious buildings.

We still do not know why 'Anjar was built in the first place, what its intended functions were, and why it was left unfinished and abandoned. Its small size and minimal provision for housing, together with its rapid abandonment (if it was ever inhabited at all), suggest that it never became a city in anything but name. Yet in its meticulous modeling of traditional urban features, albeit at a reduced scale, its urban pretensions are hard to deny. Further, the walled city where archaeological work has concentrated may be only the tip of a much larger iceberg. Aerial views reveal possible traces of irrigation canals or drainage ditches, suggesting that intensive cultivation may have been planned for the vicinity, perhaps undertaken by farmers living outside the walls, in more perishable housing that only careful survey and excavation will reveal.

Perhaps al-Walid's miniature city was, first and foremost, the realization of a grandiose dream, an architectural gesture intended to place him alongside the likes of Alexander the Great, Constantine, and Justinian, larger-than-life leaders of the distant past, who were all renowned founders of cities. 'Anjar, designed to

be al-Walid's bid for immortality in the best Greco-Roman tradition, died with him in 715, when another family came to power and devoted its resources to different projects. In any case, one thing is clear: the transition to Islamic rule in the eastern Mediterranean did not provoke the wholesale collapse of classical urban culture, nor did Muslims prefer squalid villages to majestic cityscapes.

Further Reading

The best English-language overview of the site and the interpretive challenges it presents is R. Hillenbrand, "'Anjar and Early Islamic Urbanism," in *The Idea and Ideal of the Town between Late Antiquity and the Early Middle Ages*, edited by G. P. Brogiolo and B. Ward-Perkins (Leiden, 1999), 59–98. The UNESCO website-entry on 'Anjar is another useful resource with numerous photographs of the site; at the time this book was printed, the URL is http://whc.unesco.org/en/list/293. On the archaeological evidence for cities and settlement during the first centuries of Islamic rule in the Levant, see A. Walmsley, *Early Islamic Syria: An Archaeological Assessment* (London, 2007); G. Avni, *The Byzantine-Islamic Transition in Palestine: An Archaeological Approach* (Oxford, 2014).

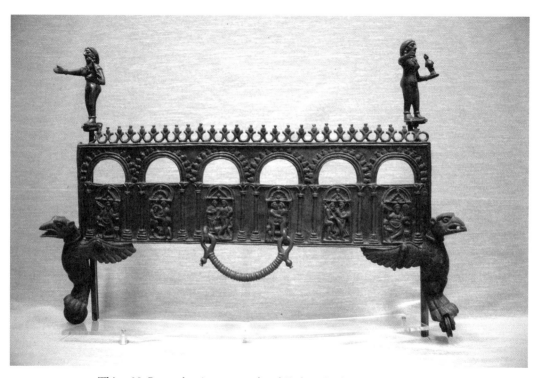

Thing 28. Bronze brazier, excavated at al-Fudayn, Jordan, Amman Museum.
© Museum With No Frontiers (Discover Islamic Art, Jordan).

28. Umayyad Bronze Brazier

al-Fudayn, Jordan, ca. 700–750

Only one side survived intact, the one in this image, but together with another seven fragments it allowed Jordanian restorers to reconstruct a square brazier that style and archaeological context date to 700–750. The brazier is about the same size as a standard stovetop (68 by 56 centimeters, or 27 by 22 inches), but it is also 48 centimeters (19 inches) from its feet to the heads of the naked women at each corner that served as handles. The brazier was made of several components cast of copper alloy, reinforced with iron structural parts. Loaded with hot embers, it would have been a difficult object to drag using one of the two dangling handles affixed to its base, or the higher female statuettes.

The brazier's ornamentation is lavish and unique. Its sides were formed by a symmetrical repetition of six arches whose semicircular openings are rimmed by a motif of pomegranates (a fruit that symbolized marriage, rebirth, and renewal, among other things, and which reappears at the top of the brazier). Elegant Corinthian columns support the arches and frame niches within which are two human figures. A panther (symbolic of the pagan god of wine and excess, Dionysus) peaks through the legs of most couples. While the women are nude, some males are partially dressed. In one of the central niches of the best-preserved side, the pair is having sex, but in the other lunettes pagan divinities like the half-goat Pan, or devotees of Dionysus hampered by the ritual rod they carry, pursue their partners more halfheartedly. In the two outermost niches a boy steadies a fat man (maybe a satyr, Silenus, or Dionysus himself) who is barely able to stand. He holds a wine bowl and clutches a wine skin, with a decanter near his left knee. The entire composition, and the brazier, is held up by winged griffins whose claws double as mounts for wheels.

The series of twenty-four pairs formed a chain, mimicking a Dionysiac procession. This had been a popular motif in the Mediterranean since Hellenistic times. The naked women at the four corners, holding birds, hearken instead to Sasanian and Persian decoration. Thus the brazier signaled more than the wealth of its owner: it also showed his familiarity with western Asian culture and his comfort with the eclectic adoption, and adaptation, of traditions. Other bronze braziers survive from the classical world, but none looks quite like this one.

The brazier's parts came to light in 1986 at al-Fudayn in northern Jordan. They had been hidden in a storeroom inside a large and luxurious mansion, along with many other expensive items of furniture made of metal, ivory, glass, and a soft soapstone from Arabia called steatite. The hoard seems to have been

deposited around 800, when the town was destroyed, perhaps as a result of a rebellion, by troops loyal to Caliph al-Ma'mun (r. 813–833), or perhaps in an earthquake.

The mansion at al-Fudayn stands out for its luxurious furniture but is quite modest compared to other surviving elite residences in Greater Syria from the eighth century. The sprawling Umayyad dynasty ruled the Islamic territories from Damascus from 661 to 750, and in Syria the male relatives of rulers and former rulers enjoyed the benefits of wealth and leisure. After the Umayyads were wiped out in the Abbasid coup of 750, most of the residences built by crown princes and court-connected aristocrats during the Umayyad heyday fell into disuse. They had been vital to the social relations of the new Arab, Muslim ruling class in the generations after the Islamic conquests: such residences made possible the lavish hospitality that reinforced the alliances undergirding the Caliphate.

Al-Fudayn was smaller than other eighth-century Umayyad "palaces" (see Thing 27), and though it had a mosque it lacked wall paintings, mosaic pavements, a reception hall, and fortification. But like other Umayyad residences, al-Fudayn arose over a previous structure (in this case a Christian monastery) in a strategic location (close to the main regional highway, in an agriculturally fertile area, on a main route to Mecca, with good access to hunting grounds) and had multiple purposes. Production, storage, and processing of food were certainly important activities there. So too was partaking of the fruits of empire: a Roman-style bath complex, complete with underpavement heating ducts, hot, tepid, and cold chambers, and a changing room, occupies a quarter of the mansion.

The mansion's owner in the 700s evidently was the great-grandson of the third "Rightly Guided" caliph Uthman (d. 656), one of the wealthiest men in Syria. Literary texts record that two Umayyad rulers resided at al-Fudayn, Yazid II (d. 724) and Walid II (d. 744). Walid II especially developed a reputation for dissolute living (much amplified by supporters of the Abbasid regime after 750). His residence at Qasayr Amra had a nicely appointed bath, decorated with a cycle of paintings that celebrate sex, drink, and bodily enjoyment much as the brazier does. One of the paintings represents a (clothed) woman, possibly one of Walid's wives, lounging on a couch with a brazier beneath her.

Either in another hall or in the bath, a brazier like the one from al-Fudayn was essential equipment for Umayyad Syria's high society. Seated around it, maybe sharing delicacies heated inside the brazier, powerful men companionably passed the time in winter. Portable heaters made much more pleasant the space of communal nakedness, the bath. Pagan moralists had criticized communal baths, but their association with illicit sex, and not just with health and hygiene, was cemented in fifth-century Christian circles. Any who looked closely at the

al-Fudayn brazier would learn that its owner understood and maybe participated in Mediterranean cultural practices, however transgressive these might appear in early Islamic Syria.

Further Reading

M. Ahsan, *Social Life Under the Abbasids* (London, 1979), reconstructs Arab habits of indoor heating using literary sources. A. Ballian, "Al-Fudayn," in *Byzantium and Islam*, edited by H. Evans (New York, 2012), 212–16, surveys the site, its Umayyad finds, and the brazier. G. Fowden, *Qasayr Amra* (Berkeley, 2004) is thought provoking on Umayyad art and culture, including bathing customs and hunting. O. Grabar, *Early Islamic Art* (Aldershot, 2005), offers a great expert's opinion on the Umayyad residences (131–40 and 187–211). M. Hodgson, *The Venture of Islam*, vol. 1 (Chicago, 1974), remains the most inspiring narrative of early Islamic history. E. Key Fowden, "Christian Monasteries and Umayyad Residences in Late Antique Syria," *Antigüedad y Cristianismo* 21 (2004): 565–81, traces continuities between two different forms of housing. H. Kennedy, "Great Estates and Elite Lifestyles in the Fertile Crescent from Byzantium and Sasanian Iran to Islam," in *Court Cultures of the Muslim World*, edited by A. Fuess and J. Hartung (London, 2011), 54–79, also traces Syrian cultural continuities.

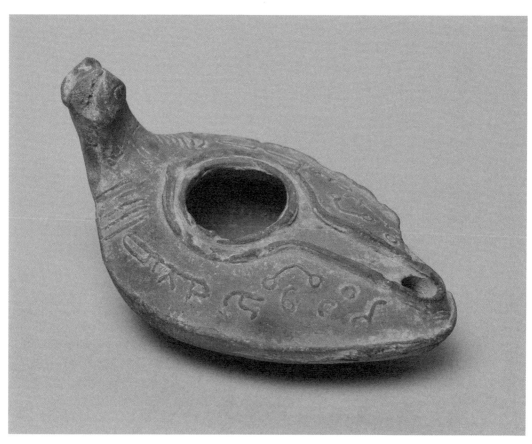

Thing 29. Terra-cotta lamp excavated at Jerash, Jordan, with Kufic inscription naming the potter Nudhur. Irbid Museum, Jordan, IR-1977. Photo courtesy of the Department of Antiquities, Amman.

29. Oil Lamp

Jerash, Jordan, eighth century

Candles, made of beeswax (required by ecclesiastical legislation) or, more often, of tallow, rose to prominence throughout the first millennium, transforming Dark Age artificial lighting in northern Europe. But in the Mediterranean region, old-fashioned olive oil–burning clay lamps remained a fixture throughout the whole period. This almond-shaped lamp was made in Jerash (Roman Gerasa, today in Jordan) in the eighth century. It is small, only 11 centimeter (4.3 inches) long and 6.7 centimeter (2.5 inches) wide, so would fit snugly in the palm of your hand. Though the handle projects higher, the fuel reservoir is a mere 3.5 centimeter (1.5 inches) high. The lamp was competently made and fired. At high temperatures in the kiln, iron in the clay oxidized, giving the lamp its orange-tan color. Firing also produced a "self-slip," or seal on the exposed parts of the fabric, so the potter did not need to apply any glaze to prevent the porous, grainy clay from absorbing oil and becoming soft again.

The potter signed his handiwork. In fact much of the decoration on this everyday, simple lamp consists of an Arabic inscription in Kufic letters circling the reservoir: "made by Nudhur son of Stephen in Jerash." There is also a stylized animal face on the tip of the handle (chipped), and a small cross at its base, flanked on either side by four tiny ridges. Both openings on the lamp are circled by a prominent lip that is functional: it caught any oil spilled when filling the reservoir through the bigger fill hole, and channeled it to the smaller wick hole on the nozzle.

Nudhur (whose unusual name is related to the Arabic word for vows) made the lamp the traditional way. He had two molds, one for the bottom half, one for the top half, and filled both with a thin layer (0.5 centimeter, or 1/4 inch, thick) of clay. He attached the resulting two convex cups, let the form dry somewhat, added the handle, cut open the holes, then fired the lamp. Nudhur's design was a late sixth-century development of Roman "discus" lamps, but incorporated innovations like the spill-proof lip.

In the 700s Jerash was a trademark worth advertising, presumably because customers trusted its manufacturing tradition. "Jerash bowls" and oval "Jerash lamps" circulated through the region. Before a violent earthquake in 749 that sent the city into decline, continuities in economic activity and craftsmanship distinguished Jerash: in the Umayyad period, kilns sprang up in abandoned spaces like the sanctuary of the temple of Artemis. The name of Nudhur's father (Stephen, a Christian name) suggests a quiet acculturation process, and maybe

conversion to Islam, in this former Byzantine administrative center during the late seventh and early eighth centuries. That Nudhur and his clients liked inscriptions is likewise an extension of ancient patterns. Other contemporary lamps from Jerash have Greek writing on them: very few are bilingual, and some show tenuous command of letter-making in both alphabets, though it *was* challenging to write backwards on the mold in order to obtain correctly aligned words on the lamps. If the custom of writing on lamps subsided during the ninth century, under the Umayyads the ancient "epigraphic habit" clearly flourished even on humdrum objects.

Like much of the eastern Mediterranean, the late Roman and Byzantine provinces of Palaestina I, II, and III enjoyed an economic boom. Demand for the region's agricultural surplus surged as Constantinople grew and North African grain and oil became less accessible. Thus there was plenty of olive oil produced in the area. The Arab conquests of the 630s recast the local administrative structures, but not the economic balance. Oil and lamps produced there continued to find users in such new Umayyad districts as Jund al-Urdun, which incorporated Jerash.

The fiber wick on this lamp left sooty stains around the nozzle as it gave off light and, no doubt, some smoke and acrid smells. For lamps, even lamps made of more luxurious materials, burned low-grade oil, extracted last by the application of heat to the already pressed oilcake, not the first press stuff people ate. Any domestic activity after sunset called for both lamps and a supply of this inedible oil. Portable clay oil lamps, set on the ground or on furniture, cast their lumens upward, unlike modern ceiling-mounted lighting. The effect was different, but not the purpose. Such lamps were part of humans' ongoing and still incomplete process of "colonization of the night."

Further Reading

K. da Costa, "Economic Cycles in the Byzantine Levant," *Levant* 42 (2010): 7–87, uses lamps from Pella to track production and circulation, and includes invaluable maps of find sites of "Jerash lamps," while her "Byzantine and Early Islamic Lamps," in *La céramique byzantine et proto-islamique en Syrie-Jordanie*, edited by E. Villeneuve and P. Watson (Beirut, 2001), 241–57, attempts to build a typology. P. Horden and N. Purcell, *The Corrupting Sea* (London 2000) chaps. 6–7, give mordant analysis to Mediterranean oil production in relation to social inequality. N. Khairy and A. Amr, "Early Islamic Inscribed Pottery Lamps from Jordan," *Levant* 18 (1986): 143–53, describes the genre, and this lamp. T. Lewit, "Oil and Wine Press Technology in Its Economic Context," *Antiquité tardive* 20 (2012): 137–49, explains eastern Mediterranean oil economics in the fourth to seventh centuries. R. Schick, "Inscribed Objects," in *Byzantium and Islam: Age of Transition, 7th–9th Century*, edited by B. Ratliff and H. Evans (New York, 2012), 186–89 is a nicely illustrated discussion of eighth-century lamps, including this one. A. Walmsley, "Trends in the Urban History of Eastern Palaestina Secunda During the Late Antique-Early Islamic Transition," in *Le Proche-Orient de Justinien aux Abbasides*, edited by A. Borrut et al. (Paris, 2011), 271–84, frames Jerash's history from 600 to 800. miri.ku.dk/projekts/djijp (accessed April 28, 2016) is the official site of the Danish-Jordanian Jerash excavations with updates and reports from 2002 to 2013.

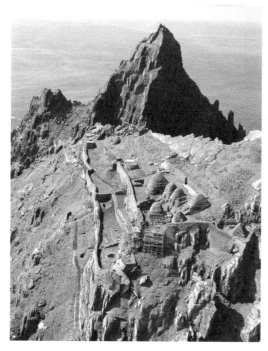

Thing 30A. Skellig Michael: view of the lower monastery with the south peak in the background. © National Monuments Service, Department of Arts, Heritage, Regional, Rural and Gaeltacht Affairs.

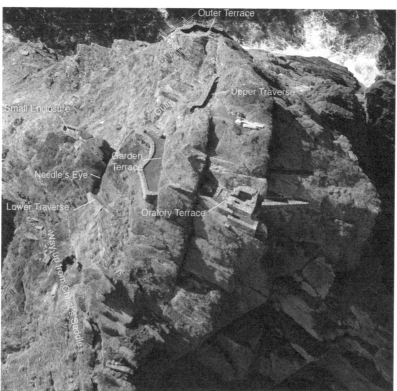

Outer Terrace

Upper Traverse

Small Enclosure

Gully

Garden Terrace

Needle's Eye

Lower Traverse

Oratory Terrace

Way up from Christ's Saddle

Thing 30B. Skellig Michael: overhead view of the structures on the South Peak. © National Monuments Service, Department of Arts, Heritage, Regional, Rural and Gaeltacht Affairs.

30. Skellig Michael Monastery
Ireland, eighth–tenth centuries

The Island of Skellig Michael is a sheer, sandstone promontory that juts out of the Atlantic Ocean 11.6 kilometers (7 miles) off the southwest coast of Ireland. The seas are so rough and the weather so inclement that it is readily accessible by boat from the mainland only between late May and late September. Today, its only inhabitants are small rodents and several species of seabirds, though Luke Skywalker does dwell there in solitary retirement in J. J. Abrams' *Star Wars: The Force Awakens* (2015), evidently because the place is so obviously remote. Between the eighth and thirteenth centuries, however, the tiny island hosted a resident community of humans. These hardy souls were Christian monks who came from the Irish mainland in search of the most radically isolated place they could find, a remote haven where they might subsist in prayer and contemplation, undisturbed by the cares of the world, like the early Christian ascetics in the Egyptian desert from whom they drew their inspiration. Ever since Christianity came to Ireland, mainly via England and Scotland, in the fifth and sixth centuries, the island had become a hotbed of monasticism, its countryside liberally sprinkled with communities of men, and of women, devoted to living separately—in both spatial and social terms—from society at large.

The principal monastic settlement on Skellig Michael sat in the protected lee of the lower of the island's two rocky summits, the so-called North Peak. Within enclosure walls that delimited the sacred precincts of the monastery proper rose six beehive-shaped dwellings, called clochans, and two small, rectangular churches, the largest of which had interior dimensions of only 3.45 by 2.35 meters (11.5 by 7.5 feet). All were built entirely of dry-stone masonry, consisting of flat stones fitted together with no mortar, tapering inward to form a corbelled roof. A total of perhaps twelve monks inhabited the complex, sleeping two to each clochan.

Yet some members of the community sought a place of still greater physical and spiritual isolation. They turned to the higher, steeper south peak, where they constructed several stone terraces clinging to the sheer sides of the summit, accessible only via a dizzying climb along narrow ledges and sheer cliff faces overlooking the sea 200 meters (220 yards) below, into which they carved just enough foot- and hand-holds to permit a determined climber to ascend. Three separate terraces were constructed with retaining walls of dry-stone masonry, infilled with rubble and earth to create level platforms only a few meters wide.

The lowest, the so-called garden terrace, preserved no traces of habitation, which led its first modern investigators to surmise that it was used as a garden to provide sustenance for the solitary hermit whom they pictured living atop the

peak. The next, higher terrace contains the most substantial structural remains, notably the foundations of a nearly square, dry-stone oratory measuring approximately 2.3 by 2 meters (7.5 by 6.5 feet) on the inside, located at the east end of the terrace. Across from the oratory to the west was a *leacht*, a rectangular, dry-stone platform that may have served as an outdoor altar or a container for relics. An upright stone slab inscribed with a cross, carved probably in the ninth century, stood nearby. Two connected, rock-cut basins collected rainwater from the face of the cliff for the use of the terrace's occupants. The third terrace was built higher still, just below the exposed, north side of the summit. Cold and wind-lashed even in sunny summer weather, the inhospitable perch offers sweeping panoramic views across the island to the lower monastery and the Irish mainland beyond. Much of the terrace has collapsed, its unmortared masonry undermined by centuries of wind and rain, but traces of paving, a leacht, and possibly a small shelter remain.

While the structures on the south peak have been intensively studied since the 1980s, much uncertainty remains about their chronology and even their function. Parts of all three terraces have crumbled away, structural remains apart from the oratory are sparse and difficult to identify, and none of the few surviving objects can be closely dated. All that can be said with confidence is that the terraces were built and occupied between about 700 and 1200, the period when the lower monastery was in use. The presence of the water basins on the oratory terrace has led some to imagine it inhabited by hermits whose effort to achieve maximal separation from human society prompted them to rely as little as possible on others for their basic needs. In part because surviving traces of living spaces are so meager, however, others have imagined the terraces as a place where members of the lower community went on a more occasional basis, performing a devotional circuit of the various *leachta* (the plural of leacht), altars, and crosses scattered across the three terraces and the paths that connected them.

It is possible that the South Peak also served as a place of refuge for the monks in times of danger. The earliest written reference to the monastery of Skellig Michael is a description of a Viking raid on the island in 824, when one of the monks was carried off to die in captivity, allegedly of starvation. From the later eighth century through the tenth, raiders from Scandinavia were a frequent presence in the waters around Britain and Ireland, and they initially found monasteries easy prey, full of valuable objects and able-bodied monks to enslave. The South Peak provided a 360-degree view over the waters all around the island, such that warning could have been signaled to the monks below in plenty of time to allow them to take refuge in case of attack; and no enemy could have scaled the South Peak under an avalanche of rocks hurled down from the upper terraces.

First and foremost, however, the terraces of the South Peak were solitary places of sublime beauty, evidently designed to bring those who made the dangerous, exhausting climb—a kind of vertical pilgrimage—quite literally closer to their God. For the monks of Skellig Michael, the effort and risk of hauling tons

of building-stone up a vertical cliff-face under the most trying weather conditions was but a prelude to the still more difficult task of inhabiting spaces as far-removed as possible from anyone and anything extraneous to the project of unstinting prayer and contemplation.

Further Reading

The dramatic account of the initial investigation of the structures on the South Peak during the 1980s is in W. Horn, J.W. Marshall, and G.D. Rourke, *The Forgotten Hermitage of Skellig Michael* (Berkeley, 1990). For presentation of the subsequent archaeological investigations that have provided the most detailed information available for the date, occupational history, and configuration of both the lower monastery and the South Peak, see E. Bourke, A.R. Hayden, and A. Lynch, *Skellig Michael, Co. Kerry: The Monastery and South Peak. Archaeological Stratigraphic Report: Excavations 1986–2010* (Dublin, 2011).

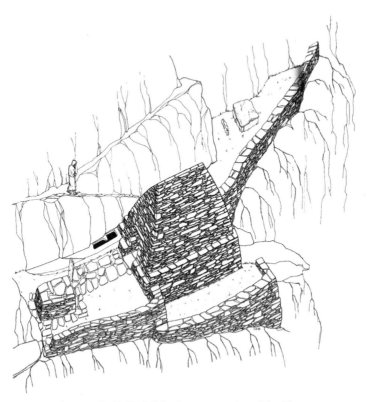

Thing 30C. Skellig Michael: reconstruction of the 'Oratory Terrace' on the South Peak. © National Monuments Service, Department of Arts, Heritage, Regional, Rural and Gaeltacht Affairs.

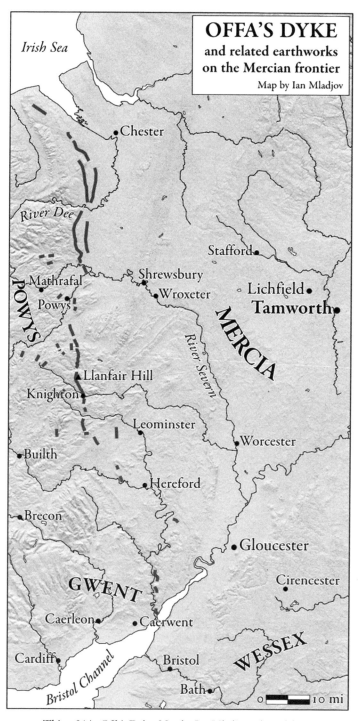

Irish Sea

OFFA'S DYKE
and related earthworks
on the Mercian frontier
Map by Ian Mladjov

•Chester

River Dee

Stafford•

POWYS

Mathrafal•

Shrewsbury
Powys• •Wroxeter

Lichfield•
Tamworth•

MERCIA

River Severn

Llanfair Hill

Knighton•

Leominster•

Builth•

•Worcester

•Hereford

•Brecon

•Gloucester

Cirencester
•

GWENT

Caerleon•

•Caerwent

WESSEX

Cardiff•

Bristol
Channel

Bristol•

Bath•

0 10 mi

Thing 31A. Offa's Dyke. Map by Ian Mladjov, adapted from
Cyril Fox, *Offa's Dyke* (London, 1955).

31. Offa's Dyke
England/Wales, late eighth century

This southward view of the section of Offa's Dyke visible today between Spoad hill (432 meters, or 1,417 feet, above sea level) and Llanfair hill (401 meters, or 1,315 feet) in Shropshire still awes. The Dyke here is monumental, made up of a wide ditch sometimes still 2 meters (6.5 feet) deep with an embankment to its east side up to 2 meters high. Though abraded by wind and rain, overgrown with vegetation, and carved by burrowing animals, Offa's Dyke takes advantage of the local terrain enough to deserve to be considered purposefully designed. The early medieval landscape was more wooded, but here the Dyke offers exceptional overlooks both eastward and, more importantly, westward towards Wales (in this picture sheep enjoy both views). The Welsh (from an Old English word meaning "alien") were unreliable allies of the kings of the Anglo-Saxon polity called Mercia on whose western edge the structure arose. But the Welsh cleric Asser, who served the Anglo-Saxon king Alfred and wrote in 893 that Offa built a great rampart (*vallum magnum*) "from sea to sea," seems to have exaggerated. Archaeological surveys currently attest to Offa's Dyke only along about 103 of the roughly 250 kilometers (155 miles) separating the Irish Sea from Bristol Channel, and English from Welsh territory. Moreover, much of the Dyke was and is less grand than at Llanfair hill, and in a few places (even in Shropshire) the diggers dug a baffling second ditch to the east of the embankment, as if they expected trouble to come from that direction. But excavators also found the ditch, some 7 meters (22 feet) wide, where no sign of it or the bank is visible today, and some archaeologists think that a parallel, shorter earthwork called Wan's Dyke filled in the main "gaps." The apparent incompleteness and erratic design have left open interpretation of this major Dark Age construction.

Offa (r. 757–796) managed to exercise a rough supremacy over most other Anglo-Saxon rulers in the latter 700s. He was less successful with the Welsh highlanders, whose economy was more pastoral than Mercia's, and who may have relied on ancient ridgeways that the Dyke severed to reach seasonal pastures. Offa's Dyke was no novelty in an island whose Iron Age populations had a long tradition of earthwork making. Roman emperors like Hadrian and Antoninus Pius (and perhaps Septimus Severus, if we believe the *Historia Augusta*, or still later leaders, in imaginative readings of Procopius's *Wars* 8.20.42) had built famous linear fortifications of masonry against Celtic threats in Britain. But Offa's Dyke's exceptional, truly Roman scale, and its old-fashioned earthy materials, expressed the diplomatic outlook of an ambitious Anglo-Saxon ruler most assiduous in securing his authority.

Like the hegemonies of most early English kings, Offa's proved ephemeral. Accelerated by Viking incursions and occupation, Mercia's ninth-century decline destroyed most royal records (an official diploma or two, and coins, are what survives of Offa's governance; English property records in this borderland region were probably never numerous, and very few exist today. Coeval Welsh writings boil down to a little poetry). Though there are some place names that associate the embankment with Offa, the Dyke became securely Offa's especially through Asser's *Life of King Alfred*. In effect, the association of massive earthwork and Mercian ruler kept alive the fame of a king who could not count on an enthusiastic propagandist like Asser or the monk-historian Bede (d. 735, who admired Rome's fortifications in northern England, but not Mercian kings) to fix for posterity his greatness. Later medieval people who knew about Offa knew him as the author of the Dyke.

It is debatable whether the ditch-and-bank structure actually was an early medieval restoration of late Roman fortifications, or a "negotiated" delimitation of the territory claimed by Welsh and Mercian kings (in an age when states did not favor linear boundaries), or a protection for Mercia's farms from over-acquisitive highlanders. Indeed, there are still no secure archaeological dates for the structure. Yet Offa's Dyke definitely succeeded as an advertisement of Offa's power to the Welsh, the Mercians, and those who toiled there. It reminded onlookers (and users of texts) of how this Mercian king had coerced thousands of diggers, and thousands of landowners and land-users, to surrender their resources. Leaving aside aspects that most impress us today, like feats of geographical vision (Offa's or Asser's) that linked the mouth of the Severn River to the mouth of the Dee, what mattered most about the Dyke to Offa's contemporaries was probably the massive digging it required. Such digging may have been made possible by Anglo-Saxon kings' theoretical right to residents' labor for "public" infrastructure projects, particularly roads, bridges, and fortifications.

Further Reading

D. Hill and M. Worthinton's *Offa's Dyke: History and Guide* (Stroud, 2003), is a grounded introduction to the surviving remains. K. Ray and I. Bapty, *Offa's Dyke: Landscape and Hegemony in Eighth-Century Britain* (Oxford, 2016), provides a comprehensive review of evidence and debates about the dyke, with an optimistic assessment of its design and completeness. P. Squatriti, "Digging Ditches in Early Medieval Europe," *Past and Present* 176 (2002): 11–65, sets the dyke in a European context of similar linear earthworks, while his "Offa's Dyke between Nature and

Culture," *Environment and History* 9 (2004): 37–56, proposes an ecological reading of the dyke. A. Williams, "Offa's Dyke: A Monument without a History?" in *Walls, Ramparts, and Lines of Demarcation: Selected Studies from Antiquity to Modern Times*, edited by N. Fryde and D. Reitz (Berlin, 2009), 31–56, surveys the evidence and debates about it.

Thing 31B. Offa's Dyke, view on Llanfair hill (near Knighton).
Photo by Charlesdrakew, Wikimedia Commons.

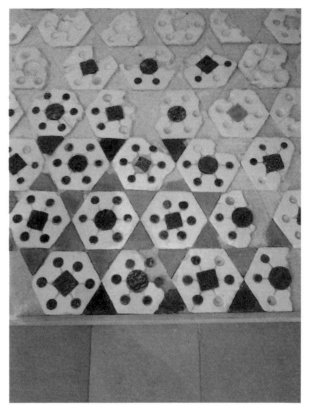

Thing 32A. Palace-chapel of Arechis II, Salerno, Italy.
Opus sectile floor-paving.

Thing 32B. Palatine Chapel of Arechis, interior. The bare stone walls at
left-center are substantially those of the eighth century.

32. The Palace of Arechis

Salerno, Italy, ca. 780

This section of pavement formed part of the floor of the Lombard prince Arechis II's palace-chapel in Salerno, built ca. 780. The polychrome geometric patterns, reminiscent of a richly colored carpet, were made from pieces of red and green marble recycled from earlier Roman-era buildings, recarved, and inserted into hexagonal tiles made from white limestone, which were set in a bed of mortar 10–15 centimeters (4–6 inches) thick. Triangles of red and green marble filled the interstices between the hexagons, surrounding each with a six-pointed star. This technique of using finely cut pieces of marble in a variety of colors to create intricate designs, called *opus sectile*, had been a characteristic form of interior decoration in the most opulent Roman and Byzantine structures, including imperial palaces and important churches.

Why did Arechis go to such trouble with the décor of his palace? The Lombards had ruled Italy since 568, but in 774, Charlemagne's Franks conquered the northern part of their kingdom. Arechis's Duchy of Benevento was the last independent Lombard polity on the peninsula, and Arechis responded by promoting himself from duke to prince, a title more fitting for the last sovereign Lombard ruler. He transformed Salerno, a coastal town less vulnerable than Benevento, into a second capital city fit for a newly minted prince, complete with expanded fortifications and the grand new palace. Just in time: in the spring of 786, Arechis's worst fears seemed about to come true. Charlemagne came south with his army to Naples and was apparently poised to swallow up the southern Lombards. Charlemagne sent a delegation to Salerno for an audience with Arechis, who put on a show designed to culminate, in the most dramatic way possible, at his new palace.

When the envoys approached, they found the Lombard army drawn up outside the city walls in parade formation, their polished weapons and armor glittering in the sun. An advance party met the visitors on the road and led them into the city, toward the main entrance of the palace, which faced the sea from the top of a wide stairway. Charlemagne's party found both sides of the stairway packed with the principality's best-looking youths, holding hunting falcons; trumpeters blew a fanfare. The visitors, puzzled not to see Arechis himself, were invited to proceed into the palace. When they entered, their path was again flanked by more youths in different attire, all playing instruments, but again, there was no sign of Arechis. Told to "go on ahead!" they came to a second room, where another group of richly dressed courtiers sent them on into yet another room, the grandest of all, where they at last found Arechis, seated on a golden throne and surrounded by distinguished, elderly councilors. "And beholding all the wisdom of Arechis,

and the palace that he had built, and the food of his table, and the dwellings of his servants and the ranks of his ministers, their clothing and their servants, [the envoy] was greatly amazed," according to the author of the tenth-century *Chronicon Salernitanum*.

Close study of the standing remains of the palace, much of which are now covered by later buildings, suggests that it was indeed designed to amaze visitors. The rectangular complex rose over the remains of a Roman bath, whose surviving walls comprised much of the ground floor, which contained storerooms, kitchens, servants' quarters, and other utilitarian spaces. The much loftier and more richly decorated upper level housed the royal apartments, a dining room, the grand hall where guests were received and official business transacted, and the palace-chapel. The sumptuous décor of the palace is especially revealing of its builders' sources of inspiration. Three sides of the upper story were lined with continuous loggias whose open colonnades overlooked the city and the sea to the south. These galleries mimicked a standard feature of the palaces built by Roman and Byzantine emperors since the third century AD. The Great Palace in Constantinople, the imperial palaces at Thessaloniki and Antioch, Diocletian's villa in Split, and later the Ostrogothic king Theoderic's palace in Ravenna all featured colonnaded galleries overlooking the sea or, in the case of Antioch, a river.

Within Arechis's palace, the *opus sectile* revetment on floors and walls throughout the upper level evoked the interiors of the imperial palaces. Arechis proclaimed his Roman credentials even more explicitly by dedicating the chapel in the name of the patron saints of Rome, Peter and Paul. And should anyone still have failed to make the connection, the exterior of the palace was embellished with a dedicatory poem written by the famous Lombard scholar Paul the Deacon, inscribed in golden-bronze letters in a continuous band on the walls, beginning: "Emulating Romulean [i.e. Roman] halls, these edifices arise . . ."

By modeling his palace on Roman and Byzantine exemplars, and using it to host elaborate spectacles also clearly based on Romano-Byzantine court ceremonial, Arechis seems to have done his best to look—and act—like an emperor. The more threatened he felt by rising Frankish power after 774, the harder he worked to present himself as a sovereign ruler worthy of Charlemagne's respect. Like the blowfish that balloons in size when threatened, he chose the appearance of might as the best substitute for the real thing. Though Arechis made some concessions in the ensuing negotiations, including handing over his son and heir as a hostage, Charlemagne took his troops back north, leaving the princes of Benevento effectively autonomous for centuries to come.

Further Reading

English-language scholarship on Arechis's palace is scarce. Start with J. Mitchell, "Artistic Patronage and Cultural Strategies in Lombard Italy," in *Towns and Their Territories between Late Antiquity and the Early Middle Ages*, edited by G. P. Brogiolo, N. Gauthier, and N. Christie (Leiden, 2000), 347–70, at 352–56. For more detail, see P. Peduto, "Quanto rimane di Salerno e di Capua longobarde (secc. VIII-IX)," in *I Longobardi del sud*, edited by P. Roma (Rome, 2011), 257–78, at 258–65. The description of the reception of Charlemagne's envoys comes from the *Chronicon Saliternanum*, chaps. 12–13. The main features of late Roman and Byzantine palaces are succinctly outlined in S. Ćurčić, "Late-Antique Palaces: The Meaning of Urban Context," *Ars Orientalis* 23 (1993): 67–90. N. Christie's *The Lombards: The Ancient Longobards* (Oxford, 1995), usefully introduces Lombard culture and history. For a shorter overview of Lombard and Frankish Italy in the eighth and ninth centuries, see P. Delogu, "Lombard and Carolingian Italy," in *The New Cambridge Medieval History*, vol. 2, *c. 700–c. 900*, edited by R. McKitterick (Cambridge, 1995), 290–319.

The Ribat at Monastir

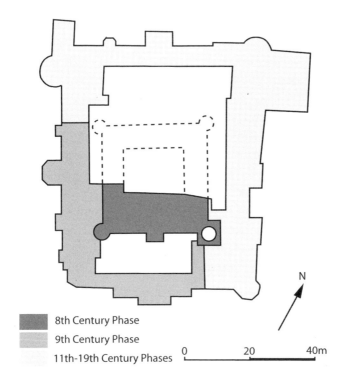

8th Century Phase
9th Century Phase
11th-19th Century Phases

0 20 40m

N

Thing 33A. The ribat at Monastir: ground plan.

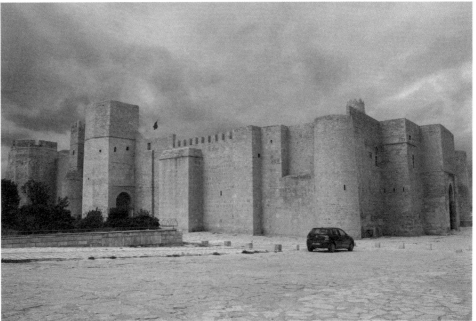

Thing 33B. The ribat at Monastir: the visible section dates primarily to the ninth century. Photo by Andrew Skudder, Wikimedia Commons.

33. The Ribat at Monastir

Monastir, Tunisia, ca. 796

On the Tunisian coast at Monastir stands an imposing, castlelike structure, whose building began in AD 796 under the Islamic governor of North Africa, Harthama ibn Ayan, one of the caliph Harun al-Rashid's most effective commanders. Though largely concealed by centuries of later additions and repairs, enough of the first structure survives to indicate that it was roughly square, with sides about 33 meters (108 feet) long and circular towers at three corners. The rectangular tower at the fourth corner was larger and probably higher, serving as a lookout post and just possibly also a minaret, the tower from which the faithful were summoned to prayer five times daily (if this was the case, it would be the earliest known minaret). A single gate in the south wall provided the only access to the enclosure, the interior of which consisted of an open courtyard surrounded on all four sides by small, rectangular rooms facing onto the courtyard. The whole complex faces south-southeast, toward the holy city of Mecca, which Muslims face when praying; a chamber above the gate probably contained a mihrab, a niche in the wall of a mosque used to indicate the direction of Mecca.

The layout of the compound resembles a cross between a fortress and military barracks on the one hand, and a medieval monastery on the other, fittingly and maybe not coincidentally, given that Monastir (the name of which derives from the Latin *monasterium*—monastery) functioned both as a religious retreat and a fort. Thanks to several writers who described Monastir in the tenth and eleventh centuries, we know that it was a *ribat*, a common and widely diffused institution in the early Islamic period, found not only throughout North Africa but also in Spain, along the coast of the Levant, and as far east as northern Iran and western Afghanistan.

But while many ribats are known, both from their surviving remains and especially from mentions in written sources, it is difficult to say exactly how they functioned. It may be best to say that ribats served diverse and sometimes multiple purposes in different parts of the Islamic world, purposes only hinted at in the surviving texts. Ribats are variously referred to as fortresses and garrisons, as hostels and way stations providing shelter and protection for travelers in remote or dangerous places, and as ascetic retreats. The Tunisian ribats such as Monastir are commonly described as guard posts and places of refuge for the neighboring people in case of raids by the "Romans," the Arabic term for Byzantine Christians, who occasionally descended on the African coast in their ships, seeking plunder and slaves, as did Umayyad loyalists from Spain and Shia schismatics from Egypt.

But the more regular, recurring role of Monastir and its neighboring ribats was as secluded places of gathering for the pious, especially during Ramadan, the Muslim holy month. Men would assemble there to "do ribat," a conspicuous act of devotion meant to purify the participants and invoke divine favor. According to a tenth-century Muslim writer in Spain, those who committed themselves to do ribat for the full forty days of Ramadan were assured remission of all their sins and immediate entrance to paradise upon death. At the end of the eleventh century, there is even a reference to a group of holy women at Monastir, the only time women are ever said to have occupied a ribat; these women are the closest known parallel in the Islamic world to Christian nuns.

The role of Monastir seems also to have evolved over time, in response to changing historical circumstances. When it was begun in 796, only a century after the Muslim conquest of Tunisia, conflict was frequent, both with the Christian inhabitants of Sicily to the north, and with the fiercely independent Berber tribes living along the northern fringes of the Sahara to the south. Strong, readily defensible compounds such as Monastir undoubtedly helped to consolidate Muslim control over the region, and to underpin further expansion. With the passage of time, however, Monastir's military role was apparently eclipsed by its spiritual profile. A resident community supported by pious donations seems to have dwelled there by the later eleventh century; holy figures were buried there, and pilgrims increasingly visited the site to pray and bask in its aura of sanctity. It may not be coincidence that the ninth, tenth, and eleventh centuries also saw the development of cloistered, Benedictine monasticism into one of the pillars of medieval Christian society. It was exactly in this period, in fact, that the square, stone-built cloister, a building-type strikingly similar to Monastir and other North-African ribats, first became a common feature of European monasteries.

Could Muslims in North Africa have drawn inspiration from European monasteries, places dedicated to fasting, prayer, and unstinting devotion to God, as were the early Ramadan gatherings in North African ribats? The coincidence between form and function may be purely casual. Or perhaps, in the deadly serious business of ensuring God's favor for the deserving, the growth and flourishing of Monastir and countless other ribats across the Islamic world speaks to a kind of spiritual arms race, as Muslims strove not to let ascetic Christians outdo them in conspicuous acts of piety. For Christians and Muslims alike in the early Middle Ages, such acts might be essential not only to demonstrate who God's chosen people were, but also to ensure their triumph over the enemies of the faith.

Further Reading

The ribat at Monastir features prominently in H. Kennedy, "The *Ribāt* in the Early Islamic World," in *Western Monasticism* Ante Litteram: *The Spaces of Monastic Observance in Late Antiquity and the Early Middle Ages*, edited by H. Dey and E. Fentress (Turnhout, 2011), 161–75; see also J. Chabbi, "Ribat," in *The Encyclopedia of Islam*, edited by H.A.R. Gibbs et al., 2nd ed., vol. 8 (Leiden, 1995), 493–506. More broadly on early medieval North Africa, see P. von Rummel, "The Transformation of Ancient Land- and Cityscapes in Early Medieval North Africa," in *North Africa under Byzantium and Early Islam*, edited by S. Stevens and J. Conant (Washington, 2016), 105–17.

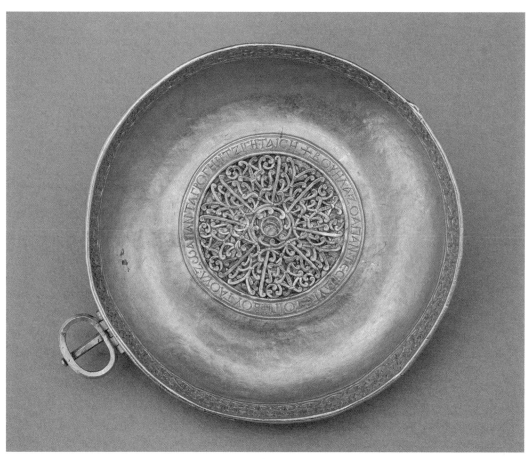

Thing 34. Nagyszentmiklós treasure, Bowl 34, inv. no. ANSA VIIb. 34.
Photo courtesy of the Kunsthistorisches Museum, Vienna.

34. Bowl 21, Nagyszentmiklós/Sânnicolau Mare Treasure

Nagyszentmiklós/Sânnicolau, Romania, ca. 650–800

In 1799, at Sânnicolau Mare in Romania (Nagyszentmiklós in Hungarian), a farmer digging a ditch found a collection of spectacular gold vessels, of which twenty-three survive, weighing almost ten kilograms. The town was part of the Austro-Hungarian Empire at the time, so the treasure was taken to Vienna, and has been held in the Kunsthistorisches Museum there ever since.

The collection consists of elaborately decorated vessels made of eighteen to twenty-two karat gold, including seven ewers, four flat dishes with buckles on the outside rim, a drinking-horn, two beaker-shaped cups, two goblets, two ladles, and other elaborately shaped bowls. Comparative studies, and recent Carbon-14 dating of the find site, have indicated that they were made and buried at some time between 650 and 800.

Bowl 21 is one of the flat dishes with a buckle on its rim, presumably so that it could be attached to a leather belt or harness. It is 12 centimeters (7.5 inches) in diameter, weights 212 grams, and is made of twenty-two karat gold. It has decorative medallions on both the inner and outer surfaces. The one on the exterior shows a lion-bodied griffin straddling a goat; the interior medallion is an abstract openwork pattern, which is surrounded by the following inscription in Greek capital letters, consisting of nine words separated by dots, with the beginning marked by a cross:

+ ΒΟΥΗΛΑ· ΖΟΑΠΑΝ· ΤΕСΗ· ΔΥΓΕΤΟΙΓΗ· ΒΟΥΤΑΟΥΛ· ΖWΑΠΑΝ· ΤΑΓΡΟΓΗ· ΗΤΖΙΓΗ· ΤΑΙСΗ

Although the letters are Greek, the language is not: the inscription is in an unknown language, probably some form of Turkic. Various translations have been proposed for this inscription, with some words interpreted as names or titles, perhaps of the craftsmen, or the patrons, or the owners of the dish. Some of the words seem to be related to known Turkic words, particularly the word ΒΟΥΗΛΑ (*buyla*), a title attested on early Bulgar inscriptions. ΖΟΑΠΑΝ (*zoapan*) might be related to the Turkic or Slavic word *zhupan*, or "village chief," implying that it too might be a title. Some scholars assume that because this word is repeated twice, we have reference to two individuals, *zupan* Buyla and *zupan* Butaul.

Clearly the treasure collection of which this bowl is part was once the possession of someone wealthy and important. To what sort of person did the treasure belong, and to whom, therefore, did the writing on this dish refer? The peoples

who occupied this region in the seventh to ninth centuries did not write about themselves, and what we know about them comes from the writings of their literate (and Christian) neighbors, who tended to be hostile. The Banat area, now along the border of Romania with Hungary and Serbia, was ruled by the khan of the Avars from the mid-sixth century until the khaganate was destroyed by Charlemagne's armies in the 790s. Who the Avars were, and what language(s) they spoke from the sixth to the eighth centuries, are matters of conjecture; they might have originally been Turkic-speakers, but by the late eighth century they were probably using a Slavic language adopted from the majority populations in the region. However, the Avars had been challenged by various Slavic- and Turkic-speaking groups in the eighth and ninth centuries. Bulgars, Utigurs, Onogurs, and Kutrigurs, who spoke Turkic languages, had also appeared in the area west of the Black Sea in the mid-sixth century, and fought against the Avars periodically, exploiting the vacuum created by Charlemagne's success. In the early ninth century the Bulgar Empire took over much of the old Avar territory. Finally, in the mid-ninth century the Magyars, who might be the same as the Onogurs and who spoke a Finno-Ugric language, appeared in central Europe; by the late ninth century they had established themselves in what is now Hungary.

A treasure buried in the Banat region dating to the seventh to ninth centuries could have belonged to any of these groups. Since Nagyszentmiklós is located right where several modern states converge, arguments about its origin have been tied to nationalistic-historical arguments ever since the treasure was found. The Buyla inscription makes the question more interesting, but does not resolve it, since the language in the inscription, probably Turkic, might have been used by several of the groups who lived in the area during the period 650–800. From the nineteenth century, some scholars have ascribed the language and the treasure to the Bulgars, though Hungarian scholars have claimed it for the Magyars.

Most recently and convincingly, scholars have proposed that the treasure must be associated in time and place with the Avar khaganate, and that it was buried at the time of either the Frankish or Bulgar conquest of the Avars around the year 800. Several of the other vessels in the treasure carry runic inscriptions in another unknown language; runes like these have also been found on a few objects from Avar tombs, confirming the Avar identity of the treasure.

We know from Frankish sources that the Avar khans, having extorted payments in gold from the Byzantine Empire for several centuries, had amassed fabulous amounts of treasure that was taken as plunder by Charlemagne's army. It is certainly feasible that the vessels from Nagyszentmiklós are a small remnant of a culture in which the possession of ostentatious golden objects was a sign of power and status. The fact that these objects were decorated with inscriptions implies that some of the elite valued writing, in a language that is otherwise not known to

have been written down, which conveys an awareness of linguistic (and perhaps thus ethnic) difference in central Europe at this time (see Thing 37).

Further Reading

The most detailed study of this treasure is C. Bálint, *Der Schatz von Nagyszentmiklós: Archäologische Studien zur frühmittelalterlichen Metallgefässkunst des Orients, Byzanz und der Steppe* (Budapest, 2010). However, in English, see T. Kovács and E. Garam, *The Gold of the Avars: The Nagyszentmiklós Treasure* (Budapest, 2002). On the languages spoken in this region, F. Curta, "The Slavic Lingua Franca (Linguistic Notes of an Archaeologist Turned Historian)," *East Central Europe* 31, no. 1 (2004): 125–48.

PART VI

Things of the Ninth Century

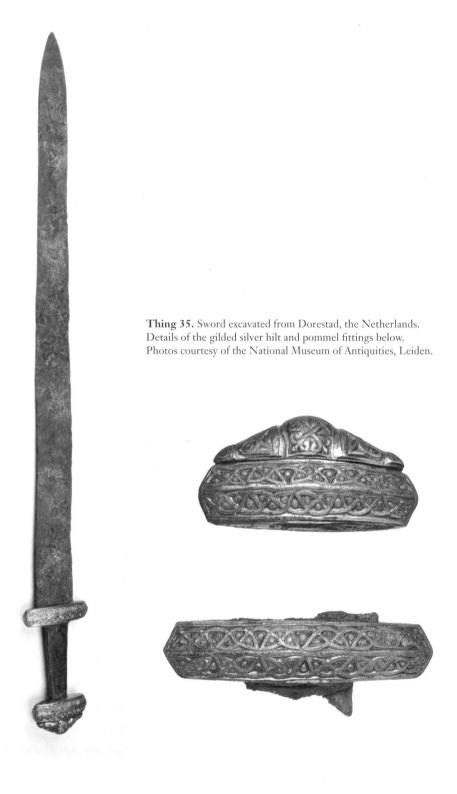

Thing 35. Sword excavated from Dorestad, the Netherlands. Details of the gilded silver hilt and pommel fittings below. Photos courtesy of the National Museum of Antiquities, Leiden.

35. Sword from Dorestad

Dorestad, the Netherlands, ca. 800

In July 1969, a group of Dutch high school students at history summer camp found this remarkable sword. They were helping members of the Dutch Archaeological Service conduct the largest archaeological excavation ever undertaken in the Netherlands, at the site of Dorestad, an early medieval *emporium* located in the Rhine delta near the town of Utrecht. One of the students noticed a rusty strip of metal in the wet, sandy soil of a recently excavated patch of ground. The strip led to the hilt of a sword in gilded silver, covered with twisting, interlaced vegetal scrolls, broken in two pieces at the hilt but otherwise complete except for the tip of the blade. When the hilt was taken to be cleaned and conserved, it was separated from the blade, which remained in a storeroom along with thousands of other finds from the excavations at Dorestad; it was only in 2008 that the missing blade was finally rediscovered and reunited with the hilt.

The surviving portions of the sword measure 82 centimeters (32.3 inches) long; including the tip, now restored, its original length was about 88 centimeters (34.6 inches). The gilded pommel (the knob at the bottom of the grip) is hollow, with sockets for thin metal rods threaded through the grip and the guard (the crosspiece at the base of the blade) that attached it firmly to the blade. The blade itself consists of high-carbon steel edges attached to a pattern-welded core at its center. Pattern-welded blades were forged from several thin metal rods laid side by side, heated in the forge and hammered flat into a single core. Each rod was itself made of many thin layers of iron or steel of differing appearance and degrees of hardness, welded together and hammered into tubular form. Often twisted before being finally forged into a complete blade, these layered rods, filed and polished, left wavy patterns in the finished metal of the blade. The technique resulted in the optimal blend of strength and suppleness: the braided core made the sword flexible and resistant to shattering, while the more brittle but harder steel along the edges allowed the blade to take and hold a lethally sharp cutting edge. Developed in the second and third centuries AD, the technique was in widespread use in Scandinavia and northwest Europe (a similar one was found at Sutton Hoo—see Thing 20) when this sword was forged around the year 800.

Blades like this one required expensive materials and many hours of labor by exceptionally skilled craftsmen to produce. A good one was the most expensive thing a warrior could take to battle, his horse included. Like the swords in *Beowulf,* they were often named, and passed down from generation to generation. A particularly interesting feature of this sword is the triangular finial of its

two-part pommel, the style of whose decoration makes it a century older than the rest of the pommel and the crosspiece; this was a composite weapon made in part of heirlooms with a storied history behind them. As for the identity of its owner, nothing can be said, except that he was wealthy and powerful—a nobleman beyond doubt. The excavators surmised that it might have been placed in a burial, along with an iron spearhead also found nearby, but as no evidence of a burial was found, it is impossible to be sure. There are many ways an exceptional sword like this might have made its way to Dorestad, and many ways it might have ended up where it was found, for Dorestad was one of the most remarkable places in early medieval Europe.

The town grew up in the seventh century in the shadow of an old Roman fort, as a base for Frisian mariners and merchants, close cousins of the Anglo-Saxon inhabitants of England just across the English Channel. In the early eighth century, Dorestad became part of the Frankish kingdom. In its heyday in the later eighth and early ninth centuries, it was the greatest marketplace in the realm. Modern scholars refer to early medieval market-towns as *emporia*, and Dorestad was one of the largest known, stretching for more than four miles along the west bank of one channel of the Rhine delta. The densely packed houses and storerooms lining the river faced onto wooden docks, where seagoing ships from the North Sea and riverboats plying the Rhine loaded and unloaded their wares. Skins, metals, amber, and slaves from the British Isles and Scandinavia came to Dorestad; weapons, textiles, wine, glass, books, jewelry, and fine metalwork made upriver went back, sent from cities such as Duisberg, Cologne, Trier, Mainz, Worms, and Strasbourg, where merchants from Dorestad established busy commercial neighborhoods—entire "Frisian" quarters.

Between 834 and 863, the Vikings took advantage of weak coastal defenses to raid the town dozens of times. The economy of the fragmenting Frankish kingdom slowed; trade shifted to smaller emporia located in other branches of the river delta; and by the tenth century, all that remained of Dorestad was a sleepy riverside village. Like its sister-emporia around the North Sea and Baltic fringes of the Frankish realm—Quentovic in France, Hamwic in England, Ribe in Denmark, Haithabu in Germany—Dorestad vanished as suddenly as it had appeared.

Perhaps the sword belonged to a visitor from Scandinavia, Britain, or the Frankish kingdom. Possibly it belonged to one of the king's officials stationed in the old Roman fort. It may have been made at Dorestad itself, in one of the town's many smithies, or it might have come from a Frankish royal workshop upriver. It may have been buried with its last owner, or hidden from marauding Vikings. In a city bursting with all the best that the early medieval world produced, and frequented by visitors (and eventually attackers) from its farthest corners, the

presence of a precious sword is as unsurprising as its provenance is impossible to explain with any certainty.

Further Reading

The discovery and restoration of the sword is described in A. Willemsen, "Dorestad, a Medieval Metropolis," in *From One Sea to Another: Trading Places in the European and Mediterranean Early Middle Ages*, edited by S. Gelichi and R. Hodges (Turnhout, 2012), 65–80. For a summary overview of Dorestad and the other northern European emporia, see, in the same volume, S. Lebecq, "The New Wiks or Emporia and the Development of a Maritime Economy in the Northern Seas (7th–9th Centuries)," 11–22. A more detailed picture of emporia and exchange in the early Middle Ages emerges from A. Willemsen and H. Kik, eds., *Dorestad in an International Framework: New Research on Centres of Trade and Coinage in Carolingian Times* (Turnhout, 2010); and M. McCormick, *The Origins of the European Economy: Communications and Commerce AD 300–900* (Cambridge, 2001).

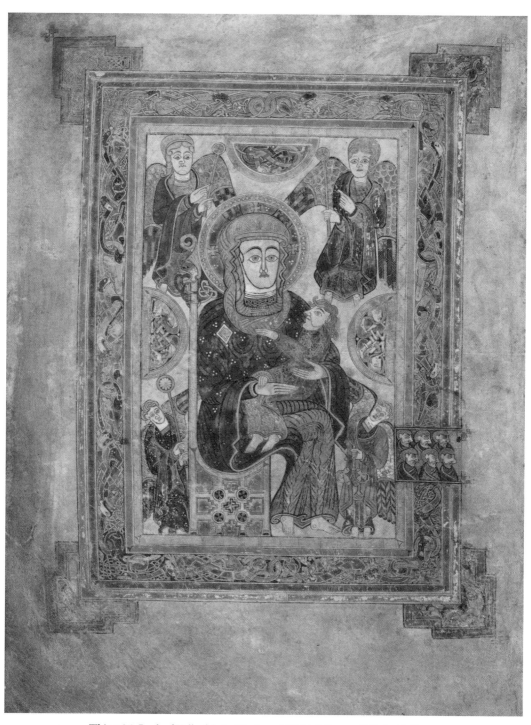

Thing 36. Book of Kells, fol. 7v, Virgin and Child. Library of Trinity College.
Photo courtesy The Board of Trinity College, Dublin.

36. The Book of Kells, Fol. 7v, Virgin and Child

Ireland, ca. 800

The Book of Kells is an illuminated Gospel book produced in an Irish monastery around the year 800. Illustrated books were known in the Roman world (see Thing 8), though the earliest surviving Christian sacred books date to the sixth century. Ireland was not part of the Roman Empire; the Irish gradually converted to Christianity starting from the fifth century. By the year 800, Irish monasteries throughout the island (see Thing 30) and abroad had mastered book learning and book production.

The Book of Kells was kept at the monastery of Kells between the tenth and the seventeenth centuries, hence its name. According to legend, Kells was originally founded around 554. In the early ninth century, monks from Iona, an Irish-founded monastery off the west coast of Scotland, returned to Kells after the Vikings sacked their island. The Book of Kells is thought to have been produced either at Iona, before its Viking sack, or at Kells shortly afterward.

The manuscript is written on calfskin vellum (requiring the skins of around 185 calves), and today its pages measure 33.0 by 25.5 centimeters (13 by 10 inches), although its edges were trimmed when it was rebound in the nineteenth century. The book has 340 folios (leaves of vellum) that are written or decorated on both sides. The resulting 680 pages contain the four Gospels in the Latin Vulgate translation, intermixed with readings from an earlier Latin version of the Bible, along with "canon tables" (lists that show where passages from different Gospels agree), summaries of the Gospel narratives, and prefaces to each Gospel.

The text is written in a very clear script, in black and dark brown ink, in types of handwriting known as Insular miniscule and majuscule. Scholars have identified the distinct handwriting of at least four scribes, who wrote the text and provided some decoration, and the work of two or three artists who supplied the more elaborate illustrations. Given the number of pages and the amount of decoration, it probably would have taken all these scribes over a year to complete the volume.

The book is embellished with illustrations ranging from colored letters to full-page pictures (such as the one shown here). Laboratory analyses of the pigments have shown that they came from indigo or woad (blue), verdigris (copper carbonate, green), chalk or gypsum (white), lead oxide (red), orpiment (arsenic sulfide, golden yellow), and lichens (purple). The ink derived either from simple carbon (black), or from iron-gall (brown). All of these materials were local, easily mixed with a binding agent such as egg-white to make a paint or ink.

This page shows a detailed representation of the Virgin Mary with her son on her lap. She is seated on a throne, her head surrounded by a halo, holding a small Christ; he gestures toward her with his left hand, while with his right he holds her right hand, a unique pose in early medieval art. Within a frame of characteristic interlaced serpents and/or human figures, four angels surround the Virgin and Child. On the right side is a small panel with six male busts, who look away from the Virgin and toward the facing page, which contains the beginning of the summary of the Gospel of Matthew describing Jesus' birth.

The Council of Ephesus in 431 declared Mary to have been the mother of God (*Theotokos*). Thereafter devotion to the Virgin Mary grew throughout the Christian world. Hymns and selections from the Gospels relating to the Virgin were daily sung in monasteries. Known from as early as the fourth century, pictures of the Virgin holding the infant Christ, surrounded by angels, became very popular after the fifth century. For example, in sculpted stone crosses that survive at Iona, this motif is found in the center of the cross, and a hymn to the Virgin, written in Latin around the year 700 at Iona, still survives. The monastic communities related to Iona seem to have had a particular devotion to the Virgin Mary, which may explain the prominent depiction of her in the Book of Kells.

Every element of the design symbolizes something. The Virgin wears a purple robe, the color of emperors in the Roman world; her breasts appear in outline in the cloth, emphasizing her role as the nurturer of Christ. Her brooch has a cross motif on it, foreshadowing her son's fate. The sets of three dots on her robe represent either the Trinity, or her triple virginity (before, during, and after the birth of Christ). The lion's head on the back of the throne refers to the House of David, from which the Virgin descended. And so on. And if most of these motifs came originally from the Roman world, the decorative elements used in the Book of Kells had a much longer Irish history. In particular, the decorative motifs in the border to this page, consisting of birds, beasts, and men forming elaborate interlace patterns, is known from metalwork and stone sculpture from pre-Christian Ireland. Irish artists adapted these designs in order to create a new visual repertoire for Irish Christianity.

Further Reading

The Book of Kells is available in print and online. The full manuscript is digitized and can be accessed via a website maintained by Trinity College, Dublin; at the time this book was printed, the URL is http://digitalcollections.tcd.ie/home/index.php?DRIS_ID=MS58_003v. For more information, see B. Meehan, *The Book of Kells* (New York, 2012); H. Pulliam, *Word and Image in the Book of Kells* (Dublin, 2006); and C. Farr, *The Book of Kells: Its Function and Audience* (London, 1997). For specific information about the image of the Virgin and Child, see C. Farr, "'Bis per chorum hinc et inde': The 'Virgin and Child with Angels' in the Book of Kells," in *Text, Image, Interpretation: Studies in Anglo-Saxon Literature and Its Insular Context in Honour of Éamonn Ó Carragáin*, edited by A.J. Minnis and J. Roberts (Turnhout, 2007), 117–34.

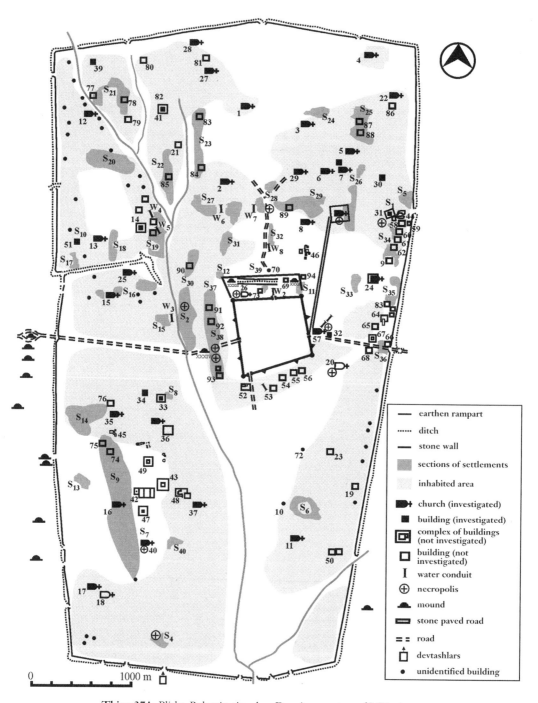

Thing 37A. Pliska, Bulgaria: site plan. Drawing courtesy of J. Dimitrov.

37. Gold Ring from the Fortified Settlement of Pliska

Pliska, Bulgaria, 814–35

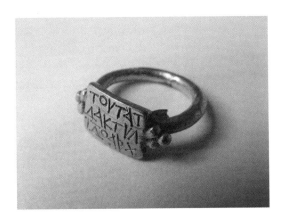

Thing 37B. Gold ring from the fortified settlement of Pliska, Bulgaria. Regional Historical Museum, Shumen, inv. no. 16030.

This ring made of twenty-two-karat gold comes from one of the most remarkable places—and archaeological sites—of the European Middle Ages, the gargantuan fortified settlement of Pliska in northeastern Bulgaria. Atop the gold band is a rectangular plaque, flanked on both sides by three small orbs applied with the granulation technique. The plaque bears an inscription, in Greek, that reads: ΤΟΥΤΑ Τ(Α) ΔΑΚΤΥΛΙ(Α) Δ(ΙΔΕΙ) Ο ΑΡΧ(ΩΝ), "The ruler gives these rings." The ruler to whom the inscription refers is probably Omurtag, the khan of the kingdom of the Bulgars from 814 to 835, who presided over a territory comprising much of modern-day Bulgaria, the capital of which was Pliska. Both the style of the ring and the wording of its inscription suggest that it was made locally. It may well have been forged in the artisans' quarter in Pliska, whose products include many surviving pieces of high-quality gold jewelry. The khan's court was a magnet for skilled craftsmen, for it was there that the wealthiest and most avid consumers of luxury goods resided.

Pliska was established on a previously uninhabited site shortly after 681, when the seminomadic Bulgars occupied most of what is now Bulgaria, including extensive territories until then under Byzantine control. By the middle of the eighth century, Pliska had become the capital of the Bulgar kingdom and the main residence of the khans. In 811, a Byzantine army under the command of the emperor Nikephoros I sacked Pliska, after which its formerly wooden royal palace was rebuilt in stone and surrounded by a rhomboid circuit-wall, also in stone, whose sides average 700 meters (2,300 feet) in length. In addition to the palace, this wall enclosed the quarter of the artisans, who produced fine pottery, glass, metalwork, and more perishable goods. Following the conversion of the Bulgar prince

Boris to Christianity in 864, a large, stone-built basilica church joined the existing structures.

But Pliska's most remarkable feature is the much more extensive fortification that surrounded this "inner city": a roughly rectangular earthen rampart, fronted by a deep ditch, that measured approximately 6.9 by 3.5 kilometers (4.28 by 2.17 miles) and enclosed 22.8 square kilometers (8.8 square miles), an area half again as large as the Byzantine capital of Constantinople! The dating of this rampart remains controversial, but a recent reassessment of the archaeological evidence suggests that it was built in or shortly after 895, when the Magyars (the ancestors of modern Hungarians) first invaded the kingdom of the Bulgars. Vast numbers of people moved inside its protective confines, where they built semisunken wooden houses (*Grubenhäuser*, or sunken featured buildings/SFBs; see Thing 15) in dense clusters whose remains have been found from one end of the enclosure to the other, but never outside of it. The size of the circuit, the density of the settlement within, and the quality of the manufactured goods (like the ring) found there all speak to the considerable resources, power, and ambition of the Bulgar khans, whose armies had more than once invaded Byzantine territory in the eighth century, arriving even at the walls of Constantinople (see Thing 6).

When this ring was made in the early ninth century, relations between the Byzantines and the Bulgars remained confrontational. After Nikephoros I had sacked Pliska in 811, the Bulgars under Khan Krum routed the Byzantines on their return journey and killed the emperor (Krum had Nikephoros's skull encased in silver and used it as a drinking-cup for the rest of his life). Krum's son Omurtag succeeded his father as khan only three years after these events. Yet this ring, given by the new khan to one of his subordinates, bore a phrase written in Greek, the language of the Byzantines, despite the fact that by Omurtag's time, the Bulgars had started to develop a written form of their own language. Even Omurtag's title is given with a Greek word, *archon* (ruler), instead of the Bulgar term *khan*.

The decision to make this ring "speak" Greek can be explained at least in part by the unrivalled status that Greek enjoyed across much of southeastern Europe in the early Middle Ages, including places like Bulgaria that had long been out of Byzantine control. Even for Byzantium's rivals and competitors, which included also Kievan Rus' (see Thing 50), the city of Constantinople and the emperors who presided there provided the archetype of earthly power and triumphal sovereignty; and the language of the Byzantine emperor and court remained the common tongue of most of eastern Europe's few literate inhabitants in the ninth century. As the rings and seals (see Thing 49) carried by privileged subordinates of the Byzantine emperor were inscribed in Greek, perhaps the servants of Khan Omurtag, too, were expected to bear tokens of office that communicated in the same, exalted language of power and sophistication. Further, if the ring's claim to

have been bestowed by the khan of the Bulgars was to be legible and understandable not only inside the Bulgar kingdom but also on any travels its wearer might have taken outside its borders, it was best written in Greek.

In light of the cultural pretensions of its rulers, there is a trace of irony in Pliska's subsequent fate. In 971–72, the Byzantines under emperor John Tzimiskes reconquered the eastern Balkans and annexed the Bulgar kingdom, which had been weakened by decades of strife in its ruling family and by pressure from Kievan Rus'. By then Bulgarian rulers were Christian and preferred to reside in nearby Preslav, so when the Byzantines devastated Pliska, it was never reoccupied. After less than three centuries, one of the largest fortified settlements ever built in Europe fell off the map.

Further Reading

The best treatment in English of Pliska and the dating of the various building and settlement phases revealed by the archaeologists is J. Henning, "The Metropolis of Pliska, or, How Large Does an Early Medieval Settlement Have to Be in Order to Be Called a City?" in *Post-Roman Towns, Trade, and Settlement in Europe and Byzantium*, edited by J. Henning (Berlin, 2007), vol. 2, 209–40; on the use of writing at Pliska and in the Bulgar kingdom, see also, in the same volume, G. Prinzing, "Pliska in the View of Protobulgarian Inscriptions and Byzantine Written Souces," 241–51. The ring itself is published in the archaeological catalogue in the same volume (666), and discussed further (in German) in V. Beševliev, *Die protobulgarische Periode der bulgarischen Geschichte* (Amsterdam, 1981), 288. More broadly on the Bulgar kingdom, see T. Stepanov, "From 'Steppe' to Christian Empire and Back: Bulgaria between 800 and 1100," in *The Other Europe in the Middle Ages: Avars, Bulgars, Khazars, and Cumans*, edited by F. Curta (Leiden, 2008), 363–78; and in the same volume, U. Fiedler, "Bulgars in the Lower Danube Region: A Survey of the Archaeological Evidence and the State of Current Research," 151–236.

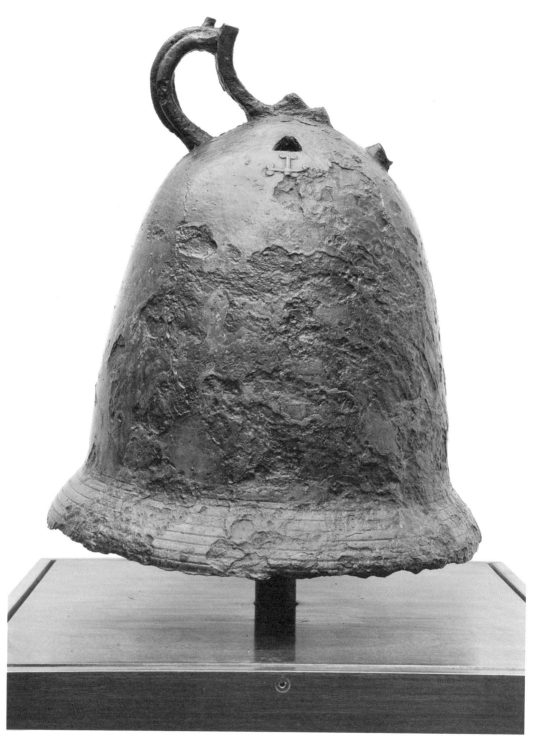

Thing 38. Bell of Canino. Photo © Musei Vaticani.

38. The Bell of Canino

Canino, Italy, ninth century

A stealthy revolution rolled across early medieval Europe, accelerating during the eighth and ninth centuries. Developing quickly, bell-making technologies had changed the soundscape by 1000. As always, older implements and techniques coexisted with the new, in this case with increasingly large, cast bronze bells attested to in many Carolingian texts. Thus, even if by 900 sonorous brazen bells with diameters over fifty centimeters (twenty inches), designed to be hung aloft and rung with ropes, had become common, people continued to use handheld, hammered iron cones too. In Ireland, monks prized worn iron bells as connections with the heroic days of earliest monasticism: some received elaborate, reliquary-like cases. By the tenth century, modest iron hand-held bells appealed to nostalgic people whose acoustic environment was shaped by louder, resonant bronze bells too heavy for any individual to hold and ring.

Exactly how tiny bells, fastened on clerical clothes or rung by hand, became the big bronze bells sounding from masonry bell towers is hard to sort out. After 500 no one cast large bronze objects using the "lost wax" method, whereby molten bronze is poured into a mold filled with wax, melting and displacing it (jewel-sized objects were still made this way, see Thing 18). This technological amnesia left forged, hammered metalworking supreme. Because metals were valuable, and therefore continuously recycled, few bells from before 1000 survive. Connecting textual references to this scanty archaeological material is difficult, and bell histories tend to be teleological, assuming as normal the late medieval situation, with bells tolling from every parish belfry, creating sound communities. A prudent reconstruction would locate in sixth-century Western monasteries an important place for bells' entry into Christian practice, specifically to summon nuns or monks to prayer (Eastern monasticism remained more attached to the wooden *semantron* for keeping the community's schedule). Around the year 606, the Papacy enjoined all monasteries to mark the hours for prayer with bells, and later in the seventh century Iberian rituals for the consecration of bells signal their growing acceptance.

But the explosion of writing in the Carolingian period has left the thickest traces of bells' dissemination. In the ninth century hefty bells appear in texts, held high by architectural elements, and not just in monasteries. Writers understood the acoustics of different alloys, and in bell foundries (one from around 800 has been excavated at the monastery of San Vincenzo al Volturno, in south Italy) the renewed use of the "lost wax" technique made bells of unprecedented

size possible. Partly because they were bigger and heavier, and so able to convey sound further and vibrate longer, ninth-century bells began to fashion Europe's public soundscape. No longer just a monastic call to prayer, bells also resounded for public alarms, and maybe at high points of the liturgy.

In the 1880s this unusually well-preserved bell was unearthed near Canino, one hundred kilometers (sixty miles) north of Rome. It is now in the Vatican museums. The Canino bell is dated, by its form and by the lettering on it, to the ninth century. It is made of bronze, with walls only some 2 centimeters (1 inch) thick. It is about 36 centimeters (15 inches) tall and 39 centimeters wide at the mouth, and weighs around 30.3 kilograms (over 66 pounds) without the (lost) hammer. Crowning it was a hanging loop of squared bronze from which the bell hung. Two side loops, whose profile is cloverleaf-shaped (only one survives), reinforced it and helped in suspension. The bell's crown is cross-hatched with a star-shaped design. Two holes intrude into this decoration, perhaps to allow sound to escape upward, something Theophilus recommended in his twelfth-century treatise on craftsmanship (actually such piercings harm sonority). Under the holes two small crosses ending in double curlicues were part of the caster's design. The bottom lip of the bell was cast with six coursings circling it. In the second coursing, part of an inscription survives, whose letters *h* and *e* are in uncial script, the rest solemn capitals. It reads: DNIN. . .CRISTIeTSCI. . . IS.ARhANGeLI. . . VIVeNTIU. . ., which might be translated as "(in the name of) our Lord Christ and Saint (Michael) the archangel, Viventius (offered this bell)." Michael was a popular saint in central Italy, while Viventius might be the patron and donor of the bell.

In the late first millennium several inscriptions on bells invoked saintly and other patrons. Though humans might not read these invocations, Carolingian thinkers began to equate bells with mouths, their hammers with tongues, announcing the divine services far and wide, and maybe propagating the written invocations too. Bells thus were better than other musical instruments, akin to the human voice that produced the most fitting sounds in praise of God, whose celestial music neither instruments nor voices equaled.

Increasingly associated with Christian worship, and increasingly able to convey sound far, during the ninth and tenth centuries church bells became contentious. In Islamic-ruled Iberia ringing bells loudly was regulated, and the removal of bells from belfries (see Thing 48), as happened in the 997 raid against St. James's shrine at Compostela, was a special triumph. Christian Iberians expressed similar anxieties about the call to prayer (from low "staircase minarets" or mosque rooftops before the ninth-century dissemination of mosque towers). In Iberia it was more contested, but everywhere in Europe the public soundscape grew louder.

Further Reading

J. Arnold and C. Goodman, "Resounding Community," *Viator* 43 (2012): 99–130, offers the most complete and sensible short treatment of bells and their medieval dissemination. J. Bloom, *The Minaret* (Edinburgh, 2013), is an efficient introduction to the subject. C. Bourke, "Early Irish Church Bells," *Journal of the Royal Society of Antiquaries of Ireland* 110 (1980): 52–66, catalogues hand bells from an early adopting region. N. Christie, "On Bells and Bell-towers," *Church Archaeology* 5–6 (2004): 13–30, probes the limits of the standard narratives and is excellent on belfries. A. Corbin, *Village Bells* (New York, 1998), a treatment of nineteenth-century bell-related culture wars in France, is considered a foundational text in the social history of sound. H. Drescher, "Die Glocken der Karolingerzeitlichen Stiftskirche in Vreden," in *799. Kunst und Kultur der Karolingerzeit*, vol. 1, edited by C. Stiegemann and M. Wemhoff (Mainz, 1999), 356–64, has the best drawings of the Canino bell. J. Smits van Waesberghe, *Cymbala* (Rome, 1951), tracks the musical uses of medieval hand bells.

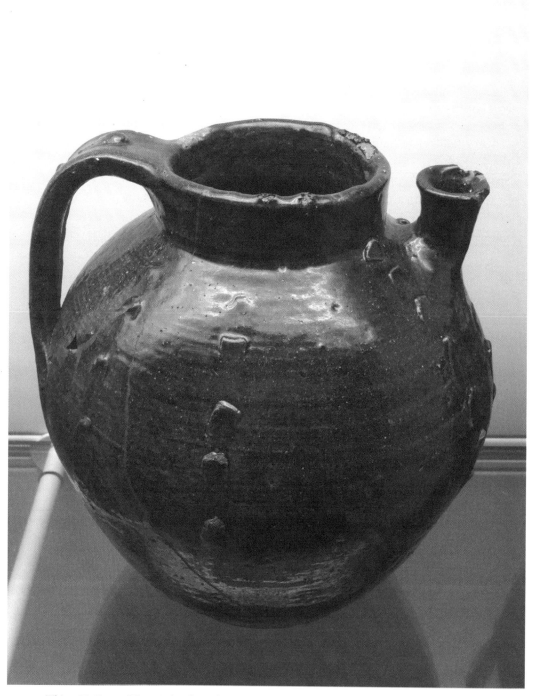

Thing 39. Forum Ware pitcher from the Crypta Balbi. Museo Nazionale, Rome. Photo by H. Dey.

39. Forum Ware Pitcher

Rome, ninth century

The body of this ceramic pitcher was thrown on a fast wheel, with the handle and spout subsequently added by hand, along with the distinctive "petal" decoration in relief. It measures approximately a foot (thirty centimeters) in height, and nearly as much in width at its widest point. The glassy, green finish results from the application of a transparent, lead-based glaze made from lead oxide powder mixed with trace elements of iron that give this pitcher its characteristic olive-green color. (Slightly different mixtures of trace elements produced a gamut of colors ranging from yellowish to brown in this period, though shades of green from dark olive to yellowish-olive are the most common.) The glaze was brushed onto the unfired pitcher, inside and out, before it was placed in a kiln and fired. A ubiquitous feature at Roman meals, where it could hold wine, water or other potables, with a rope tied to the handle a pitcher like this could also be used to draw water from wells and underground cisterns.

In fact, the first documented examples of this distinctive class of pottery all came from a well in the Roman Forum, called the Lacus Juturnae, where in 1900 excavators recovered eighty-three complete pots, among them this pitcher, and fragments of hundreds more. Hence, this type of thickly glazed pottery, much but not all of it decorated with similar "petal" appliqués, incised lines, or both, has come to be called Forum Ware. Though the pots found at the well do in fact seem to have been made in the immediate vicinity of the Roman Forum, Forum Ware is now known to have been produced far more widely in Rome and its environs, and in smaller quantities throughout much of central and southern Italy (in Abruzzo, Campania, Puglia, Molise, Calabria, and Tuscany) by the ninth century. But Rome was always the leading center of production. Forum Ware first appears there in the later eighth century and was made there in unparalleled quantities through the tenth century, after which it was gradually replaced by a new type called Sparse Glazed Ware. The widely spaced vertical lines of petals on this particular pitcher are characteristic of productions of the later ninth and tenth centuries.

Similar glazed pottery had been made in quantity until the fifth century, and a few examples from the seventh and eighth centuries found at Rome show that the knowledge and skills needed for its fabrication never totally disappeared. But something changed at Rome toward the end of the eighth century, when the new types of glazed pottery with their characteristic "petal" appliqués suddenly went into production on a large and growing scale. The earliest known examples of

Forum Ware at Rome have a *terminus ante quem* of 782, when the floor at the church of San Sisto Vecchio under which they were buried was installed, which puts the start of production strikingly close to 774, the year Charlemagne conquered the Lombard kingdom in northern Italy and brought Rome directly under Frankish protection.

For much of the eighth century, Rome's connections with the rest of Europe had been threatened by a series of aggressive Lombard kings who had pushed the Byzantines out of north-central Italy and gradually encroached on papal-controlled lands north of Rome, even besieging Rome itself for several months in 756. All that changed with Charlemagne's conquest. While remaining largely autonomous, Rome was now contiguous with the powerful and wealthy Frankish kingdom. Money and pilgrims flowed into the city from the north, and Charlemagne himself visited the city three times before being crowned "Emperor of the Romans" at St. Peter's by Pope Leo III in 800. Flush with money and secure as never before, the popes repaired crucial infrastructure, including the aqueducts and walls of the city, and built or restored dozens of churches, endowing them with lavish gifts of silks and liturgical furnishings of gold and silver. Papal estates outside the city called *domuscultae* provided vast quantities of foodstuffs for the people of Rome, much of it distributed free to pilgrims and paupers.

The renewed production of high-quality tableware was part and parcel of Rome's economic boom. In addition to meeting the growing needs of local consumers, Roman producers took advantage of the city's place as a hub of trade and long-distance communications to export Forum Ware as far afield as Corsica, Sardinia, northern Italy, and southern France. The shapes and decoration of the pitchers made in ninth-century Rome are especially evocative of the city's unique cultural and geographical matrix, its fusion of ancient, local traditions with influences from Byzantium and Western Europe. While pitchers like this one, with the spout on the shoulder of the vessel well separate from the rim, followed an unbroken Roman tradition stretching back to late antiquity, the other most common form, with a larger spout closer to the rim, mirrors types common north of the Alps in the Frankish heartland. The "petals" applied to both types, meanwhile, derived from Byzantine Petal Ware, produced in Constantinople and other sites in the eastern Mediterranean in the eighth century. This is cosmopolitan pottery for a cosmopolitan city.

Further Reading

The English-language literature on Forum Ware produced since Lucia Saguì and others properly dated and sourced it in the 1980s and 1990s is sparse. N. Christie, "Forum Ware, The Duchy of Rome, and *Incastallamento*: Problems in Interpretation," *Archeologia Medievale* 14 (1987): 451–66, is useful on the discovery of Forum Ware and the early debates over its dating. For the broader historical and archaeological context of eighth-century Rome, T.F.X. Noble, "Paradoxes and Possibilities in the Sources for Roman Society in the Early Middle Ages," in *Early Medieval Rome and the Christian West, Essays in Honour of Donald A. Bullough*, edited by J. Smith (Leiden, 2000), 55–83; also in *Early Medieval Rome and the Christian West*, P. Delogu, "The Papacy, Rome, and the Wider World in the Seventh and Eighth Centuries," 197–220; and R. Schieffer, "Charlemagne and Rome," 279–95, are good places to start. On the ninth century, see C. Goodson, *The Rome of Pope Paschal I* (Cambridge, 2010).

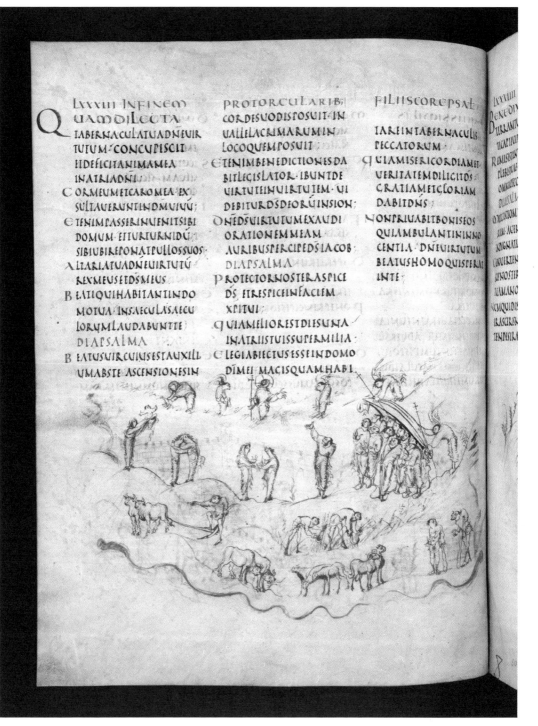

LXXXIII INFINEM
QUAMDILECTA
TABERNACULATUADNEVIR
TUTUM·CONCUPISCIT
HDEFICITANIMAMEA
INATRIADNI·
CORMEUMETCAROMEA·EX
SULTAUERUNTINDMVIVU;
ETENIMPASSERINUENITSIBI
DOMUM·ETTURTURNIDU·
SIBIUBIREPONATPULLOSSUOS·
ALTARIATUADNEUIRTUTU
REXMEUSETDSMEUS·
BEATIQUIHABITANTINDO
MOTUA·INSAECULASAECU
LORUMLAUDABUNTTE
DIAPSALMA
BEATUSUIRCUIUSESTAUXILL
UMABSTE·ASCENSIONESIN

PROTORCULARIB;
CORDISUODISPOSUIT·IN
UALLELACRIMARUMIN
LOCOQUEMPOSUIT·
ETENIMBENEDICTIONESDA
BITLEGISLATOR·IBUNTDE
UIRTUTEINUIRTUTEM·UI
DEBITURDSDEORUINSION·
ONEDSUIRTUTUMEXAUDI
ORATIONEMMEAM
AURIBUSPERCIPEDSIACOB·
DIAPSALMA
PROTECTORNOSTERASPICE
DS·ETRESPICEINFACIEM
XPITUI·
QUIAMELIORESTDIESUNA
INATRIISTUISSUPERMILIA·
ELEGIABIECTUSESSEINDOMO
DIMEI·MAGISQUAMHABI

FILIISCOREPSAL

TARE INTABERNACULIS·
PECCATORUM·
QUIAMISERICORDIAMET
UERITATEMDILIGITDS·
GRATIAMETGLORIAM
DABITDNS·
NONPRIUABITBONISEOS
QUIAMBULANTININNO
CENTIA·DNEUIRTUTUM
BEATUSHOMOQUISPERAT
INTE·

Thing 40. Utrecht Psalter, illustration of Psalm 84. Utrecht University Library, Ms. 32, fol. 49 v.

40. The Utrecht Psalter, Fol. 49v, Depicting Psalm 84

France, ca. 820–30

Charlemagne, king of the Franks from 768 until his death in 814, expanded his realm to include Italy and parts of Germany and central Europe; in the year 800 the pope crowned him "emperor ruling the Roman empire." Even before that, Charlemagne actively promoted a cultural revival in his realm to surpass the glories of the Roman Empire. For this "Carolingian renaissance" Charlemagne encouraged scholars and artists of all sorts to move to his kingdom, where he gave them jobs in the church or in his government. Charlemagne's ideal of rulership included patronage of books, buildings, and artworks, a vision continued by his successors and imitated by rulers in other parts of Europe.

Under the Carolingians, churches and monasteries became centers of learning and book-production. One of the leaders of this movement was Ebbo, archbishop of the important diocese of Reims, and it was a scriptorium under his direction (probably the monastery of Hautvillers) that produced the Utrecht Psalter between 820 and 830. Ebbo himself represents the possibilities opened by Carolingian patronage. Born an unfree peasant (his mother was the nurse to Charlemagne's son and successor Louis the Pious), Ebbo was freed, educated, and raised to high positions. His rise and background provoked hostility, and he fell from favor in 835 due to political intrigues.

A psalter is a book that contains the biblical Book of Psalms. By the ninth century, the psalms formed the basis of much of the liturgy in church services and were also recited in a weekly cycle in monasteries; most priests and monks memorized them. The Utrecht Psalter contains all 150 psalms, in their biblical order, and 16 additional canticles (hymns that are not psalms). This manuscript's layout shows that it was not written for liturgical or monastic use, but was perhaps intended as a gift to an important secular person.

The Utrecht Psalter is written in capital letters that imitate Roman script, and its format may have been copied from a fifth-century psalter. It is written on ninety-two folios of calfskin vellum. The manuscript today measures 33 by 25.5 centimeters (13 by 10 inches), after it was trimmed in the seventeenth century. The text of the psalms is written in three columns, with gold or red letters marking the psalm and verse divisions. Both text and drawings are executed in dark-brown ink made of the bark of the thorn-bush, dissolved in water and white wine plus a small amount of vitriol for the text, but not the drawings. Each psalm is illustrated by one drawing. The style of the drawings, with fluttering drapery patterns

and vivid, even frenetic, expressions and gestures, is similar to other works of art known to have been made at Reims. At least eight different artists created the 166 illustrations.

These illustrations are endlessly fascinating. Typically for the Carolingian renaissance, word and image work together in a complex intellectual puzzle to convey meaning. Psalms are poems that praise God, often using vivid metaphors. The artists tried to illustrate every phrase in each psalm by something in the physical world, combined into one pen-and-ink drawing. This illustration of Psalm 84 is an example: see if you can identify pictures for the following verses from the psalm:

"Thou hast forgiven the iniquity of thy people: thou hast covered all their sins."
"Thou hast turned away from the wrath of thy indignation."
"Mercy and truth have met each other; justice and peace have embraced."
"Truth is sprung out of the earth, and justice hath looked down from heaven."
"For the Lord will give goodness, and our earth shall yield her fruit."
"Justice shall walk before him, and shall set his steps in the way."

Each of these concepts has received a concrete illustration, combined into one composition. The Utrecht Psalter offers a similar brilliant exposition for each psalm. Even someone who had long ago memorized the psalms would find this book enthralling!

Because the illustrations depict so many concepts, they include not just rulers and religious figures, but also ordinary people. The artist of Psalm 84, to depict "our earth shall yield her fruit," has chosen to show people engaged in agriculture: plowing with an ard pulled by two oxen, and harvesting grain with sickles. While pictures of toiling peasants would later become a common way of illustrating the months of the year, ninth-century depictions of farmers are very rare. Even in this psalter, they only occur a few other times (21r, 59v, 62v, and 73r). Because these illustrations may have been copied from a much earlier manuscript, they may not reveal agricultural techniques of the ninth century (see Thing 26); but they are almost all we have. At least this illustration shows that educated monks were aware of the numerous members of society who spent their lives tilling the soil.

Further Reading

The Utrecht Psalter is fully digitized and can be accessed on a website full of texts and explanations, maintained by the Universiteitsbibliotheek Utrecht; in 2017, the URL is http://bc.library.uu.nl/utrecht-psalter.html. K. van der Horst, W. Noel, and W.C.M. Wüstefeld, eds., *The Utrecht Psalter in Medieval Art: Picturing the Psalms of David* (London, 1996), provides a full introduction to every aspect of the manuscript. For more on illustrations of peasants, see C. I. Hammer, *Charlemagne's Months and Their Bavarian Labors: The Politics of the Seasons in the Carolingian Empire* (Oxford, 1997).

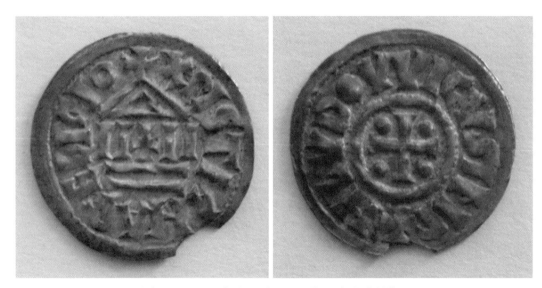

Thing 41. Louis the Pious denarius. Photos by Bob Miller.

41. Carolingian Silver Denarius

France, 822–40

Pictured here are both sides of a Carolingian silver penny (from the Old English *pfaenning*, or token) manufactured sometime between 822 and 840. This specimen's diameter is 2.1 centimeters (0.82 inches), about the same as a U.S. nickel or a twenty Euro-cent coin, but considerably thinner, so it weighs only 1.62 grams (0.06 ounces). The dull grey disc has deep markings imprinted on it, so feels rougher than modern coins. The coin's rim is chipped, or perhaps a user clipped off a bit of silver.

Numismatists call the side of the coin that contained the more elaborate and ideologically important design the "obverse," as opposed to the simpler "reverse." In this case the obverse shows a colonnaded building topped by a gabled roof at whose peak is a cross. Just right of this rooftop cross begins a Latin inscription: XPISTIANA RELIGIO (the Christian religion, hereafter XR). The reverse design is centered on a small, even-armed cross, separated from a circular inscription by a row of tiny beads or pellets that sometimes resembles a laurel wreath, an ancient symbol of victory. The reverse inscription, beginning at another small cross, reads HLVDOVVICVS IMP (emperor Louis; the last letters of "imperator" were omitted). This is Louis "the Pious," son and heir of Charlemagne, who ruled (often tenuously) over his father's dominions as king of the Franks and "emperor of the Romans" from Charlemagne's death in 814 until his own death in 840.

The XR coinage of Louis the Pious adopted as its obverse an older design. On coins Charlemagne minted in small numbers after 812 the reverse displayed the same XR around a columned building. These, the earliest coins to acknowledge the imperial status Charlemagne acquired in 800, used the Greek letters X (chi) and P (rho) in the XR inscription to replace the Latin C and R, perhaps because the Chi-Rho evoked the most awe-inspiring Christian-Roman emperor, Constantine (d. 337), and not just because Carolingian writers often transcribed Christ's name in Greek. Louis's coins of 814–19 had also used this reverse. Instead, the XR coinage's reverse duplicated a classic Carolingian obverse layout, but Louis's new coins arranged around their central cross a circular inscription declaring the name of the emperor and not, as previously, the name of the town where they were minted. Thus XR coins innovated by omitting the place of production and sending a message about the empire's homogeneity, and associating Christianity with Carolingian imperial authority. XR coins were also conservative, recycling designs associated with the most successful ruler of early medieval

Europe and connecting the reign of Louis to that of his famous father and pre-decessor in imperial power. Like all Carolingian coinage, the XR coins are epi-graphic, reflecting a deep-seated Frankish preference for communicating by text, not images.

But the XR coins do contain an image. The templelike structure that char-acterizes this coin mimics pagan temples on several types of ancient Roman coins. The Carolingians replaced the goddess Roma, most commonly repre-sented on the Roman coins amidst the columns, with a cross. Thus scholars have tended to see the templelike structure as a Christian church, or even as *the* Christian Church as an institution. However, because the biographer and friend of Charlemagne, Einhard, uses the phrase "religio Christiana" in describ-ing the construction of Charlemagne's palace chapel, Philip Grierson argued that the structure represents the atrium to that chapel in Aachen. Another possibility moves attention from the most celebrated place of worship built in the Carolingian Empire to the most famous religious structure in the Bible, the Temple of Solomon. According to Simon Coupland, since Charlemagne was thought a new David, Louis self-consciously represented himself as a new Solomon, consolidator of his father's glorious conquests, stabilizer of the econ-omy, giver of justice. Thus the XR coins of 822–40 reflect Louis's self-image as a pious, God-sanctioned, peace-giving ruler by evoking the Temple. Finally, the representation of the Holy Sepulcher in early medieval art (including on highly mobile souvenirs like ampullae: see Things 19 and 13) resembles the XR coins' temple, which has suggested to some that the coins evoke the holiest structure in the Christian universe, and one over which Charlemagne had extended his patronage, sending funds for refurbishment.

This commonest type of Carolingian penny survives in large numbers today thanks to finds from within and outside Frankish boundaries, especially in Scandinavia. Numismatists believe the XR coins were produced in greater num-bers and circulated more widely than any other early medieval coin. For eigh-teen years every imperial subject encountered the XR coin whenever s/he used money, as it was the sole legal tender. This coinage both propelled and reflected Europe's economic boom of the early 800s, when the emperor made available standardized, reliable silver coins, and monetary exchanges became normal for many Europeans, but especially for elites and in the empire's trading centers.

The silver necessary to saturate Carolingian markets came from the shallow ore mines at Melle in southwest France, from a burgeoning slave trade with the Caliphate, and from the vast bullion reserves of the Avar rulers (see Thing 34), looted and transported to Aachen during Charlemagne's reign. Discoveries like the Duesminde hoard (unearthed on the Baltic island of Lolland in 2002) reveal how full of silver was the Carolingian world in the ninth century. Exclusive use of the silver penny ("denarius" in Latin) set Carolingian Europe apart from the

Byzantine and Islamic economic commonwealths and hampered economic integration with them. Until about 750 Europeans had used mostly gold coins, but for ill-understood reasons (gold shortages?) English and Frankish rulers switched to silver pennies in a few decades (740–70). After Charlemagne reformed weights and measures in 793–94, Carolingian denarii weighed 1.7 grams and their fabric was like this XR coin. Until the thirteenth century similar pennies, issued by diverse authorities, were the only locally minted coins Europeans knew, even far beyond Carolingian imperial boundaries.

Further Reading

S. Coupland, "The Medieval Euro," *History Today* 52, no. 6 (2002): 18–19, is brief but informative. H. Fallon, "Imperial Symbolism on Two Carolingian Coins," *Museum Notes* 8 (1958): 119–31, discusses the "temple" design's Roman antecedents. P. Grierson and M. Blackburn, *Medieval European Coinage*, vol. 1 (Cambridge, 1986), is still the unrivaled tool of reference on early medieval numismatics, including Carolingian (190–266). R. Hodges and D. Whitehouse, *Mohammed, Charlemagne, and the Origins of Europe* (London, 1983), proposed that Abbasid silver funded Carolingian Europe. M. McCormick, *Charlemagne's Survey of the Holy Land* (Washington, 2011), chap. 9, discusses possible reasons behind Charlemagne's enthusiasm for the "temple" reverse. C. Morrison and H. Grunthal, *Carolingian Coinage* (New York, 1967), shows its age and sometimes errs, but is the sole comprehensive treatment of the topic in English. R. Naismith, "Kings, Crisis, and Coinage Reforms in the Mid-eighth Century," *Early Medieval Europe* 20 (2012): 291–332, presents current orthodoxies on why silver replaced gold coinage. F. Tereygeol, "Production and Circulation of Silver and Secondary Products (Lead and Glass) from Frankish Royal Silver Mines at Melle (Eighth to Tenth Century)," in *Post-Roman Towns, Trade, and Settlement in Europe and Byzantium*, vol. 1, edited by J. Henning (Berlin, 2007), 123–34, is the best English treatment of Carolingian silver mining.

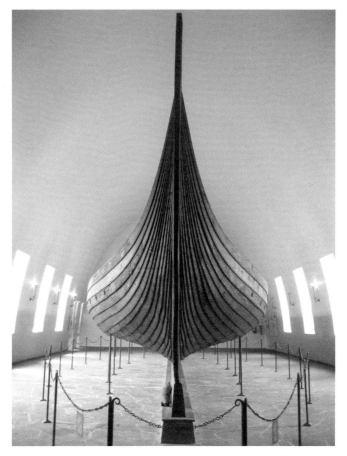

Thing 42A. Gokstad Ship, bow and underhull view. Viking Ship Museum, Norway. Photo by Karamell, Wikimedia Commons.

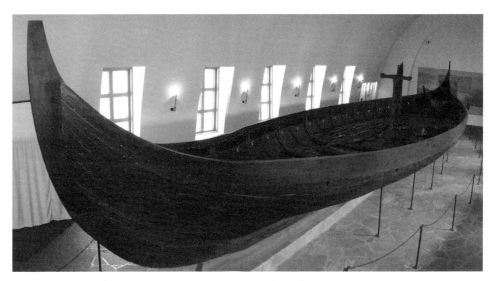

Thing 42B. Gokstad Ship, side view. Viking Ship Museum, Norway. Photo by Bjørn Christian Tørrissen, Wikimedia Commons.

42. The Gokstad Ship

Gokstad, Norway, ca. 900

In 1880, archaeologists excavated a burial mound at Gokstad, near Sandefjord in eastern Norway. They found that a large ship had been used for the burial of a high-status man in the middle of the Viking Age, around the year 900. Due to a remarkable lack of oxygen in the soil, the wood of the ship was extremely well preserved (the microorganisms that ordinarily cause wood to decay need oxygen to survive). Today, the ship is conserved in the Viking Ship Museum outside Oslo, looking very much as it did when it was interred eleven centuries ago.

Viking ships could be propelled either by oars or by sails; the latter were adopted by Scandinavian sailors sometime after 600, although they had been used in the Mediterranean for centuries. Sails, woven of wool, allowed Scandinavians to travel beyond their coastlines, which favored both the long-distance trade and the raids of the Vikings. The Gokstad ship was more than 23 meters (75 feet) long and 5.1–5.2 meters (about 17 feet) wide, with a mast and fittings for one large sail. There were thirty-two ports for rowers' oars, sixteen on each side, with shutters to close them when they were not needed. A single rudder steered the ship.

The Gokstad ship, along with others that similarly survived buried in tombs, provides invaluable evidence of how Viking ships were actually built. It was "clinker-built": its keel had curved stems at either end, to which were fastened strakes (wooden planks also curved to fit the shape of the ship), overlapping and fastened together with iron nails or rivets, and strengthened by framing timbers on the interior. Reinforced by wool wedged between the planks, "clinker-built" hulls were light, watertight, and rugged. The Gokstad Ship had sixteen rows of strakes, and the keel was made of one curved piece of oak. The prow and stern posts projected above the mound and therefore did not survive; on other contemporary ships, they were elaborately decorated. Most of the ship was made of oak, but pine was used for the deck and the mast. Dendrochronology suggests the wood used in the Gokstad Ship was felled around the year 890.

The ship had a full deck across its interior, but no benches or thwarts on which the rowers could sit, so they would probably each have had their own chests, both to sit on and to stow their belongings. The Gokstad ship was large enough for a crew of thirty-four to forty men. Below the deck, there was space for cargo or booty. The draft of the ship (the distance between the waterline and the bottom of the keel, thus the minimum depth it can safely navigate) was 1.2 meters (4 feet), which means that it was stable on the high seas but also could reach inland destinations by sailing up rivers.

From the time it was found, people have wanted to know how seaworthy a ship like this would be. In 1893, a replica of the Gokstad Ship was built, and sailed across the Atlantic Ocean from Bergen to Newfoundland, a journey that took twenty-eight days.

Who was buried in such a magnificent ship? The occupant had been laid on a bed in a burial chamber on the deck (compare Thing 20), which was covered with birch bark. Fragments of silk woven with gold thread imply that luxurious hangings decorated the walls on the interior. While the original excavators concluded that the man was sixty to seventy years old with rheumatism, scientific analysis of the surviving parts of his skeleton carried out since 2007 shows that he was in his forties, and between 181 and 183 centimeters (about six feet) tall. Signs of unhealed weapon cuts to both legs suggest he died in battle. The weapons and jewelry buried with him were robbed before the ship was excavated, but other pieces were found, including a game board, fish hooks, harness tackle of iron, lead, and gilt bronze, kitchen equipment, six beds, a tent, a sled, and three smaller boats. He was buried with twelve horses, eight dogs, two hawks, and two peacocks. Thirty-two shields were fixed to each side of the ship, painted alternately yellow and black. The burial included oars, gangplank, sail, and other pieces of ship's equipment. Whoever was buried in this ship was clearly a very important warrior, buried by his followers with items that demonstrated his status as a leader of a seafaring band.

Further Reading

The Viking Ship Museum, Oslo, maintains a very informative set of web pages about the Gokstad Ship; in 2018, the URL is http://www.khm.uio.no/english/visit-us/viking-ship-museum/exhibitions/gokstad/. See also Anton Englert, "Opening Up the Northern Seas: The Gokstad Ship," in *The World in the Viking Age*, edited by S. Sindbaek and A. Trakadas (Roskilde, 2014), 30–31. For ships generally, the standard work remains A. W. Brøgger, *The Viking Ships, Their Ancestry and Evolution*, trans. K. John (Oslo, 1951).

PART VII

Things of the Tenth Century

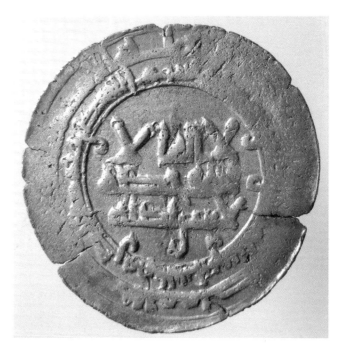

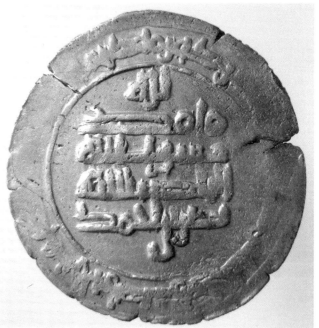

Thing 43. Abbasid (Samanid) dirham, excavated at Birka, Sweden, obverse (top) and reverse (bottom). Photos courtesy of Professor Kenneth Jonsson.

43. Abbasid (Samanid) Dirham

Birka, Sweden, 933–34

This Islamic coin, called a dirham (see Thing 7), is made of almost pure silver and measures 2.7 centimeters (about 1 inch) in diameter. Like most Islamic coins from after 692, it is aniconic (without images) but replete with Arabic text. The three lines in the field (the center) of the obverse side proclaim "There is no deity but / God [Allah] alone / He has no equal." The circular text looping around the margin of the field is heavily worn, but enough remains to show that the coin was minted in the city of al-Shah (modern Tashkent, capital of Uzbekistan), in Islamic year 322 (AD 933–34). On the reverse, the field reads "For God / Muhammad / is the Messenger of God" followed by the names of the Abbasid caliph al-Radi Billah (r. 934–40) and the Samanid amir Nasr ibn Ahmad (r. 914–43).

Persian-speaking descendants of the Sasanians (see Thing 7), the Samanids presided over the easternmost regions of the Islamic world in the ninth and tenth centuries, first as vassals of the Abbasids, and then, from the reign of Ismail ibn Ahmad (892–907), as rulers of an effectively independent state. At their height in the tenth century, the Samanids controlled eastern Iran, all of Afghanistan, most of Turkmenistan, Uzbekistan, and Tajikistan, and parts of Pakistan, Kyrgyzstan, and Kazakhstan. Their domains were ruled from Bukhara, a city in modern Uzbekistan that rivaled the Abbasid capital of Baghdad in size and wealth.

But this coin was found more than four thousand kilometers from the Samanid mint in Tashkent that produced it, in a grave in Birka, Sweden. From the middle of the eighth century until the middle of the tenth, Birka was one of the two or three leading *emporia* (see Thing 35) in the Baltic Sea, and the largest and most populous in modern-day Sweden. Located on the island of Björkö in the middle of Lake Mäleren, not far from Stockholm, and connected to the Baltic by a long strait, it was the gateway between Scandinavia and the trading-routes leading east and south via the Dnieper and Volga rivers, through Ukraine and Russia and on to the Black and Caspian seas, beyond which lay the territories of the Byzantine Empire and the Abbasid Caliphate.

Beginning in the eighth century, the fabled wealth of the great empires far to the southeast drew Viking ships ever farther into Russia, along the great river routes that began in the Gulf of Finland and along the coasts of Latvia and Estonia. Some went as traders, bringing northern slaves, wax, honey, amber, and skins to exchange for luxury goods from the east, such as silks and spices, and silver. Others went as soldiers and raiders. Around 870, a Viking flotilla (unsuccessfully) besieged Constantinople itself, at a time when the Byzantine emperor's palace

guard was staffed by other Scandinavians: warriors whose exotic appearance made for an awe-inspiring spectacle in the capital. Around 862, another Swede, Rurik, took control of the emerging Rus' kingdom centered on Novgorod, founding a new ruling dynasty that would ultimately preside over the flourishing of Kievan Rus' in the tenth and eleventh centuries (see Thing 50).

Whether through pay for their services, plunder, or commercial exchange, many of these adventurers returned to Scandinavia with great riches. Much of that wealth was in the form of silver coins, the vast majority of which were minted in the Islamic world, mostly from central Asian mints. More than 90 percent of all the "Viking Age" (eighth-to-tenth-century) coin finds from Scandinavia are silver dirhams. This is largely because both the Abbasids and the Samanids minted far more coins than any of their contemporaries, including the Byzantines (and the Franks—see Thing 41), thanks to their control of Eurasia's richest silver mines in eastern Iran and the Caucasus. Across the Islamic world and beyond, from the borders of India in the east to Spain in the west, the silver dirham, along with the gold dinar, was the principal unit of monetary exchange. Produced in huge numbers, widely distributed, immediately recognizable, and (reasonably) consistent in weight and silver content, it was the closest thing of its time to a global currency. Hence, when traders or returning travelers arrived back at Birka, their purses were often filled with dirhams.

At Birka, however, and throughout most of Scandinavia, coins were not used as they were in the Islamic world. The inhabitants of Birka valued dirhams primarily as a source of raw silver, or bullion. Prices were set in terms of quantities of silver, weighed on a balance-scale against weights of fixed denominations. The payer simply added bits and pieces of silver onto the scale until the requisite weight was reached, and since the quantities involved could be minute, this often required cutting silver objects—coins, but also jewelry, silver bars, etc.—into tiny slivers. Whether the source was a dirham or a bracelet, what mattered was achieving the desired weight. This practice shows up clearly in the materials excavated at Birka, where many of the dirhams discovered are actually only small fractions of coins, often tiny bits representing one-tenth or even one-twentieth of the whole. In addition, nearly three hundred balance weights were recovered from an excavated space comprising only 0.5 percent of the town's area. There was much weighing and chopping going on at Birka!

The quantities of dirhams arriving at Birka peaked between ca. 900 and 930, after which there was a sudden and rapid decline until the 960s, when the latest coins found there were minted. This has led archaeologists to conclude that the emporium disappeared by about 970, for reasons that are not fully understood. While a sudden attack may have been the immediate cause of Birka's end, there seem to have been longer-term processes at work, too, which affected trading sites across Sweden and beyond, all of which contributed to a decline in imports

of dirhams beginning in the 920s and 930s. As these coins continued to reach Kievan Rus' in large quantities thereafter, one possibility is that the increasingly powerful Kievan kingdom began to absorb more and more of the wealth arriving from the east, through taxes and tolls or outright seizures, such that little made it as far as Scandinavia. Whatever the cause, the constant flow of people and goods, which for two centuries had bridged the thousands of miles separating Baghdad, Bukhara, and Tashkent from Scandinavia, had slowed to a trickle by the time Birka was abandoned.

Further Reading

For an introduction to Islamic numismatics, start with S. Heidemann, "Numismatics," in *The New Cambridge History of Islam*, vol. 1, *The Formation of the Islamic World, Sixth to Eleventh Centuries* (Cambridge, 2010), 648–63. On the Samanids, see F.M. Donner, "Muhammed and the Caliphate: Political History of the Islamic Empire Up to the Mongol Conquest," in *The Oxford History of Islam*, edited by J.L. Esposito (Oxford, 2000), 38–41. On the excavations at Birka and the coins found there, see I. Gustin, "The Coins and Weights from the Excavations 1990–1995: An Introduction and Presentation of the Material," and "Islamic Coins and Eastern Contacts," both in *Birka Studies*, edited by B. Ambrosiani (Stockholm, 2004), vol. 6, 11–25 and 96–120; I. Gustin, "Coin Stock and Coin Circulation in Birka: Silver Economies, Monetisation, and Society in Scandinavia 800–1100," in *Silver Economies, Monetisation and Society: an Overview*, edited by J. Graham-Campbell, S. Sindbæk, and G. Williams (Aarhus, 2011), 227–44. More broadly on the economy of Viking age Scandinavia, D. Skyre's *Means of Exchange: Dealing with Silver in the Viking Age* (Aarhus, 2008), is a useful starting point.

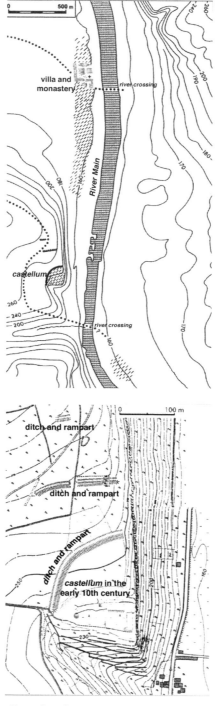

Thing 44. Castellum of Karlburg am Main, plan of site and village (top), and detail plan of castle site in the early tenth century (bottom). After P. Ettel, "Karlburg am Main (Bavaria) . . ." 2007.

44. *Castellum* and *Villa* of Karlburg am Main

Karlburg am Main, Germany, ca. 900–950

Was there a "castle revolution" between 950 and 1050? In 1973, Pierre Toubert proposed that in Italy, a radical change in the nature of settlement took place starting in the late-ninth century, which affected not only settlement, but lordship, peasant life, and the economy. Toubert's *révolution castrale*, known in Italian as *incastellamento*, has been alternately endorsed and attacked by historians. Indeed, not just in Italy, but throughout Europe, from Italy to Ireland, from Poland to Spain, both documents and archaeology testify to a great increase in the construction of fortifications starting in the ninth century. Fortifications imply violence, warfare, and the need for defense or deterrence. Certainly many historians have characterized these centuries as particularly insecure and violent, marked by the collapse of central authority and an increase in local elite competition and warfare, and dominated by invasions of non-Christian outsiders—Vikings, Magyars, and Muslims.

The fact that the number of castles greatly increased in the tenth century became linked to the "feudal revolution," the transformation of Western European society into an institution based on a warrior aristocracy's dominance of land and peasants (See Thing 17). However, since the 1970s, many historians have argued that "feudalism" cannot be said to have emerged full-blown around the year 1000, and that European society, rather than being organized according to its supposed norms, varied dramatically from place to place. Recently, Oliver Creighton has argued that while the "feudal revolution" did not happen, a "castle revolution" did, and that the large numbers of new fortifications was rooted in social competition that arose out of a new aristocratic ideology. Even if actual danger of violence was not omnipresent, the perception that it was led kings and aristocrats alike to build more castles in order to consolidate their authority.

In tenth-century Germany, a new dynasty of Saxon kings, known as the Ottonians, came to the fore, supplanting the last of Charlemagne's descendants and consolidating their control over an area roughly corresponding with modern-day Germany. Like the Carolingians, they sought legitimacy and an imperial title from the Roman popes; Otto I (r. 936–73) was crowned emperor of the Romans in 962, a title taken by his son Otto II (r. 973–83) and grandson Otto III (r. 983–1002). Under these rulers, large numbers of fortifications (*castella*) were either newly established or rebuilt and garrisoned with troops to serve as a defense against various peoples to the east and north. But in the interior of the kingdom, fortifications were also built everywhere. Ottonian narrative sources describe warfare, both invasion and civil war, as a series of sieges of these fortified places

(which included both smaller forts and cities). Ottonian estates given by kings to both noblemen and churches usually include a fortification (*urbs* or *castellum*) and a villa (village) or several *villae*. By 1000, then, whatever the social or political reason, the landscape was organized around units consisting of a fortification and its associated villages.

Karlburg-am-Main represents such a settlement. It is documented as having been given by Frankish kings to the bishops of Würzburg in the 740s and 750s, when it is described as having a monastery (*monasterium*) and a castle (*castellum*). The locality has been extensively excavated from the 1970s to the 2000s, giving us a good picture of the way that it both changed and remained the same over time. The site is located along the Main River, which runs east-west before it feeds into the Rhine River, and thus connects the heartland of the Ottonian realm with the Frankish kingdom to the west.

Karlburg's castle stands on the top of a hill, at the tip of a V-shaped promontory overlooking the river. Because of the steepness of the terrain on the sides of the V, there was only a need for a defensive wall on the northern side. There is no evidence for fortifications before the eighth century, but in the Carolingian period this location was provided with a wall made of stone and mortar, with a ditch on the exterior. In the early tenth century someone leveled this original fortification and filled in the ditch, and a new, bigger, fortification was built. It included a rampart 9–10 meters (30 feet) wide, made of stones and earth behind a ditch; 100 meters (about 330 feet) in front of this barrier, there was another rampart with a ditch, and yet another rampart-ditch was partially built 100 meters in front of that. The rebuilding took place at the start of the Magyar invasions, which may be the stimulus for the construction. The new *castellum* measured approximately 170 by 120 meters (558 by 394 feet), covering about 1.7 hectares, or 4.2 acres. In the eleventh century, the main wall was topped with a wall of mortared stones and a tower, and the castle continued in use in that form until the thirteenth century, when it was modified again with even larger walls.

The castle overlooked a settlement along the river that had existed since at least the late sixth century, and which presumably included the monastery. Less than 1 kilometer (1/2 mile) from the castle, it covered about 20 hectares (50 acres), and included docks along the river. Archaeologists found many sunken huts (see Thing 15), with evidence of metalworking, tool making, textile production, and grain storage. In the early tenth century, at the same time that the castle was rebuilt, the center of this villa was surrounded by a ditch 7–8 meters (25 feet) wide and 3 meters (10 feet) deep, and a simple earthen wall.

Who lived in the Karlburg *castellum*? We have no documentation of their names, but we do know that they were members of an elite who lived differently from the inhabitants of the villa. Elaborately worked metalwork, including *fibulae* (see Thing 18), glass drinking vessels, and imported pottery indicate the presence

of higher-class people at the *castellum*. Some of the houses in the Ottonian *castellum* had stone floors and fireplaces, unlike the earlier buildings. Analysis of the animal bones found on the two sites shows two distinct patterns of meat consumption. Bison, wild boar, and red deer made up 10.7 percent of the bones in the *castellum*, but only 0.9 percent of the bones in the *villa*. This seems to indicate that hunting was carried out by the elites, and that they ate what they killed. In addition, in the *castellum*, the bones of chickens, geese, and young pigs were found, whereas in the villa there were fewer fowl, and the bones were of older, less tender animals.

Thus, on a site that was continuously occupied from the Carolingian period to the tenth century, we can see that the elite inhabitants were able to command increasing amounts of the labor necessary to build elaborate defensive structures on both settlement areas.

Further Reading

Karlburg-am-Main's archaeology has been extensively published by Petter Ettel, mostly in German; this article is easily accessible: "Karlburg am Main (Bavaria) and Its Role as a Local Centre from Late Merovingian through Ottonian Times," in *Post-Roman Towns: Trade and Settlement in Europe and Byzantium*, vol. 1, *The Heirs of the Roman West*, edited by J. Henning (Berlin–New York, 2007), 319–40. On *incastellamento*, see P. Toubert, *Les structures du Latium médiéval: le Latium méridional et la Sabine du IXe siècle à la fin du XIIe siècle* (Rome, 1973); and C. Wickham, *Medieval Rome: Stability and Crisis of a City* (Oxford, 2014), 42–51. On castles and the "feudal revolution" generally, see T. N. Bisson, "The 'Feudal Revolution,'" *Past and Present* 142 (1994): 6–42; O. Creighton, *Early European Castles: Aristocracy and Authority, AD 800–1200* (London, 2012); N. Christie and H. Herold, "Defining and Understanding Defended Settlements in Early Medieval Europe: Structures, Roles, Landscapes, and Communities," in *Fortified Settlements in Early Medieval Europe: Defended Communities of the 8th–10th Centuries*, edited by N. Christie and H. Herold (Oxford, 2016), xix–xxviii. On warfare in Ottonian Germany, see D. S. Bachrach, *Warfare in Tenth-Century Germany* (Woodbridge, 2012).

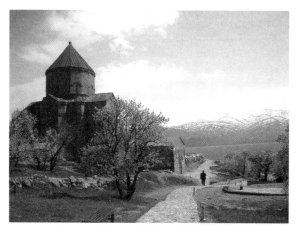

Thing 45A. Cathedral of the Holy Cross, Akdamar, Turkey, exterior view. Photo: birasuegi, Wikimedia Commons.

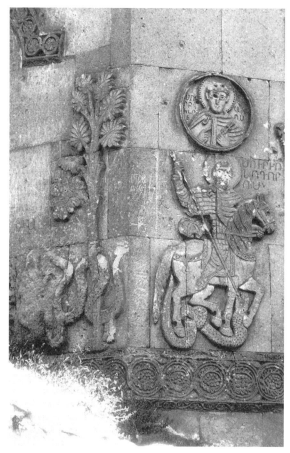

Thing 45B. Cathedral of the Holy Cross, Akdamar, Turkey, view of external wall. Photo courtesy of Lynn Jones.

45. The Church of the Holy Cross, Akdamar

Akdamar Island, Turkey, ca. 900–930

On an islet in the southeastern corner of Lake Van, today in eastern Turkey, rises the church of the Holy Cross. Early in his reign the ambitious southern Armenian ruler Gagik I Artsruni (r. 908–44) chose Akdamar Island to build one of his residences. A contemporary chronicle described the dazzle and charm of the palaces, gardens, and other structures that the architect Manuel erected for Gagik, who created a beautiful, ordered, and fruitful island paradise in a previously barren place. Though the site became an important Armenian ecclesiastical center, and Artsruni family members were buried there into the 1400s, today all that remains is the palace chapel, which contained a relic of the True Cross and was dedicated accordingly.

Dominating the church is a conical roof, protecting a dome that soars twenty-one meters (sixty-nine feet) high inside it. This dome collapsed in an earthquake in the thirteenth century but was rebuilt, as a long inscription on the dome's drum records. While conical domed churches were characteristic in medieval Armenia, in another way Holy Cross is unusual: few palace churches survive in the eastern Mediterranean region and this one is unique in its ornamentation. Manuel and Gagik imported soft tufaceous pink stone (according to chroniclers from a sacked Arab settlement near Lake Van) to build on one of the basaltic island's few flat outcrops. The carefully cut masonry blocks line a concrete core both inside and outside to create massive walls, in sections almost three meters (ten feet) thick. The walls are decorated on both sides, but whereas a frescoed interior is not so unusual, in the early 900s a complete program of external sculpture was unheard of, in Armenia or elsewhere in Christendom. Sculptors carved more than two hundred figures in low relief, several larger than life, for the external walls' nineteen courses of stone. Some project up to ten centimeters (four inches) from the flat surface, creating stark shadow effects as the sun's rays change angle. Though the faded frescoes seem to echo themes introduced by the sculptures, it is these unusual carvings that receive most scholarly attention.

Armenians built central-plan churches from the seventh century, but Gagik's had a complex design, with deep extensions (larger exedras and smaller chapels) radiating from the central square under the dome. The closest parallel to Holy Cross' plan is the seventh-century Church of St. Echmiadzin at Soradir, where members of the Artsruni clan were buried and the architect Manuel carried out some restorations. At both churches the effect was similar: lively external walls with many angles and projections.

The second figure here (Thing 45B) shows a corner of the north-facing wall of Holy Cross Church, where the sculptors exploited an angle to juxtapose unrelated scenes. On the left the serpent of Genesis 3 coils around the Tree of Knowledge, while Eve (much abraded) kneels to listen to its suggestions, perhaps holding its head (compare with Thing 3). The tempter has legs, for early Christian exegetes thought God's later condemnation ("on your breast you shall go") meant that previously the serpent had moved like the rest of God's terrestrial creatures. Just around the corner, with head pointed in the opposite direction and body knotted in powerless confusion, a postlapsarian and legless serpent is speared in the mouth by Saint Theodore, a military saint and third-century martyr whose cult center was in nearby Cappadocia. Haloed and bearded, Theodore rides a prancing horse, wearing armor and a cape. He is labeled in Armenian. Also labeled, above him, in larger scale, is a roundel with the haloed bust of Saint Cyriacus, legendary bishop of Jerusalem who helped find the True Cross in the early 300s. The two scenes share a writhing villain, which allowed the sculptors to make a theological point about the presence of evil in the world and the efficacy of saints against it. The composition is further united by both scenes' base, an elegant, spiraling vine motif that traverses the whole north wall.

A powerful theme underlying Holy Cross's external sculptures is that of human sin and its consequences. The repeated inclusion of Edenic symbols, and scenes of harmony and ease, juxtaposed to those of strife, violence, and labor, may allude to Gagik's circumstances at the time of construction, probably 915–21. Like any successful Armenian lord, Gagik took advantage of opportunities created by the competition between caliphs and Byzantine emperors for influence in this borderland. Allied with the Islamic governor of Armenia, Gagik participated in devastating campaigns against the Baghratids, rival Christian lords of northern Armenia whose growing autonomy the Abbasid caliphs sought to curb. Rewarded for his efforts with the royal title and emblems, Gagik still competed for hegemony against the famously devout, now martyred Baghratids. Thus the church of the Holy Cross may have been expiation for Gagik's transgression. It certainly asserted his Christian credentials. He appears in several carvings, sometimes near his ancestors (especially those conveniently known for piety), sometimes as a Second Adam, like Jesus restoring equity, and therefore order and prosperity, to the world.

Holy Cross church may assert Gagik's worthiness as a Christian ruler and his victory over sin, yet the sculptors represented him in Abbasid outfits and postures: by the tenth century these were not perceived as Islamic but had entered a common cultural idiom of aristocrats from Andalusia to Iran.

Further Reading

J. Davies, *Medieval Armenian Art and Architecture* (London, 1991), connects the church's imagery to early medieval Armenian liturgical, theological, and literary texts. S. Der Nersessian, *Aght'amar, Church of the Holy Cross* (Cambridge, MA, 1965), is the foundational study of the church in English, updated with indispensable line drawings of the sculptures by A. Sarafian. T. Greenwood, "Armenian Neighbors (600–1045)," in *The Cambridge History of the Byzantine Empire*, edited by J. Shepard (Cambridge, 2008), 333–64, provides invaluable background on the geopolitics of medieval Armenia. L. Jones, *Between Islam and Byzantium* (Aldershot, 2007), offers a meticulous reconstruction of the royal imagery at the church and its meaning. M. Stone, "Satan and the Serpent in the Armenian Tradition," in *Beyond Eden*, edited by K. Schmid and C. Riedweg (Tübingen, 2008), 141–86, surveys Armenian writings on this topic. An annotated translation of the dynastic chronicle about the Artsrunis' rise is by R. Thompson, *Thomas Artsruni: The History of the House of Artsrunik'* (Detroit, 1985).

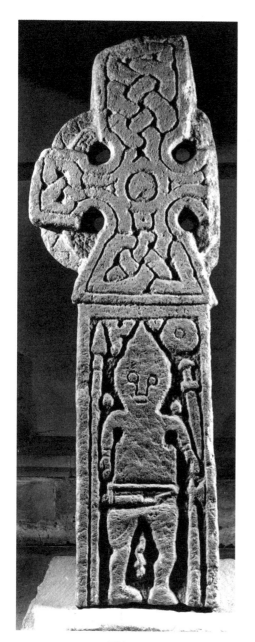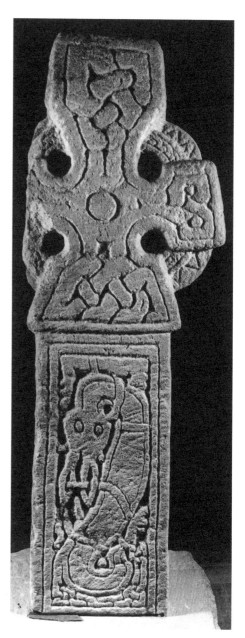

Thing 46. Middleton Cross, view of front (left) and back (right).
Copyright Corpus of Anglo-Saxon Stone Sculpture, photographer T. Middlemass.

46. The Middleton Cross B/2

Middleton, England, ca. 920–50

In eighth-century Ireland and England, a distinctive monument appeared across the landscape: the monumental cross, made of wood or stone. Ranging from less than one meter to six meters (about three to twenty feet) in height, these crosses were usually decorated with relief sculpture depicting abstract ornament and/or figural decoration. Often the four arms of the cross are linked by a ring, a feature that originated in Ireland. The crosses are obviously Christian symbols, but their purpose is disputed. Some were funerary markers, some were erected in church-yards or monasteries, but some are found out in the countryside, and these latter examples have been interpreted as boundary markers, or as marking places where Christian preaching took place in the absence of a church.

Anglo-Saxon sources uniformly identify Viking raiders as pagans, that is, non-Christians. The Viking raids that began in the late 780s and 790s had, by the 840s, led to more sustained settlement, especially in the northern and eastern parts of England. In the treaty eventually made between the Anglo-Saxon King Alfred and the Viking leader Guthrum in the 880s, those northeastern areas were ceded to Scandinavian rulers and became known as the Danelaw. Scandinavian settlement increased, and when the Anglo-Saxon kings reconquered the Danelaw between the 910s and 954, many settlers remained in England. They had been exposed to Christianity during the period of the Danelaw, and certainly by 1000 most people in the region were Christian.

Stone crosses proliferated in the Danelaw, becoming more prevalent than in the earlier Anglo-Saxon period, and their use continued after English rule was restored. They are generally funerary, set up over the tombs of aristocrats. Many are without any writing or identification of their patrons, but some indicate they were set up by Scandinavians. For example, several display Christian scenes and symbols side-by-side with scenes from Norse mythology. Scholars do not agree on the meaning of such juxtapositions; their use may have been a means for Scandinavian settlers to attempt integration into Anglo-Saxon society, by com-bining their own artistic and religious motifs on an Anglo-Saxon form. While today these crosses survive as plain stone, there is evidence that they were orig-inally painted, and thus their visibility, pattern, and meaning would have been further enhanced.

Middleton Cross B (or 2) dates to about 920–50, during the Anglo-Scandinavian period. It is made of sandstone and stands only 106 centimeters (42 inches) high. A ringed cross tops a short rectangular shaft, whose front and back contain

figural depictions. On one side of the shaft, we see a warrior (possibly seated on a throne, represented by the knobs above his shoulders), surrounded by his symbols of power. These include his pointed helmet, shield, spear, sword, knife or scramasax at his belt, and an axe, which he is holding. Between his legs, looking rather like a tail, is something most scholars identify as "decorative filler."

This is a rare example of a picture of a person from the Viking or post-Viking period; it is assumed that this was the person whose grave was marked by the cross. R. N. Bailey has proposed that this and similar warrior portraits on crosses around Middleton assert the aristocratic military ideals of northern England's new economic and military leadership. Nothing specific tells us that the deceased was a Viking, though he lived during the period of Viking dominance, and the serpent on the other side of the cross is a Scandinavian motif. The weapon-kit of spear, sword, knife, axe, and shield corresponds to the types of objects that were buried with men in Viking-age Ireland and England; someone buried with all of these objects would have been a high-status male, however he imagined his ethnicity.

The ring-cross above the warrior is decorated with an interlace pattern that recalls early Anglo-Saxon motifs. The same patterns are found on the two sides of the cross. The reverse of the cross depicts a dragon or serpent, twisted to fit in the rectangular space, and possibly bound by ropes. The style of the beast is similar to that found on many other sculptures and metal objects from Scandinavia, representative of the "Jelling style" of art. The motif of a serpent or dragon on a cross may represent the serpent in the Garden of Eden (now bound), or the Devil, or the worms that will eat the body, or may simply be decorative. The fact that other such *wyrms* are found on other similar crosses implies that they had a meaning that was relevant to the monument's function, even if now we do not know what it was.

Further Reading

This cross is published in J. T. Lang, *Corpus of Anglo-Saxon Stone Sculpture*, vol. 3, *York and Eastern Yorkshire* (Oxford, 1991), 181–87; the *Corpus* can also be found online, in 2017, the URL is http://www.ascorpus.ac.uk/catvol3.php?pageNum_urls=87. Studies of stone crosses include R. N. Bailey, "Scandinavian Myth on Viking-Period Stone Sculpture in England," in *Old Norse Myths, Literature and Society: Proceedings of the 11th International Saga Conference*, edited by M. Cluies Ross (Sydney, 2000), 2–7; and Victoria Thompson, *Dying and Death in Later Anglo-Saxon England* (Woodbridge, Suffolk, 2002), esp. chap. 5, "The Gravestone, the Grave, and the *Wyrm*." On Viking graves, see S. Hamilton, "Viking Graves and Grave-Goods in Ireland," in *The Vikings in Ireland*, edited by A.-C. Larsen (Roskilde, 2001), 61–75.

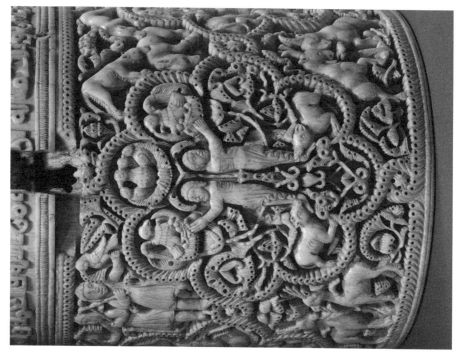

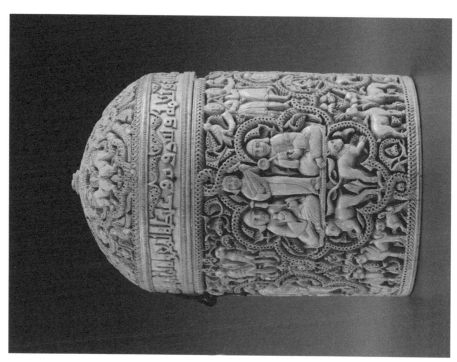

Thing 47. Pyxis of al-Mughī-ra (left) and detail (right). Musée du Louvre, Paris, France, inv. no. OA4068. Photos by Hughes Dubois. @ RMN–Grand Palais/Art Resource, NY.

47. The Al-Mughīra Pyxis

Spain (probably Cordoba), 967–68

For 250 years, the Muslim rulers of the Umayyad dynasty controlled the wealthy province of Spain and were active patrons of the arts. In 929, 'Abd al-Rahman III took the title of caliph and "commander of the faithful" (*amīr al-mu'minīn*), in direct competition with the Abbasid caliph in Baghdad. Under his rule, Iberia reached a zenith of wealth and culture. This cylindrical domed box, or *pyxis*, is a masterpiece from the Umayyad court at the palace of Madīnat al-Zahrā' outside Córdoba.

Luxurious objects like this pyxis played a role in court ceremonies. Surviving texts tell us that the most important festival was the one that took place on 'Eid al-Fitr, at the end of the month of Ramadan. During an elaborately choreographed ceremony, all of the royal family, nobility, and government officials acclaimed the caliph, newly composed poems and panegyrics were recited, and gifts were presented. It is very likely that this pyxis was created as a gift for such an occasion, by someone at the highest level of the court to be given to a member of the royal family.

The pyxis is fifteen centimeters high with a diameter of eight centimeters (six by three inches). The Arabic inscription around the rim of the pyxis reads: "Blessings from God, goodwill, happiness, and prosperity to al-Mughīra, son of the Commander of the Faithful, may God's mercy be upon him; made in the year 357." This text thus provides a rare identification both of the date in which the object was made (the year 357 in the Islamic calendar corresponds to AD 967–68) and the name of the owner.

Al-Mughīra was the youngest son of 'Abd al-Rahman III and a brother of caliph al-Hakam II (r. 961–76). Al-Hakam had been childless until his accession, although he soon fathered two sons, and a faction at the caliphal court had hopes that al-Mughīra would succeed him as caliph. This precise political context, the pyxis's imagery, and its extremely high level of craftsmanship suggest we should view it as a statement of political authority.

The cylinder is decorated with four eight-lobed medallions, each of which contains a scene (though Islam forbids the making of images of people, examples of figural Islamic art in nonreligious contexts are common during the Middle Ages; see also Thing 28). Below the beginning of the inscription are a standing musician flanked by two beardless youths who are seated on a throne held up by lions. One youth holds a flowering plant and a bottle, and the other holds a round ceremonial fan. These are presumed to be al-Hakam's young sons, the heir 'Abd al-Rahman and his brother Hisham. The medallion to the left contains

two lions who symmetrically battle two bulls. The next medallion encloses two bearded men who stand back-to-back and are reaching up to steal eggs from falcons' nests, while dogs bite their feet. The final medallion (not pictured here) frames two bearded men on horseback, facing each other, who pluck dates from a palm tree; birds grasp their hair, while cheetahs bite the tails of the birds. Around the medallions and on the lid are a variety of animals, birds, plants, and men, all symbolic in specific ways of power, court life, and/or the Umayyad dynasty.

Relying on contemporary poems, literary texts, histories, and other similar images, art historians have proposed several ways to interpret the alternation of courtly men with scenes of violence. Upon al-Hakam's death in 976, al-Mughīra was assassinated so that he would not claim the throne, making plausible a rivalry between al-Mughīra and the sons of al-Hakam going back to the early 960s. Thus the pyxis decoration might be a warning to al-Mughīra that he should respect the inheritance of the caliphal title by al-Hakam's sons. Alternatively, it might be meant to encourage al-Mughīra to take the throne for himself, or possibly the pyxis was a gift from al-Mughīra's mother, with no political meaning.

Certainly the pyxis shows how material objects intersected with political power. Ivory objects were extremely precious, since the ivory had to be imported from sub-Saharan Africa. Although the supply to Europe shriveled up in the seventh-century economic restructuring, by the ninth-century Islamic trade routes brought ivory back as a luxury material. As many other contemporary ivory objects attest, 'Abd al-Rahman III's expansion of his authority into North Africa made ivory a highly visible symbol of caliphal rule. Wealthy rulers were able to command the services of expert craftsmen; this pyxis was deeply carved by such an artist, who utilized the full thickness of the tusk to create a fascinating interplay of textures and shadows.

Further Reading

A description of the pyxis, with a consideration of the issues surrounding its manufacture, can be found in R. Holod, "Ivories," in *Al-Andalus, the Art of Islamic Spain*, edited by J. Dodds (New York, 1992), 190–206. Articles about the meaning of the pyxis include F. Prado-Vilar, "Enclosed in Ivory: The Miseducation of al-Mughira," *Journal of the David Collection* 2 (2005): 139–63; S. Makariou, "The al-Mughira Pyxis and Spanish Umayyad Ivories: Aims and Tools of Power," in *Umayyad Legacies: Medieval Memories from Syria to Spain*, edited by A. Borrut and P. Cobb (Leiden, 2010); and G. D. Anderson, "A Mother's Gift? Astrology and the Pyxis of al-Mughira," *Journal of Medieval History* 42 (2016): 1–24.

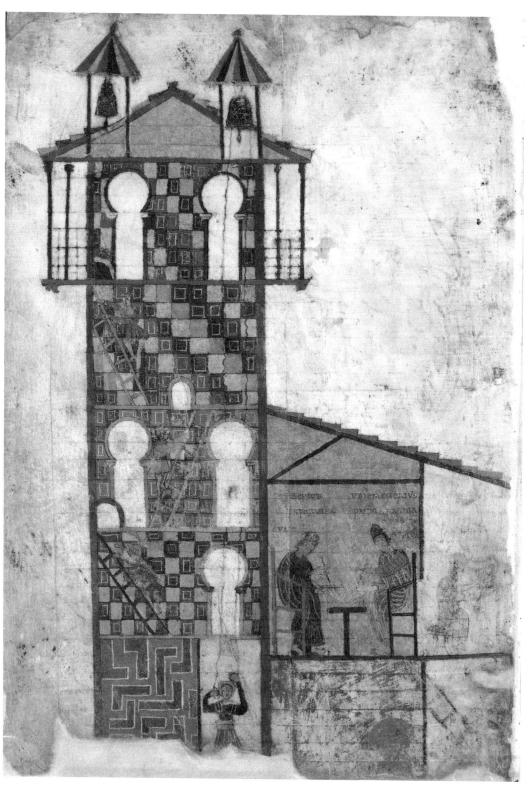

Thing 48. Beatus of San Salvador de Tábara. Madrid, Archivo Historico Nacional ms. 1097b, fol. 341r.

48. Beatus of San Salvador de Tábara, Fol. 341r

Tábara, Spain, 970

Many illustrated manuscripts survive from the early Middle Ages, but it is very rare to find a picture of the scribes who produced them. In this 25.5 by 35.4 centimeter illustration we see the bell tower of the monastery of Tábara, in Spain, attached to a room in which two scribes are at work. Labels over their heads identify the scribes as Emeterius (right), described as a "weary priest," and Senior. On the back side of the page, a lengthy inscription by Emeterius himself explains that the book had been begun by his teacher Magius, a priest and *arcipictor* ("master painter"), who died in 968. Emeterius was recalled to Tábara in order to complete the book, which he did on July 27, 970. This implies that after he had been trained, he had gone to live elsewhere. Once back at Tábara, Emeterius stayed there; we know that five years later, a second manuscript of this type, the Girona Beatus, was produced there, with Senior identified as the scribe, and Emeterius and a nun, Ende, as the illuminators.

In the inscription, Emeterius goes on to say, "O tower of Tábara, tall and of stone, the first place where Emeterius sat bent over for three months and, having maneuvered the pen with all his limbs, finished the work." In the picture, we see this tower. The scribes sit in an upper-story room, holding pens as they write the text. To the right, there is a monochrome sketch of another monk apparently preparing parchment for the book. Since Emeterius was an illuminator, it is likely that this is a self-portrait.

This remarkable illumination seems to depict an actual belfry in the monastery of Tábara. The monastery was founded by the monk Froila (d. 904), as a double monastery for monks and nuns, sponsored by King Alfonso III of Léon (r. 866–910). A church dedicated to the Savior was built at Tábara in the tenth century, and indeed the tower of the current parish church there encloses the remains of an older tower. The five-story belfry shown in this manuscript holds two bells at its summit, which are accessed by a walkway at the top level. A series of ladders, depicted with monks climbing up them, provided access. Doorways are found at various levels, each topped by what is known as a "horseshoe arch," a typical feature of both Christian and Islamic architecture in tenth-century Spain.

This illustration is found at the end of a manuscript that contains a text of Beatus of Liébana's *Commentaries on the Apocalypse*. Beatus was born around 750 in the Christian kingdom of Asturias in northern Spain, and became a monk. He wrote an illustrated commentary on the Book of Revelation (the last book in the New Testament, that predicts the last judgment) in the 770s, some sixty years after the conquest of (most of) Iberia by Muslim armies. Interestingly,

his text does not reflect contemporary concerns, such as the Muslim conquest or the Christian heresy of Adoptionism, against which Beatus himself had argued. Instead, he seems to have been inspired by the apocalyptic prophesy that the world was going to end in the year 800.

Beatus's commentary became popular from the 870s, when some Christians had attempted to rebel, unsuccessfully, against their Muslim rulers. In the Christian kingdoms, the Book of Revelation's promised ultimate salvation of Christians might have seemed attractive. The earliest surviving manuscript of Beatus's *Commentaries* dates to the 870s, and the number of copies increased markedly at the end of the tenth century, when it is possible that apocalyptic expectation was directed toward the year 1000. Tábara was one of the centers for dissemination of this text: in addition to our manuscript and the Girona Beatus, a third Beatus manuscript (the Morgan Beatus) was also produced there by Magius, the teacher of Emeterius. Thus, in addition to providing access to the visual world of Mozarabic Spain, this manuscript also shows how artistic and textual traditions were transmitted between generations of scribes.

Further Reading

This manuscript has been fully digitized and can be viewed online on a website maintained by Archivos Estatales of Spain; at the time this book was printed, the URL is http://www.mecd.gob.es/cultura-mecd/areas-cultura/archivos/mc/registro-memoria-unesco/2015/comentarios-libro-apocalipsis/b-tabara.html. The fundamental publication of the Beatus manuscripts, including this one, is J. Williams, *The Illustrated Beatus: The Ninth and Tenth Centuries*, vol. 2 (Turnhout, 1994). A study that includes discussion of scribes and production of such manuscripts is J. Sponsler, "Defining the Boundaries of Self and Other in the Girona Beatus of 975" (Ph.D. diss., UNC-Chapel Hill, 2009).

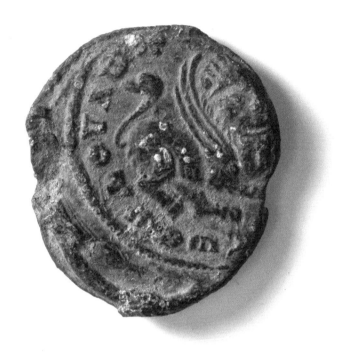

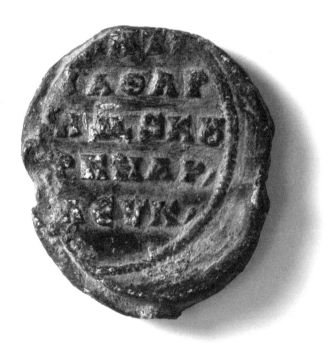

Thing 49. Lead seal of Demetrius, *kommerkiarios* of Seleukeia, obverse (top) and reverse (bottom). Photos © Dumbarton Oaks, Byzantine Collection, Washington, DC.

49. Lead Seal of Demetrius, *Kommerkiarios* of Seleukeia

Seleukeia (modern Silifke), Turkey, mid–late tenth century

This object began life as a blank lead disc, 2.5 centimeters (about 1 inch) in diameter, with a hollow channel bored through the middle across its full circumference. The channel was meant to be threaded with twine used to close letters, documents, and various sorts of packages. Once the thing to be sent was securely tied up, the ends of the twine were threaded through the disk, whose sender then used an instrument called a *boullouterion*, a sort of iron pliers with incised disks on its upper and lower jaws, to compress the soft metal disk around the twine, attaching it so firmly that the twine could only be undone by cutting it. The incised disks of the boullouterion left an impression in relief that could depict a portrait, a design, or words on both faces of the lead seal. Seals served two important purposes: they showed that whatever they were attached to was authentic and unopened (as long as the seal was undamaged and the twine uncut), and they provided information about the identity of the sender and/or the origin of the materials sent, thanks to their distinctive images and their inscriptions, which could include names and titles, locations, and occasionally dates.

On its obverse (front) face, this seal bears an image, stamped badly off-center (was the sealer in a rush?), of a winged lion encircled by the words of a common Christian invocation of divine protection: "Lord, aid your servant." The reverse consists of five lines of text, contained within a circular border of dots: "[Sealed] by Demetrios, imperial *spatharokandidatos* and *kommerkiarios* of Seleukeia." The first of Demetrios's two titles, *spatharokandidatos*, translates roughly as "swordsman of the white guards." These were attendants of the Byzantine emperor, a ceremonial corps of guards who wore white uniforms and gold necklaces, or gilded armor and helmets with white cloaks on especially important occasions. The title was largely honorary, a marker of rank at court, and the title holder need not have literally guarded the emperor; in fact, they often lived and served far from Constantinople, as did this Demetrios in Seleukeia (modern Silifke), a port city on the southeast coast of Turkey, near the empire's frontier with the Abbasid Caliphate.

Demetrios's presence at this port, at the crossroads of both land and sea routes between Byzantine Anatolia and the Muslim Levant, is explained by his second and more significant title, *kommerkiarios*. *Kommerkiarioi* first appeared in the sixth century, as government officials responsible for the import of silk, a rare and precious commodity produced in China that reached Byzantium on the "Silk Road" via the hostile Persian (and later Muslim) empires to the east. Its

purchase across an armed frontier was a delicate business, conducted exclusively by licensed government agents, who procured raw silk mostly for the workshops in Constantinople, which produced silk fabrics—the ultimate sartorial symbol of wealth and rank—for the imperial court. By the tenth century, however, Byzantium was less dependent on imported silk, supposedly thanks to two Indian monks who had supposedly smuggled silk worms from China into the empire in the sixth century and revealed the secrets of silk-making to the delighted Byzantines. With the Chinese monopoly broken and silk production launched on an industrial scale inside the Byzantine Empire in western Turkey and the Balkans, the role of the kommerkiarioi changed and diversified. They became tax and customs officials, responsible for regulating the flow of goods into and out of the empire, and collecting sales taxes and the dues the government levied on exports and imports.

It is not coincidence that the large majority of the *kommerkiarioi* whose locations are known were stationed in Asia Minor, for the Abbasid Caliphate just to the east remained the Byzantine Empire's leading trading partner, despite the nearly constant state of war existing between the two. The Abbasids had ample wealth to spend on Byzantine goods, and demand in Byzantium remained high for commodities from beyond the frontier, from spices and textiles to jewels, ivory, and precious metals. The need for *kommerkiarioi* in this region was therefore especially high. Seleukeia seems to have been a flourishing urban market in the tenth century, as it was promoted to become the capital of its own administrative district (called a Theme) between 927 and 934, home to an expanded corps of government officials and administrators in which the *kommerkiarios* Demetrios would eventually serve.

But while Demetrios probably dealt with a wider range of commodities than earlier *kommerkiarioi* of the sixth and seventh centuries, silk evidently remained one of his primary concerns. According to a tenth-century author from Constantinople, merchants based in Seleukeia still dealt in silks imported from Baghdad and Syria. Possibly these products included special fabrics or finished garments unavailable inside the empire. As harvests of silk vary from one region to another depending on a variety of factors, including the effects of weather and climate on the annual crop of mulberry leaves—the only food silk worms eat—demand for imported silk may also have increased in times of local scarcity. Business, in any case, was business, even between enemies as long-standing as the Byzantines and their Muslim neighbors to the east.

Further Reading

The seal is published in E. McGeer, J. Nesbitt, and N. Oikonomides, eds., *Catalogue of Byzantine Seals at Dumbarton Oaks and in the Fogg Museum of Art*, vol. 5, *The East (continued), Constantinople and Environs, Unknown Locations, Addenda, Uncertain Readings* (Washington, DC, 2005), no. 6.17. The Byzantine sources mentioned are Procopius, *Gothic Wars*, 4.17, on the Indian monks who broke the Chinese silk monopoly; and *The Book of the Eparch*, chap. 5, for Seleukeia and the silk trade with Baghdad and Syria in the tenth century. For the rest, see N. Oikonomides, "Silk Trade and Production in Byzantium from the Sixth to the Ninth Centuries: The Seals of the *Kommerkiarioi*," *Dumbarton Oaks Papers* 40 (1986): 33–53; and for more on kommerkiarioi, N. Oikonomides, "The Role of the Byzantine State in the Economy," in *Economic History of Byzantium*, edited by A. E. Laiou (Washington, DC, 2002), 973–1058, at 983–88.

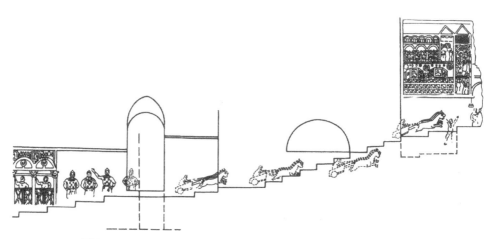

Thing 50A. Schematic diagram of the hippodrome fresco in the church of St. Sophia, Kiev, reconstruction. After D. D. Radchenko.

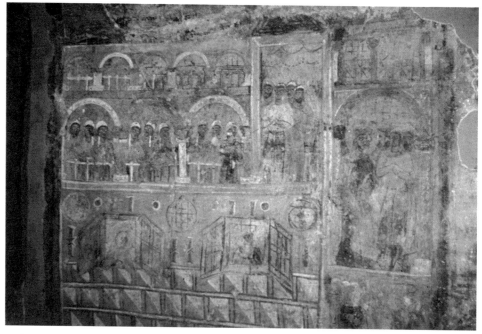

Thing 50B. The hippodrome fresco in the church of St. Sophia: detail showing the crowd in the stands (left) and the emperor and his retinue in the imperial box, or *kathisma* (right). Photo: George Majeska. Courtesy of the Image Collection and Fieldwork Archives, Dumbarton Oaks.

50. The Hippodrome Fresco in the Church of St. Sophia

Kiev, Ukraine, 1030s

In the year 988, Vladimir, prince of Rus', a growing state centered on Kiev in present-day Ukraine, was baptized a Christian. The ritual was performed by the Greek bishop Theophylact, dispatched for the occasion by the Byzantine emperor Basil II and consecrated the first archbishop of Rus'. Basil was fighting for his throne against a rebellion led by two of his most experienced generals; desperate for aid, he appealed to Vladimir for military assistance. In return, Basil promised his sister, Anna, in marriage, and Anna insisted that her pagan betrothed convert to Christianity before she married him. Thus the principality of Rus', a conglomerate of Varangians (the descendants of Scandinavian traders and warriors led to the region by the Viking chieftain Rurik) and indigenous Slavs, began to embrace Christianity in earnest. Subsequent rulers of Rus' deliberately sought to model the physical and ideological aspects of their rule on the model of the Byzantine Empire of Constantinople.

Probably in the 1030s, Vladimir's son Jaroslav ("the Wise," lived ca. 976–1054) commissioned a new cathedral for his capital, Kiev. In imitation of the cathedral in Byzantine Constantinople, it was dedicated to Saint Sophia, "Holy Wisdom." The imposing (ca. 55 by 42 meters, or 180 by 138 feet), stone-built church became the largest masonry structure in Rus' upon its completion (earlier churches, such as the cathedral at Novgorod, built around 989, were made of wood). It featured five naves, five apses, and thirteen domes, and contained the only spiral staircase known in the whole kingdom, which led to a second-floor gallery over the entrance to the church reserved for the royal family and the prince's guests. The most remarkable feature of the stairway, and indeed of the church as a whole, is the fresco that covers its walls, spiraling up the stairway for over 14 meters (46 feet). It depicts a chariot race, so detailed in execution and faithful to ancient Roman tradition that it would have been immediately recognizable to the patron of the chariot-race mosaic at Piazza Armerina (see Thing 1), done seven centuries earlier. Like the dedication of the church itself, the inspiration for the scene must have come from Constantinople, the only city in the world that continued to stage chariot-races on the ancient Roman model. The 100,000-seat hippodrome adjacent to the imperial palace was still the site of Byzantium's most elaborate public ceremonies and preferred point of encounter between the emperor and his subjects.

In the church at Kiev, those permitted access to the stairway via its only entrance, on the façade of the church, first encountered a depiction of four chariot

teams in the starting gates (*carceres*), awaiting the starter's signal, perhaps from the man with the raised arm standing with three others just to the right of the carceres. The fresco on the ascending wall of the staircase, now mostly lost, showed all four chariots at full speed. At the top, where one stepped out into the raised balcony facing the majestic apse-mosaic of the Virgin Mary, visitors beheld the culminating moment of the race, as the winning team crossed the finish line beneath the imperial box (*kathisma*), where a haloed emperor looked on with his retinue. Around the box, a few select images evoke the grandeur of the spectacle: the stands packed with roaring spectators; a group of nine musicians with various exotic instruments. The most notable of the instruments was an organ, a technological marvel that was a specialty of Byzantine craftsmanship and was associated directly with the emperor as the embodiment of victory: his public appearances unfolded to the sound of organ fanfares, as did the celebration of victors in the hippodrome.

In the eleventh century, the most famous spiral staircase in the world was the "secret" one that led to the imperial box in the hippodrome in Constantinople, the final stretch of the passageway connecting the palace and the *kathisma*. In Kiev, the raised gallery in the church, reserved for the royal family, thus became both the architectural and functional equivalent of the imperial box in the hippodrome of Constantinople: accessed via another spiral staircase, painted with images of the hippodrome in Constantinople, and associated with the local equivalent of the Byzantine emperor, the prince of Rus', in a church whose dedication itself evoked Constantinople's Hagia Sophia. Prince Jaroslav, in short, was doing all he could to re-create Constantinople at Kiev.

Why did Jaroslav choose to do this, and why, of all the possible scenes he might have picked, did he choose to show chariot racing in the hippodrome in Constantinople on this stairway? A few things are clear. Almost nobody in Kiev had ever been to Constantinople. Fewer still had seen a chariot race, or knew much about the rules of the sport, the architecture and rituals of the hippodrome, and the prodigies of technology on display there, such as the organ. Perhaps this was the point. From the vantage point of Kiev, Byzantium was the greatest empire in the world, the unrivaled center of culture, learning, religion, and power. Its mystique was all the greater for being almost impossibly distant and unfamiliar. By quoting some of Constantinople's most famous landmarks and most awe-inspiring spectacles, Prince Jaroslav may have sought to claim insider status, intimate knowledge of the mysterious institutions, ceremonies, and technologies that shaped daily life in the Byzantine capital.

Certainly Jaroslav had a complex game to play as the sovereign of a small but dynamic principality growing up in the shadow of the ancient and still-mighty Byzantine Empire, and surrounded by other Christian kingdoms. He himself was married to the daughter of the king of Sweden, and his daughters were married

to the kings of Norway, Hungary, and France. In his foreign policy, he adopted an aggressive stance toward Byzantium, often even fighting to take Byzantine towns and territory. As his father knew and used to his advantage, the emperors in Constantinople would only take their rustic northern neighbors seriously when compelled to do so. The paradox was that this militant posturing toward Constantinople was the means of seeking the sort of prestige and international stature that recognition from Constantinople could provide. At home, meanwhile, Jaroslav placed himself as a privileged intermediary between his own people and Byzantium, a ruler uniquely empowered by his special connection with, and fluency in, the architectural and ceremonial language of Constantinople.

Further Reading

The principal discussion of the hippodrome fresco itself is E. Boeck, "Simulating the Hippodrome: The Performance of Power in Kiev's St. Sophia," *Art Bulletin* 91, no. 3 (2009): 283–301. More generally on the history and architecture of the cathedral, see A. Poppe, "The Building of the Church of St. Sophia in Kiev," *Journal of Medieval History* 7, no. 1 (1981): 15–66; and O. Powstenko, *The St. Sophia Cathedral in Kiev* (New York, 1954). The principal medieval source for the Christianization of Kievan Rus' is the early-twelfth-century *Primary Chronicle*.

Index